On Color

On Color

DAVID SCOTT KASTAN

with Stephen Farthing

Yale

UNIVERSITY PRESS

New Haven and London

Published with assistance from the foundation established in
memory of Calvin Chapin of the Class of 1788, Yale College.

"Living with a Painting," by Denise Levertov, from *Poems, 1968–1972*, copyright © 1972
by Denise Levertov. Reprinted by permission of New Directions Publishing Corp.

"Reno Dakota," written by Stephin Merritt, published by Gay and Loud (ASCAP).
Lyric reprinted by permission of the author.

"Another Birth," by Forough Farrokhazad, trans. Hamid Dabashi, in *The Green Movement in Iran*
(New Brunswick, NJ: Transaction, 2011), reprinted by permission of Hamid Dabashi.

Yale University Press books may be purchased in quantity for educational,
business, or promotional use. For information, please email sales.press@yale.edu
(US office) or sales@yaleup.co.uk (UK office).

Designed by Sonia L. Shannon

Set in Fournier by Tseng Information Systems, Inc.

Printed in China.

Library of Congress Control Number: 2017955138

ISBN 978-0-300-17187-7 (hardcover : alk. paper)

A catalogue record for this book is available from the British Library.

This paper meets the requirements of ANSI/NISO Z39.48-1992 (Permanence of Paper).

10 9 8 7 6 5 4 3 2 1

For Pete Turner, 1934–2017.
Other photographers shot the world in color;
Pete shot great pictures of color itself.

Contents

■

Preface

∎

COLOR IS A COLLABORATION — a collaboration, as Paul Cézanne said, of the mind and the world. So it seems only right that a book about color should itself be a collaboration (as all books in fact are). This one began in 2007, in a restaurant in Amagansett village on Long Island, when a mutual friend pulled us together, saying, "You two should talk," then wandered off, leaving us to get on with it.

As it happened, he was right about our compatibility, and we were able not simply to talk but to start an ongoing conversation. During that first meeting, we quickly covered the usual introductory topics, then without too much effort found a large chunk of common ground, which has been the basis of our subsequent meetings, many emails, and a friendship.

It turned out that the writer had an interest in painting and the painter an interest in writing. When we parted company that first evening, neither of us imagined that this conversation would last over ten years and stretch over nearly that many countries.

It took us from the painter's studio to the writer's study, from Orhan Pamuk's novel *My Name Is Red* to Derek Jarman's movie *Blue*, from a color-man's shop in London to the paint-splattered floor of the Krasner-Pollack house in Springs, New York, from Josef Albers's *Interaction of Color* to George Stubbs's *Zebra*. It took us from Amagansett to New Haven and to London, and then through Washington, DC, New York City, Amsterdam, Paris, Mexico City, and Rome. Very often the conversation was accompanied (aided?) by glasses of wine, whose wonderful colors were not the least of their pleasures and not the least of what was remarked upon.

The chapters usually started, or restarted, in a gallery or museum. We began in front of a set of dark drawings at the top of that ramp in the Van Gogh Museum in Amsterdam and ended up six hours later separated by a white tablecloth in a restaurant on the Herengracht. In other cities, the catalysts and the contrasts were different, but always there was the conversation, and always there were the colors.

The division of labor within our collaboration was clear-cut from the beginning. The project was ours, but we would elect Kastan for obvious reasons as the writer. Yet like all good collaborations, this one also had more than two people in the conversation. There were, of course, all the people who have written about color before us, each a part of the larger conversation and community of engagement that now we have joined. Endnotes will acknowledge some of our indebtedness, but we know well how much more we owe others and how little of our debt these notes have discharged. And there were the conversations that were more literal. We discussed the idea of the book and the ideas with everyone who would listen and shared drafts with anyone who was willing to read.

Fortunately there were many. Color is a topic that everyone has experience with and opinions about. The list of names here is almost certainly not complete, and the only thing that makes us feel a bit better about the inevitable omissions is our awareness of how utterly inadequate even this mention is for the remarkable generosity that has been shown us. Certainly the book would have been impossible to write without the intelligence and kindness of many people: Svetlana Alpers, John Baldessari, Jenny Balfour-Paul, Jennifer Banks, Amy Berkower, Rocky Bostick, Stephen Chambers, Keith Collins, Jonathan Crary, Hamid Dabashi, Jeff Dolven, Laura Jones Dooley, Robert Edelman, Rich Esposito and John Gage (for both of whom this thanks has sadly come too late), Jonathan Gilmore, Jackie Goldsby, Clay Greene,

Marina Kastan Hays, Donald Hood, Kathryn James, Michael Keevak, Robin Kelsey, Lisa Kereszi, Byron Kim, András Kiséry, Doug Kuntz, Randy Lerner, James Mackay, Alison MacKeen, Claire McEachern, Amy Meyers, John Morrison, Robert O'Meally, Caryll Phillips, John Rogers, Jim Shapiro, Bruce Smith, Caleb Smith, Donald Smith, Michael Taussig, Pete Turner, Michael Watkins, Michael Warner, Dan Weiss, John Williams, Christopher Wood, Julian Yates, Ruth Yeazell, Juan Jesús Zaro, and Gábor Á. Zemplén. That's a long list, and it should be still longer. It is, nonetheless, an A to Z of deeply felt gratitude, however meagerly expressed.

Color has been the inspirational and inexhaustible subject of our ongoing conversation. Over the decade that it has lasted, our view of ourselves changed. Sometimes we were two professors with a shared interest in painting and literature engaged in a cross-disciplinary exploration of the relations between words and color; other times we were simply a writer and a painter sharing ideas and images as we each thought about the nature of color itself, which always, of course, always involved thinking about the nature of the world we live in. Color, it turns out, is something shared, and also something impossible to share, or maybe just impossible to know if or how it is shared. But color is also unavoidable and irresistible — and always worth the effort of trying to understand its many wonders.

On Color

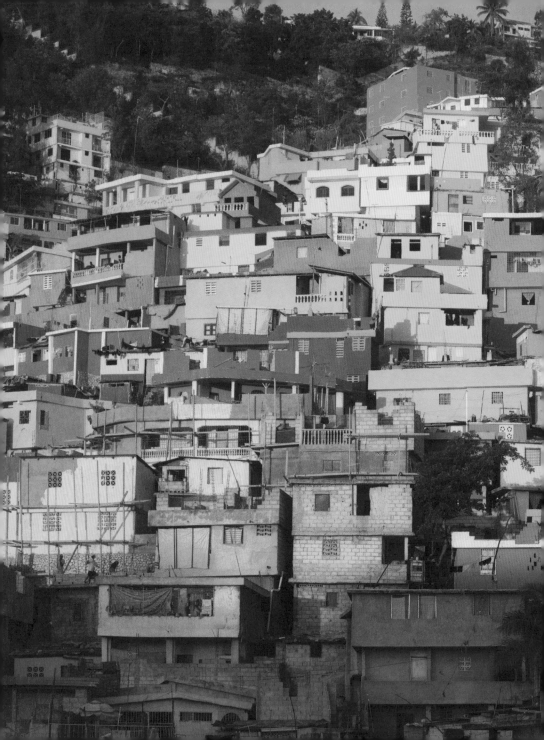

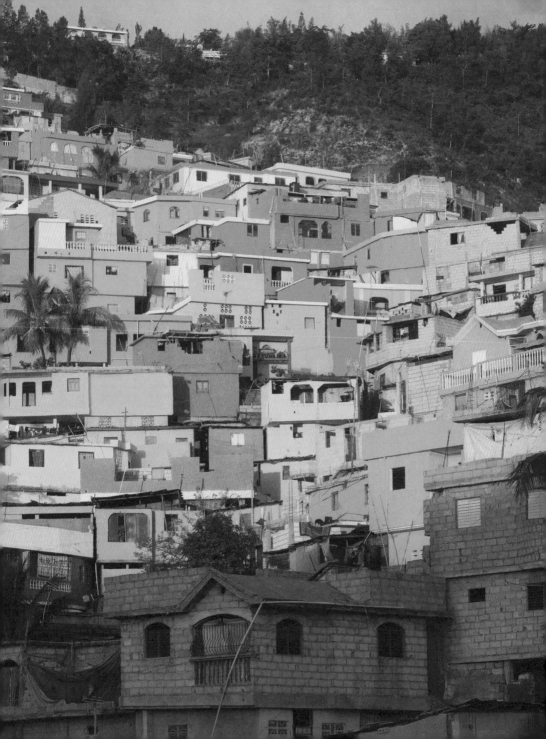

Color Matters

AN INTRODUCTION

■

Man needs color to live.

FERNAND LÉGER

OUR LIVES ARE SATURATED by color. The sky above us is blue (or gray or pink or purple or nearly black). The grass we walk on is green, though sometimes it is brown. Our skin has color, though not exactly the color we normally ascribe to it. Our hair has color, even if that color inevitably changes with time — and may change again with the skill of our hair colorist. Our clothes have color; our furniture and our houses, too. Our food has color; so do milk, coffee, and wine. Color is an unavoidable part of our experience of the world, not least as it differentiates and organizes the physical space in which we live, allowing us to navigate it.

We also think in (or, maybe better, *with*) color. Color marks our emotional and social existence. Our psychological states have color: we see red, feel blue, are tickled pink, and, not infrequently, are green with envy, particularly when confronted by those so tickled. Gender is distinguished — maybe even shaped — by color: we dress baby girls in pink and baby boys in blue, though at one point in history we did it the other way around. Class has color designators: there are rednecks and bluebloods, though bluebloods often declare their blue blood with their resistance to all vivid colors — even blue. The political world is demarcated by its colors: for example, the polarized red and

1

blue states in America, and green parties now almost everywhere committed to environmental causes.

But for all color's inescapability, we don't know much about it. There is no comparably salient aspect of daily life that is so complicated and so poorly understood. We are not quite sure what it is. Or maybe it is better to say we are not quite sure *where* it is. It seems to be "there," unmistakably a property of the things of the world that are colored. But no scientists believe this, even though they don't always agree with one another about where (they think) it is.

Chemists tend to locate it in the microphysical properties of colored objects; physicists in the specific frequencies of electromagnetic energy that those objects reflect; physiologists in the photoreceptors of the eye that detect this energy; and neurobiologists in the neural processing of this information by the brain. Their disagreement, or, more accurately, the mismatch of their inquiry, seems to suggest that color inhabits some indistinct borderland between the objective and the subjective, the phenomenal and the psychological. Crudely put, the chemists and physicists operate on one side of the boundary, the physiologists and neurobiologists on the other. Philosophers, at least those who think about the ontological question of color (that is, *what is it?*), function in all this somewhat like NATO peacekeeping troops patrolling the borders and are successful mainly when they are clearly neutrals, with their own interests of little concern to the disputants.

For artists, the precise scientific nature of color is more or less irrelevant. What matters is what color looks like (and also, and not to be underestimated, how much the paint costs). The artists are, one could say, the indigenous population, largely uninterested in the scholarly debates but who have been successfully cultivating color for millennia in order to survive.

The rest of us, with no professional stake in the matter, are for the

most part color tourists. We enjoy what we see, take the occasional color photo, and, happily, are at no risk from the conflicts.

The lack of a coherent and unified understanding of color reflects the fact that all the individual disciplines concerned with color are studying and solving distinct problems. The word "color" functions differently for each of them, and it is defined by each in carefully specified ways that appropriately reflect and clarify the concerns of the particular discipline, even if this only reveals how fractured our understanding of color is.

But this admittedly hasty disciplinary overview should not be taken as a version of "The Blind Men and the Elephant." Each field of inquiry might possibly be thought to correspond to one of the blind men accurately describing that part of the elephant he has touched but failing to realize how incomplete his experience of the whole has been. That isn't the case here.

Usually in this familiar children's story there is a framing narrative of the king and his court, who are watching and much amused by the scene of each blind man confidently describing the elephant in terms of which part he is feeling. One man thinks the elephant is like a snake because he is holding its tail; another, rubbing the elephant's tusk, believes the elephant is like a spear; and another is certain that the animal must be like a large tree, as he has wrapped his arms around one of the elephant's legs. In the story, the blind men are all wrong, mistaking what is a mere part for the whole. But the point is not that we need — and it is certainly not that we can provide — some regal perspective that would allow us to see the elephant in this room in its entirety. Our point here is exactly the opposite: that color, unlike an elephant, cannot be understood as a coherent whole.

That is, the scholarly thinking about color doesn't so much offer us a set of partial perspectives that can be combined to provide a comprehensive understanding of color as much as it reveals a fundamental disunity that de-

fines the subject. There are no blind men in our story, and in fact, there is no elephant. There is only the extraordinary enigma that is color, a topic blind men perhaps should stay away from.

LOCAL COLOR

And that, surprisingly, brings us to Homer. "The blind poet of rocky Chios," in Thucydides' phrase, did stay away from color.[1] That is, two of the greatest poems in the world, *The Iliad* and *The Odyssey,* display an extremely limited and counterintuitive color vocabulary. This was not, however, because their author was actually blind but, it has been claimed, because he was color-blind, as were, in fact, all of the ancient Greeks. That was the notorious conclusion of William Gladstone, hardly a crank, but rather one of the most eminent of Victorians, who in the second half of the nineteenth century served four terms as prime minister of Great Britain, as well as four as chancellor of the exchequer. And he was also a distinguished classicist.

What Gladstone had noticed in his reading of *The Odyssey* and *The Iliad* was how strange the descriptions of colors were, particularly those in the range of colors English speakers normally think of as blue. For most people, Homer's best-known phrase is his description of "the wine-dark sea" (though the adjective usually translated as "wine-dark" means something closer to "wine-like," composed of the Greek word for wine and a form of the verb that means "see"). The word is also the one the poems use to describe oxen. So it seems to indicate a reddish brown shade, if it describes a color at all.

Although the sea in a storm might possibly appear the color of wine, in sunlight, as anyone knows who has visited Greece, it looks blue (and it is the color as something appears in sunlight that our color terms name). But the poems never use a word meaning "blue" to describe it. Various English trans-

lations of Homer do have phrases like "the dark blue wave," but the "blue" in the phrase is always the translators' imposition. Homer just calls the wave "dark." Gladstone's explanation for this was that it didn't look blue to the ancient Greeks because they were incapable of seeing that color. And this idea about their inability to see blue gets recycled in the popular media every few years.

Presumably the color of the ocean hasn't significantly changed between Homer's time and our own. Gladstone decided on the basis of the linguistic evidence that what has changed is our ability to process color. "The organ of color and its impressions were but partially developed among the Greeks of the heroic age," he wrote.[2] Greeks, he hypothesized from his study of their use of color words, saw the colors mainly as contrasts of light and dark tinged by shades of red. So Homer's "wine-dark," if not literally what the Greek adjective means, perhaps does describe what Greeks saw — at least some of the time.

Yet how would we know? Do the words we use accurately describe the colors we see? Color inevitably exceeds language — or maybe defeats it. But regardless, Gladstone's hypothesis was just bad science. His speculations were published in 1858, a year before Charles Darwin's *On the Origin of Species* — and quickly it became clear that the five hundred years or so that Gladstone proposed for the development of what he called the "color-sense" was impossible. Evolutionary change could not possibly have happened as quickly as he assumed. And in any case, it is hard to imagine that the ancient Greeks never saw a blue sky or a blue sea (Figure 2).

There is, however, another — and better — explanation for the color vocabulary of the two great classical poems. Homer (if indeed there was such a person and if indeed he could see) would of course have seen blue skies and blue seas, but he may not have known that they were blue. Or, more precisely,

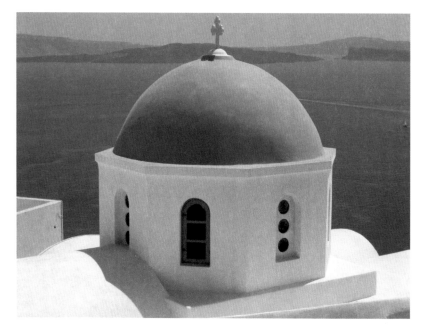

FIGURE 2: *"Wine-dark sea"? The view from Santorini*

he may not have known that "blue" was the appropriate word for what they were. It wasn't that the Greeks' color-sense was underdeveloped. It was that they had a different color vocabulary for what they saw.

Lots of languages, it turns out, do, although this says almost nothing about how their speakers see the colors of the world. Hungarian, for example, has two words for red: *piros* and *vörös*. Most Hungarian-English dictionaries define both as "red," though some suggest that vörös is a darker red than piros, closer perhaps to the English crimson. But the two words do not really differentiate particular shades of red. A linguist would say that they differentiate an *attributive* rather than a *referential* difference: the words mark not

a difference of the color itself but rather a difference in the feeling the color provokes. A child's ball is almost inevitably piros; blood is always vörös — but a dark red wine, possibly the same color, would be piros. Red apples are piros; red foxes are vörös. The red in the Hungarian flag is piros; the red of the Soviet flag was vörös. To the degree, then, that vörös is a darker red than piros, the darkness is as much conceptual as it is chromatic.

There are languages that have no distinct color vocabulary at all, at least if we expect them to isolate and abstract color in the ways that English, for example, does. But there are many languages that tie color words to particular experiences that our color vocabulary ignores. For example, the indigenous people of Bellona, one of the Polynesian Islands, have only three discrete color categories: one for black-dark, one for red, and one for white-light, rubrics under which the entire visual spectrum is divided. Yet they have a robust color vocabulary. Among their words for shades of red, there is a specific word used for the red of a feather of a certain bird, another for the red used as a dye made from a particular root, a different word for the red of the clouds at sunrise or sunset, and a separate one to describe the red color of teeth stained from chewing betel nuts. Somewhat oddly the two Danish anthropologists who studied the Bellonese concluded that in their language "colours are vaguely demarcated."[3] But they are in fact quite precisely demarcated, as their careful distinguishing of the various reds shows. They are just not demarcated in terms of what most people today usually think of as color.

Gladstone, then, might well have been on to something, but not exactly what he thought he was on to. It wasn't the Greeks' physiologically undeveloped color vision that explained what Gladstone found in his reading of Homer but a culture that had little use for abstract color words — and particularly for "blue," which existed in ancient Greece mainly in the great expanses of sea and sky, both of which can dramatically change colors. Neither

is chromatically unified nor stable. Who needs "blue"? Clearly not Homer or the Greeks, who, in any case, always responded to color more in terms of luminosity (with words like "radiant" and "shining") than in terms of hue (for example, "blue" or "yellow").

But Gladstone's error points us to something true about words used to describe color in particular—and about language in general. Although what we are able to see is a function of a common human physiology, what we call it is a function of culture. If we don't have a word "blue," obviously we don't use it to name the color sensation English speakers normally identify as that color. Maybe "wine-dark" will have to do.

Color words, then, aren't exactly the names attached to properties we know without them but are part of how we come to know those properties. The eye sees what it is disposed to see, and language does a lot of the disposing. Language, as the anthropologist Edward Sapir famously said, may not be as much "a garment as a prepared road or groove."[4] That is, it focuses our vision, providing the lenses through which we look, defining, we might say, the visual field.

It is easy to think that language is mere labeling. That seems to be what Genesis tells us. The animals parade before Adam, and Adam then gives them names: "And whatsoever Adam called every living creature, that was the name thereof" (Gen. 2:20, KJV). Something *is,* and then it gets a name. And it might easily seem as if our names for color work more or less this way. A parent plays Adam, pointing at a colored object, saying, "This is blue." A child hears the reiterated word "blue" in relation to various objects with similar color characteristics and over time comes to generalize these to form a coherent category of blueness that eventually allows the child accurately to apply the word "blue" to previously unseen examples. God says let there be blue, but we give it its name.

Yet that won't quite do. It obviously didn't work for Homer. He called it "wine-dark." In English, however, there is a word "blue," but it refers to a wide range of colors we are willing to call blue, from powder blue to navy blue — that is, from a blue that is almost white to one that is nearly black. And then there is teal. Or is that green? And yet English speakers confidently assemble and distinguish a whole variety of shades as types of blue. Is it our eyes or our language that enables this?

"Both" is of course the answer. Color *vision* must be universal. The human eye and brain work the same way for nearly all people as a property of their being human — determining that we all *see* blue. But the color *lexicon*, meaning not merely the particular words but also the specific chromatic space they are said to mark, clearly has been shaped by the particularities of culture. Since the spectrum of visible colors is a seamless continuum, where one color is thought to stop and another begin is arbitrary. The lexical discrimination of particular segments is conventional rather than natural. Physiology determines what we see; culture determines how we name, describe, and understand it. The *sensation* of color is physical; the *perception* of color is cultural.

UNWEAVING THE RAINBOW

This is true even for the colors of the rainbow. In the smooth gradation of the visible spectrum from red to violet arching across the sky, colors are spectacularly revealed to us in their perfection. William Wordsworth's iambic-marked joy at its appearance is hardly unique: "My heart leaps up when I behold / A rainbow in the sky."[5]

For John Keats, the accompanying emotion was even stronger. "There was an awful rainbow once in heaven," he wrote in his poem "Lamia" — "awful," not in the pejorative sense in which we use the word

today, but in its original meaning: awe-inspiring.[6] Keats feared that the efforts of natural science to "unweave the rainbow" would reduce it to just another item in "the dull catalogue of common things." Understanding would abolish awe. At an infamous dinner organized by the English painter Benjamin Haydon at his London studio late in 1817, Keats rushed to agree with his friend Charles Lamb that Isaac Newton had "destroyed all the poetry of the rainbow by reducing it to prismatic colors" (a comment provoked by Haydon's inclusion of Newton's face in the crowd scene of his new painting *Christ's Entry into Jerusalem*).[7]

For many writers of his day, Newton's optical discoveries were thought presumptuously to pull back "Enchantment's veil," as the poet Thomas Campbell complained.[8] But the wonder of the rainbow's radiant colors survives its scientific explanation, and another poet, James Thompson, was so taken with Newton's account of "the grand ethereal bow" that for him it was Newton who was "awful" (in the sense that Keats had intended the word) rather than the rainbow whose appearance Newton had explained.[9]

Although scholars gradually came to understand the phenomenon in scientific terms—as an optical illusion produced by sunlight reflected and refracted through a water droplet and viewed from a particular angle—the rainbow never loses its ability to astonish and delight (Figure 3). And even the science that explains it creates its own surprises: no two people, even if they are standing next to each other, ever see exactly the same rainbow, and each eye of each observer actually sees a different one. And, in fact, the rainbow is constantly being re-formed as the light strikes different water droplets. The rainbow is not an object; it is a vision—a vision dependent upon sunlight, water, geometry, and a sophisticated visual system. Like color itself, even explained, it remains a wonder.

The truly "awful" rainbow "once in heaven" was the one that served

as the symbol of God's covenant with the creatures of the earth after the flood. "I do set my bow in the cloud," God tells Noah, as the sign of the guarantee never again "to destroy all flesh" (Gen. 9:13). The rainbow's perfectly organized spectral arc of luminous color was the visible promise of the reconciliation of heaven and earth. Now, the sight of a rainbow most likely produces pleasure rather than awe. (Vladimir Nabokov comments on "the quick smile with which we greet a rainbow.")[10] For Keats, however, it still inspired something of the wonder of that awful rainbow of peace with its reiterated gift of color.

Although it may seem ungrateful to ask, how large was that gift? How many colors are there? Seven is, of course, the obvious answer. Newton,

FIGURE 3: *Rainbow on a Long Island beach, 2016*

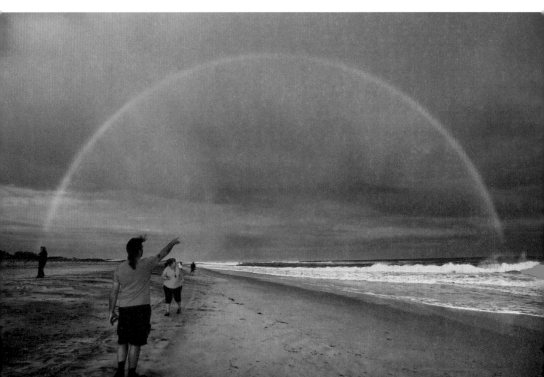

we all know, saw seven colors in the rainbow's seamless continuum: red, orange, yellow, green, blue, indigo, violet. ROY G. BIV in the familiar mnemonic—or, as is sometimes said in the United Kingdom, "Richard Of York Gave Battle In Vain," though in our historically unmindful, consumerist age, this in Britain for a time became "Rowntree Of York [a British candy maker now owned by Nestlé] Gives Best In Value." But, however the colors are remembered, almost no one else (though Dante, in the *Purgatorio,* is a prominent exception) seems to have seen seven. Not even Newton at first.

In a letter written in 1675 to Henry Oldenburg, the secretary of the Royal Society, Newton confessed that his eyes were "not very critical in distinguishing colors."[11] Once he saw eleven in the rainbow. Usually he saw only five—red, yellow, green, blue, and violet—until he looked again or, rather, until he stopped looking. There were seven musical notes in the diatonic scale. The world was created in seven days. And the rainbow was a sign of cosmic harmony, so it had to have seven colors—and Newton therefore added (saw?) orange between red and yellow, and indigo between blue and violet. Although Shakespeare in *King John* had said it was a "wasteful and ridiculous excess" to "add another hue / Unto the rainbow" (4.2.13–16), for Newton it was necessary to add two to those he had seen. Our seven-colored rainbow was born, though more as a child of faith than as one of science.

Aristotle, and most of the ancients, saw only three colors in the rainbow. About two thousand years later, perhaps John Milton did, too. In *Paradise Lost,* he writes of the "triple-colored bow," though it must be admitted that he was blind at the time. Isidore of Seville saw four. Titian saw six (see his painting *Juno and Argus*), and so apparently did Steve Jobs (look at the Apple apple). Virgil, more discriminatingly, recognized "a thousand colors," and Percy Bysshe Shelley saw a "million-colored bow," but he, of course, was prone to romantic exuberance. Newton's faith-based seven, however, has

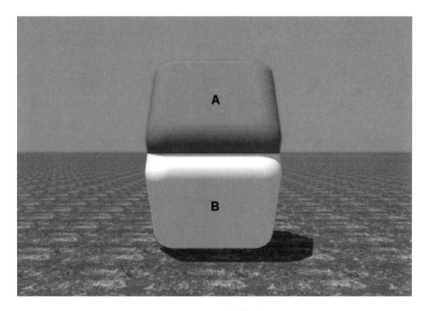

FIGURE 4: *Color illusion*

carried the day. We now are convinced that the rainbow consists of "seven proper colors chorded," as the poet Robert Browning wrote, his participle picking up Newton's musical analogy. We see seven whether or not there are in fact seven to see. Always with color, what we see is what we think is there.

PIGMENTS OF THE IMAGINATION

Look at Figure 4.

The two seemingly tilted square tiles are obviously different colors. The lower one is white; the top one is a darkish gray, what the paint manufacturer Sherwin-Williams calls "Serious" gray. But place your index finger over the line that separates them, covering the adjoining edges. The two squares

in fact are the same gray color, but it is impossible to see them that way. This is often known as a "Cornsweet illusion," named after the psychologist who first described it in the 1960s. Our eyes trick us. Or, rather, our brains do. Our brains introduce all sorts of information that our eyes have not transmitted to them. The differing backgrounds somewhat affect how we see the tiles, but primarily we extrapolate from the adjoining edges of the squares (the darker edge seemingly in shade, the lighter one apparently illuminated), and our brains *create* the sharply contrasting colors we think we see.

But all color is always something created rather than merely detected, not just in these cleverly created optical illusions. The electromagnetic waves our eyes detect are not colored, yet our brains allow us to see them as colors, and even to see them as colors different from those we presumably are seeing. We know, for example, that colors look different in different light. "Colors seen by candle-light / Will not look the same by day," as the poet Elizabeth Barrett Browning wrote.[12] But still it is the daylight color that we take to be real, though even in daylight shadows will make different parts of the same object appear to be different colors. If we look at a white bowl, it does not appear all white since some of it is in shadow. We are, however, certain that it is a white bowl, though an artist could not use only white paint to depict what we are seeing. Our brains not only create the color but also correct for the lighting conditions, normalizing what we see.

And colors are perceived differently as they appear in relation to other colors. A student of Leonardo reported that the great painter would teach his students that "colors appear what they are not, according to the ground which surrounds them."[13] This, of course, was also the essence of the teaching of the legendary twentieth-century painter and teacher Josef Albers, whose brilliant *Interaction of Color* explores the inevitable discrepancies between color as it is physically presented and color as it is perceived.[14] It is

the almost daily intuition we have as we choose our clothing and wonder if this "goes with" that. It is also the logic of the old joke of Rodney Danger-field: "I told my dentist my teeth were turning yellow; he told me to wear a brown tie."

In addition, there are colors we see with our eyes open but that aren't in any sense present in the object we are looking at. Stare at an illustration of an American flag for about thirty seconds and then look at a blank piece of paper. You will see an image of the flag, but one in which the red stripes appear to be blue-green. This is called an after-image. The color distortion is produced by the fatigue of the retina's red color receptors as a result of staring at the flag, allowing the more active green and blue receptors to be excited by the white light reflected off the blank paper, and this colors the image. We see a flag with blue-green stripes, but no such flag is there.

We even can see colors with our eyes closed. We rub our eyes and blobs of color often appear floating behind our eyelids. These are called phosphenes. Scientists explain that these are the result of biophotons produced by atoms in the retina. This is a kind of light but more like that produced by some deep-sea creatures than by the electromagnetic energy of the sun.

Isaac Newton's physics couldn't account for these color illusions, but he knew that they existed. In a manuscript begun about 1665, Newton records various of his experiments with color, including one in which he took a sharp knife and placed it "betwixt my eye & the bone as neare to the backside of my eye as I could," and saw "severall white, darke, & coloured circles" as he stimulated his eye "with the point of the bodkin" (Figure 5).[15] This, it should go without saying, is not an experiment you should try at home.

But all colors seem in some fundamental sense to be illusions, not just the illusory ones. As objective, physical facts, colors are not colored. Always with color there is something more than meets the eye.

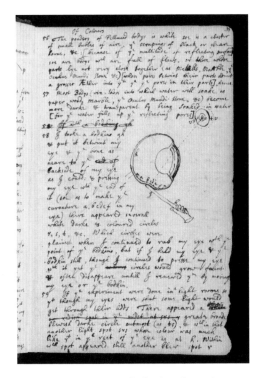

FIGURE 5: *Isaac Newton, "Of Colours," experiment 58,*
Cambridge University Library, MS Add. 3995

LIVING COLOR

This is really what the book is about — about both what meets the eye and the
so much more that doesn't. It is about how we see colors, about what we see or
think we see, and about what we do with the colors that we recognize or imag-
ine. It is about how we make color and how color in turn makes us.

The book's structure is neither thematic nor chronological. It is

topical (in several senses of the word) and opportunistic. Color provides the book's principle of organization, which, among other things, means that you can read the book straight through or start with your favorite color. There are ten chapters. We begin by unashamedly unweaving the rainbow and following the order of its seven constituent colors. And the book ends with three more — on black, white, and gray. These are achromatic colors, which don't appear in the spectrum of visible light and define their own independent color scale, though they appear in the spectrum of our concerns.

Each chapter uses its nominal focus on a single color to explore some discrete aspect of what makes the subject of color as compelling as color is itself. Each individual color becomes — as is the way with colors generally — emblematic. In each chapter the color functions as the focal point of a consideration of one of the various ways in which color appears and matters in our lives.

A friend (clearly an academic), reading an early draft of the book, recognized that its central argument was twofold: that colors are ontologically impure, toggling between the self and the world, and that they are figuratively promiscuous, available for almost any kind of metaphoric appropriation. That seems more or less right, though the adjectives "impure" and "promiscuous" seem unconsciously to import an all-too familiar anticolor bias, which suspiciously views color as mere seduction.[16] Color is indeed seductive, but it isn't *mere* seduction, or mere anything else. It is essential to what it means for us to be human. It doesn't get much more essential than that.

The book begins with a chapter called "Roses Are Red," which asks if even the red ones really are. It is about how we perceive color, but it is also about the nature of color itself: what is the property that we see — or more accurately make, for we make color color. An eye for color turns out not to be just a term of praise but a literal fact of its composition. And the book ends

with a chapter on "Gray Areas," on that dull color, indeed the very color of dullness, but that is also the color of what once in photography, television, and film successfully stood in for all the vibrant colors of the world. We call that effect "black and white," but it is almost always gray (although if the images are pornographic they become still differently colored: "blue" movies, we say in English, but they are "green" in Spanish and "pink" in Japanese).

In between there is a chapter that thinks about how color serves as a remarkably inexact metaphor for racial difference, beginning with an account of when Asians first "became" yellow; and another about how very material color can be, focusing on the dyes and pigments that allow us to reproduce the colors that we (think) we see. There is an exploration of color names, although as Fairfield Porter said, colors don't always correspond to words we know but "are themselves a language that is not spoken" — and of the related issue of color spaces, wondering why it is, as Herman Melville asks in *Billy Budd*, that "distinctly we see the difference of the colors, but [wonder] where exactly does the one first blendingly enter into the other?"[17] There are discussions of an Iranian election and a Ukrainian revolution, of George Washington, Napoleon Bonaparte, and *The Wizard of Oz*, of pigeons and zebras and whales (oh my!), and of little black dresses, little white lies, and the Little Red Book.

On Color may seem too minimalist a title for the book or just too vague. It is, however, accurate. It is a book about color seen from ten angles created by ten colors as each intersects with the world. Each chapter explores a distinct way in which we understand color as we use it to construct the world we live in.

From every angle that we look at it, color appears as a glorious set of complexities and contradictions. What Colm Tóibín says about blue is true of every color: "It comes to us through silence and mystery and much argument."[18] Yet color viewed head on is easy to take for granted. It seems so very

obvious. We see it wherever we look, and we normalize and naturalize our experiences of it. These ten chapters are intended to make that impossible. Their individual angles of vision are designed to unsettle our sense of color, while together they bring the subject of color sharply into view.

Of course we know that there are more than ten colors. It is impossible to know exactly how many there are, even though some scientists maintain that more than 17 million are distinguishable. Others claim that there are 2.2 million colors, while some, even more parsimoniously, insist that there are a mere 346,000. Other people interested in color insist that there are only the eleven basic colors: all the rest are merely tints and shades of one or another of those. And some believe with Newton that there are really just seven (though Newton acknowledged each of "their innumerable intermediate gradations"); and even others, like the people on Bellona, are sure that there are only three. Ten, however, seems a good number, at least for a book.

CHAPTER ONE

∎

I hear the question on your lips: what is it to be a color?

ORHAN PAMUK, My Name Is Red

ROSES ARE
Red

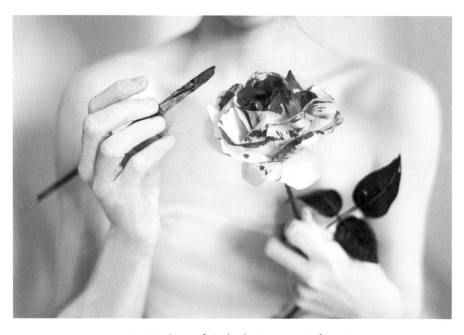

FIGURE 6: *Susannah Benjamin*, Roses Are Red, *2016*

Roses are red. Not all of them, of course. Near the beginning of James Joyce's *Portrait of the Artist as a Young Man,* Stephen Dedalus sits in his Dublin schoolroom, staring at an addition problem he can't quite solve. But rather than worrying about his inability to add, he distracts himself by focusing on something else: "White roses and red roses: those were beautiful colours to think of." And then Stephen begins to imagine differently colored flowers, "lavender and cream and pink roses," which seemed to him no less beautiful, although quickly he is disappointed when he realizes "you could not have a green rose."[1]

Roses do come in a wide range of beautiful colors, and, in whatever color, they provide, if not lasting consolation, some temporary escape from the problems of the world, both arithmetical and otherwise. But most roses are red (and these are the ones that have allowed the word "rose" to become a recognizable color name, in a way that the similarly multicolored tulip has not). According to the Society of American Florists, red roses make up 69 percent of all roses bought for Valentine's Day, and if we count pink as a shade of red, the figure rises almost to 80 percent.

Yet regardless of how many roses are red or of what other colors roses can be, it isn't so obvious what it actually means for a rose, or anything else, to *be* red, or indeed to be any color at all. Maybe it isn't important—the experience of color may be enough—but the question seems like the logical place for a book on color to begin. Although nothing about color turns out to be logical, or even to be in any obvious place.

SEEING RED

It seems, quite literally at first glance, simple enough. Color is part of the visual appearance of things that are colored, and to be red is to be red. A rose

that is red is a rose that is not lavender or cream, or any other color except for one of those we are usually willing to consider some variety of red. It is hard to get past the tautology.

"Red" names the color of things that are red (except, oddly, in the case of naturally occurring red hair, which falls into a range of color that almost every native English speaker would in any other context recognize as orange). Still, saying that "red" names things that *are* red is unlikely to provide much clarity or satisfaction. Nonetheless, we have such a robust experience of red as a visual property of the world that the lack of a meaningful definition rarely causes us any problems or leads us to wonder about what "red" really is. Or even that there is something to wonder about. But there is; that's the very nature of color.

We could start with: Is the rose red or does it merely appear to be red? This may seem a distinction without a difference. But the difference could be that if something *is* red, unsurprisingly, it usually appears to be red, but if something only *appears* to be red, it might very well not. A mountain at sunset might appear red, but we think of this as a trick of the light rather than an actual property of the mountain (Figure 7).

The redness of a rose, however, seems different, as if it is a property belonging to the rose. Unlike the mountains, where the late afternoon light distorts their actual color, the redness of a red rose seems to be a manifestation of what it essentially is. A red rose, we sensibly believe, *is* red, rather than merely appearing to be so.

So far, so good. But, although the distinction between being and appearing seems reasonable enough, some further thought about physical properties begins to unsettle it and make it more interesting for our purposes. A twelve-inch wooden ruler, for example, is twelve inches long regardless of how it appears. Length is an objective property of an entity. It is objective in

the sense that it is not a function of the observer. It is what it is, and the observer can only get it wrong: viewed from the other side of a room or seen on an angle it may look shorter, as it will if it is viewed by someone affected with an odd neurological disorder known as micropsia, which results in objects being perceived as smaller than in fact they are (and if the viewer is affected with macropsia, the ruler will look larger). But the ruler is twelve inches long regardless of the conditions in which it is encountered or the visual capabilities of the observer. "How long is a twelve-inch ruler?" is one of those comically self-answering questions like "Who's buried in Grant's tomb?"

"What is the color of a red rose?" seems to be another one of these, but it turns out not to be. (Neither, in fact, does "Who is buried in Grant's

FIGURE 7: *"Red" mountains, Los Glaciares National Park, Argentina*

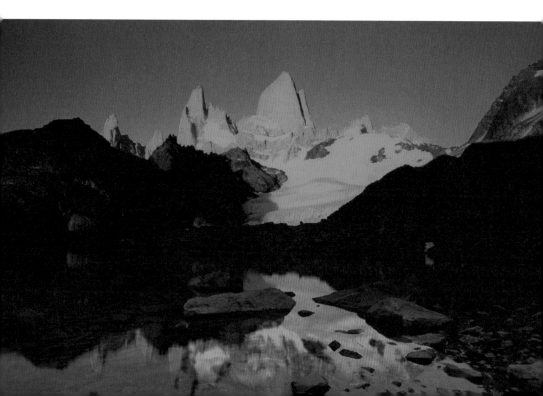

tomb?" since it is the burial place not only of the eighteenth American president but also of his wife, Julia Ward Grant.) Color and length each are properties of objects, but they are different kinds of properties. Length can be confirmed in various ways, color only by sight. Length we know is extension in space. Color is . . . well, what?

Color, we might say, is a particular aspect of an object's appearance. What aspect? Unfortunately, its *color* is what we are tempted to answer. And that's the problem. With color we always seem to get trapped in circularity, and it is hard to figure out how to escape it.

Still, we should try.

So we need to start again, this time by trying to figure out why red things look red, or, to be more precise, why, for normally sighted viewers in normal lighting conditions, red things look red. This admittedly graceless phrasing gets rid of the difficulty of the mountains at sunset, though it adds a new problem of what we should consider normal. But more of that later. For now let's try to answer the question with its stipulations. The obvious answer, "Because they are red," is simple and it is intuitive (and secretly what all of us think). But it avoids the question. And it isn't, in any case, true.

As early as the fifth century B.C.E. Democritus suggested that it merely *seems* that an object has color. The only things that are real, the philosopher presciently thought, were "atoms and the void," and since the atoms are colorless, colors couldn't have an independent existence.[2] For a long time, however, almost everyone else disagreed. (Plato was said to have wanted to burn all of Democritus's writings.)[3] People for the most part were convinced that our senses were designed to reveal the world as it is. And they were confident that color therefore had to be a real property in the world, one of the things that our vision was designed to recognize.

Slowly, however, they came to change their minds about the senses.

By the eighteenth century, sense and science were increasingly at odds. Micro-scopes and telescopes had made it obvious that the world as it really is could not be apprehended by our unaided faculties. And as various phenomena be-came better understood, science slowly began to separate the sensation of color from what was previously thought to be its external cause. Color, which once seemed so clearly to belong to the things we saw as colored, gradually was relocated: from the objects that ostensibly had them to the light by which we saw them and, finally, to the mind, which lets us see that light as color.

Many scientists have contributed to our modern scientific under-standing of color, but no one more than Isaac Newton. Beginning sometime around 1665, when he first began to explore what he called "the celebrated *Phenomena* of *Colours*," he had come to believe that color didn't reside in ob-jects but was a function of the light that illuminated them.[4] It wasn't that light merely allowed the colors of objects to be seen but that the light was the source of the colors that we see.

This was, however, not light as we usually see it, but light as it is "composed" of its various "colorific rays," as Newton termed them. "If the Sun's light consisted of but one sort of rays, there would be but one Colour in the whole world."[5] It was the misnamed "rays," which Newton had shown with his prism experiments to be the constituent colors of light, that were the source of the colors we see.

But it wasn't exactly clear how they accomplished this. Newton was certain that the rays themselves, "to speak properly, are not coloured," but merely have the ability "to stir up a sensation of this or that Colour."[6] Whether we see "this" or "that" color seemed to depend upon some physical property of the illuminated objects acting upon the light that illuminates it, absorbing some and scattering others of its rays to produce the "sensation" of whatever color the objects seem to be.[7]

Though much of this has been clarified, refined, and augmented by modern science, Newton's theory still provides the basis of much of our understanding of color today. The most important addition to what he proposed has come from thinking further about those sensations of color that are produced once the light has been reflected. His physics, that is, has been supplemented with our neurobiology. For a rose to be red, the scattered light has to be detected and processed by the visual system to produce the color experience that we (at least the English-speaking "we") recognize as "red." And, although we now know quite a lot about that processing, we still don't really know why we see something red as something red.

The physical scattering of the light is the easy part; even the activity of the millions of photoreceptor cells in the retina (the rods and the three types of cones) is relatively well understood. Neuroscientists have also now begun accurately to map the flow of information from the optical nerve to various cortical regions in the brain. But exactly how the brain decodes and translates this into the experience of the colors that we see is still a mystery.

Neurons in the brain emit and receive electronic impulses — and somehow we see some of this activity as color. That "somehow," however, is asked to do a lot of work. It isn't clear how what they do allows us to change what we could call "color signals" into colors. It seemed easier when we thought that the colors we see are the colors of the world. But it turns out that what we see are the colors of the mind.[8]

We just don't know how the color gets there. Cognitive scientists have offered various explanations for our perception of color, but most of these seem a lot like saying that it's the magician who makes the coin appear from behind your ear, rather than explaining how the trick is done. We don't know really how this trick is performed, but we do know that it is a trick and that the mind is the magician. Color is mind-dependent. Unlike length or

shape, color doesn't exist on its own. It is "relational," as some philosophers say, maybe better thought of as an experience than as an attribute.[9] And probably we should say that color happens rather than exists.

In most contexts, of course, it makes no difference how it happens (or what verb we use for it). Why we see a color normally doesn't matter, any more than why the car we drive goes when it is turned on and we step on the gas or how our smartphone is able to access the internet. We just want these reliably to happen, and the same is true for the rose's red.

If the science is right, however, a mind-dependent red turns out to be something surprisingly unreliable. If color doesn't exist without the contribution of someone perceiving it, in the absence of a perceiver a red rose would no longer be red. It's not exactly that its redness goes on and off with the comings and goings of a viewer or with the blinking of someone's eyes. This doesn't work like a switch. It's that the color is constituted *as color* only as it is experienced. This is more or less what Galileo, for example, believed. Writing about colors, along with tastes and odors, he said that these are "mere names [*puri nomi*] for something that resides exclusively in our sensitive body, so that if the perceiving creature were removed, *all of these qualities would be annihilated and abolished from existence.*"[10] That is, the rose would still be there, but its redness would not.

Common sense says that can't be right. But science insists it is, although Galileo provocatively explained it backwards. It isn't that the color is "annihilated" when the perceiver is removed; it is that it doesn't exist without the perceiver present. Red roses aren't red in a room without a viewer or in a dark one in which the roses cannot be seen. It is not just that we can't see their redness but that without it being seen, the redness really isn't there.

They are just roses, roses perhaps with the possibility of color, perhaps something like a stove turned off but always with the possibility of be-

coming hot. This seems weird only because we have misunderstood or mis-described (or didn't much care) what colors are. Nothing in the scientific account of redness is red—except for the perception. In fact, without a perceiver not only is there nothing that is red but there is nothing that can properly be thought of as color.

Admittedly, this is all so very counterintuitive. If roses are red, it would be nice if they had the decency to stay that way. It would, therefore, be better if we could say that the perceiver's role merely *reveals* the color of the roses rather than serves as a necessary part of what constitutes it. This seems preferable, because it conforms more closely to our intuitive sense of what color is—a stable visible property of objects that we are able to detect. But as hard as it may be to grasp or accept, a perceiver is necessary for there to *be* a color, not just to see one. Without a perceiver there are only the roses.

All of this doesn't mean that colors aren't real. It just means that their reality is different (and less well understood) than we usually imagine. But they are still colors, even if some of the things we have always thought about them turn out to be wrong. But the sun doesn't really rise in the East, as Copernicus taught us, and we got over worrying about that.

The one thing that seems certain is that "color must be seen," as the twentieth-century German cultural critic Walter Benjamin said.[11] It probably seems strange to insist on something so self-evident, but Benjamin's statement, which seems at first to be a pointless truism, turns out to be a crucial fact about color—certainly as important as the understanding of an object's microphysical properties or the composition of light, or even the transmission and processing of neurons by the visual system. And arguably more so, since if color were not seen, we would have no reason to imagine that it exists.

But we do see it, so we know that it exists. We see it, and that is part of

the process by which it comes into existence. We see it, and maybe there isn't much more to say about it — or any more that we need to say.

KNOWING RED

There's a group of philosophers that has made this the foundation of a rigorously argued theoretical proposition. In fact, they say that there is nothing else that we *can* say that will help us to know a color. We might know all the scientific information about how we come to see a color, but only the visual experience of it *reveals* the color's essential nature (and thus the philosophical position is sometimes termed revelation theory).[12] With color, they say, experience is not merely the best teacher; it is the only one.

Bertrand Russell famously insisted about one hundred years ago, "The particular shade of color that I am seeing . . . may have many things to be said about it. . . . But such statements, though they make me know truths about the color do not make me know the color itself better than I did before: so far as concerns knowledge of the color itself, as opposed to knowledge of truths about it, I know the color perfectly and completely when I see it, and no further knowledge of it itself is even theoretically possible."[13]

Russell makes a group of sometimes-hard-to-follow distinctions, but there is (or should be) something compelling in this theory about the appeal to the immediacy of color experience rather than to scientific explanations of what produces it. But if "knowledge of the color itself" can only come from the experience of it, then, *by definition*, this doesn't tell us anything that we don't already know.

Russell's version of revelation theory collapses the difference between understanding and experience. It uses what he calls "the color itself" to mean a specific sensation of color (as he says, "The particular shade of color

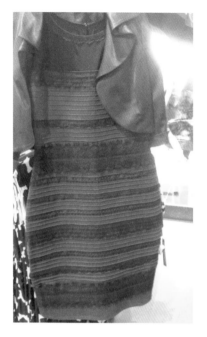

FIGURE 8: *"The Dress,"* 2015

that I am seeing"). If "the color itself" is the shade that he sees, there can be no essential knowledge of it other than what perception provides.

But what do we do with the fact that we regularly say that something *is* one color but *looks* another, as, for example, with those red mountains seen at sunset? Or any of the color illusions produced not by changed conditions of illumination but by dissimilar background contexts that make the same color appear different when seen against a different background? Which of these is "the color itself"?

Take, for example, "the dress" (Figure 8). On February 26, 2015, the dress became an Internet sensation. A post on Facebook asking about the

colors of the dress was reposted on Tumblr, and somehow this went viral. Tens of millions of people, from Katy Perry and Taylor Swift to John Boehner, debated the colors of the dress on Twitter. "From this day on, the world will be divided into two people. Blue & black, or white & gold," tweeted Ellen DeGeneres.[14] For a week or two, people passionately argued which it "really" was, until eventually the meme was swallowed up in the news cycle.

"The dress" could be thought to pose a problem for Russell. What are the colors that we know "perfectly and completely" when we looked at the dress? Russell would presumably have said that they are the colors that each individual sees when looking at it. That is, the colors are gold and white — or they are blue and black. That there is a disagreement seems to be a function of the ways individual brains "correct" for the presumed lighting condition. They differently decide what visual information to process or discard as people looked at what in any case wasn't a dress at all but a photograph of one, and a photo that almost everyone was viewing on a computer screen. But whichever colors you saw would be, in Russell's account, the colors you knew. That was good enough. Whichever colored dress you saw, you knew *its* colors "perfectly and completely," even if what you were seeing was only a trick of the light played upon the brain or a con job pulled off by the mind.[15]

Ultimately all color might be said in some fundamental sense to be a trick of the light or a con job. But for Russell, that isn't important. From revelation theory, "what you see is what you get" — that is, "knowledge *of* the color itself," as Russell says, rather than knowledge "of truths *about* it." "*I know the color perfectly and completely when I see it, and no further knowledge of it itself is even theoretically possible.*"

But it is difficult to avoid thinking that the adverbs "perfectly and completely" here are more than a little perverse, regardless of how precise the words might be in their philosophical intention. At the very least they

seriously underperform, and maybe so does the theory. For most of us, revelation theory probably doesn't seem worth the effort to understand it. It is no more satisfying than any of the other philosophical theories of color, and maybe it's less. One might reasonably wonder if the revelation provides any *knowledge* at all.

Still, unlike many of these theories, it usefully reminds us of the irreducibility of our experience of color. And it also reminds us that, in all nonspecialist contexts, the word "color" unproblematically refers to a conspicuous aspect of the way things in the world look to us. That, too, is good. The problem, however, is that color is so very problematic. There is so much more to say.

We can see that roses are red, but we *have* to see that. The necessity here comes not from the fact that it is the color of the roses that is there to be seen but because no explanation could ever make that "red" imaginable to a person who was congenitally blind. And the roses wouldn't even be red if we weren't there to see them. But at least they are red when we do.

SEEING RED?

Well, a lot of roses are — at least in daylight, or with the lights on. Just ask a florist, though a florist who isn't color-blind. Perhaps as many as 8 percent of men have some color discrimination deficiency, but apparently fewer than 1 percent of women. No one, however, is truly color-blind. It is a misnomer for a set of visual deficiencies caused by anomalies in the functioning of the cones, which serve as one of the two types of photoreceptor cells in the retina. In the rarest and most extreme form of color-blindness, called achromatopsia, sufferers have no functioning cones at all and process light exclusively through rods, the receptor cells of the retina that support our vision at low levels of light. With only rods detecting light, the world appears in shades of gray.

In the more common forms of the deficiency, one of the three types of retinal cones doesn't function, affecting the ability to detect colors in specific sectors of the visible spectrum. In normal color vision, the three types of cones, each responsive to a different subset of the spectrum, overlap, enabling its entirety to be detected. For most color-blind people, it is difficult to make some color distinctions, most often between red and green but sometimes between yellow and blue. The Ishihara test, named for the Japanese professor Shinobo Ishihara, who first developed the technique in 1917, uses a portfolio of discs with variously arranged colored dots for the assessment of color vision.

In Figure 9, "normally" sighted people see the numeral 6 formed of orange dots. People who are color-blind, however, usually see no number at all in the disc, only, as a "color-blind" friend reported, "a bunch of colored circles: yellow, blue (maybe?), green, and some orange." Even in our age of euphemism, sensitively designed to prevent invidious comparison, we can probably with good conscience call this a deficiency rather than just a difference. But what should we say about the colors that *are* seen by color-blind people? Are they mistakes? Misperceptions? Illusions? "Yellow" might be the right name for the color that a color-blind person sees. It is just not always the right name for the color that most of the rest of us are seeing then. We (that is, normally sighted people) can probably legitimately say that their "yellow" is a mistake, because color names get attached to colors as they appear to normally sighted people in normal lighting conditions, though our colors are illusions, too.

One could raise various objections to the appeal to normalcy (for example, its definition is usually a function of circularity — some version of: "normal is what normally is thought to be normal" — or of some statistical prescription: such as what a majority of people experience). But the objections all seem to be outweighed in this case by the fact that "normal" color

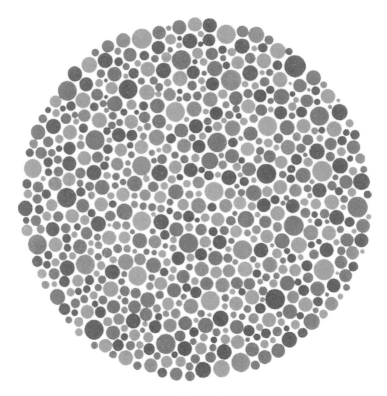

FIGURE 9: *Ishihara Plate No. 11*

vision is defined neither circularly nor statistically but qualitatively. Normal color vision involves the optimal functioning of the three sets of cones in the human retina able to absorb the energy waves in the visual spectrum. Other forms of color vision are categorically deficient, with something limiting the spectral sensitivity of one or more of these sets of photoreceptors. So colors, properly named, are what optimally functioning visual systems see, not what a "color-blind" person is seeing.

A pigeon, however, would laugh if it could. Pigeons have photo-receptors in their eyes that function much like those of the human eye, only they have an additional set of cones. Some scientists think they actually have two additional sets. Pigeons are, therefore, what is called tetrachromats (or pentachromats), while normally sighted humans are trichromats. What this means is that where our three kinds of cones have specialized sensitivities to light of different wavelengths allowing the visible spectrum to be perceived, a pigeon has four or maybe five, allowing a more complex color experience than we humans are capable of. Pigeons see colors we don't, and they see the colors we do see differently than we see them. Our roses don't look red to them.

Is this important? Should we care? We readily admit that eagles have better distance vision than we do and that owls can see better in the dark. Yet something seems different about admitting that pigeons have better color vision than we do. It is no less true than the other claims for avian visual superiority, but something more seems to ride on it. Maybe color matters too much for this concession.

We know that a pigeon's color-processing mechanism is more refined than our own, so what should we say about the colors that are seen by normally sighted people? Are *they* mistakes? Misperceptions? Illusions? "Yellow" might be the right name for the color that a normally sighted person sees. It is just not always the right name for the color that most of the pigeons are seeing then.

Normally sighted people seem to be in the exact relation to pigeons as color-blind people are to the normally sighted. So maybe pigeons should get to decide which is the mistake. Or should we say that standards of correctness exist only within individual species? What a normally sighted pigeon sees as red is red for pigeons, whereas what a normally sighted human sees as red is red for humans. These aren't the same color. But so what?

Perhaps species-specific color names is a good solution. It avoids an unthinking anthropocentrism, and it preserves the functional definition of color as what is generated by the neural activity processing the wavelengths of energy that reach the eye. And it is also good because it doesn't insist that either pigeon red or human red is the "real" color, whatever that might mean.

What is less good about it is that it makes it harder to answer the question "What is it to be a color?" since it seems to suggest that whatever a color is, it is not a specific visual experience. The color we see will be seen as a different color by a pigeon, and maybe different still by other creatures. Red roses are, then, at least two different colors. Jonathan Cohen, an excellent philosopher, argues that this is indeed the case but isn't troubled by the implications: "We *can* hold that one and the same object can be simultaneously green for your vision and not green for the visual system of the pigeon on your window ledge." For Cohen, this inclusiveness poses no problem, since, as he says, "The properties perceived by pigeons and other non-human organisms are, even if they are not the very same properties we perceive, at least properties of the same kind—in a word, that they are *colors*."[16]

But "in a word," maybe "*colors*" are exactly what they are not, if only because pigeons don't have that word. Uniquely, human beings conceptualize color sensations and cognitively assemble these as the particular "colors" we see and as the category of experience we think of as "color." Most creatures can detect and process light waves, distinguishing different reflectance properties. Clearly the ability to perceive and discriminate colors offers various kinds of advantages: for mating, finding food, or recognizing predators. But it isn't apparent that any of these nonhuman creatures, however sophisticated their visual systems are, have any ability or any need to conceptualize color rather than merely to experience it. Pigeons (and other creatures) have color sensations; only humans have colors.[17]

And, of course, only we have language to name them. "Color is not 'our' term," says another philosopher writing about sense perception and defending exactly what we have just denied. "We must accord pigeon colors exactly the same authority as . . . the colors that humans experience."[18] "Principled" is his word for his gracious concession. But "color" is in fact only "our" term. Who else could it belong to? Pigeons don't have terms. "Color" (in whatever language) is our word that we use to refer to a particularly sensuous aspect of the world we see, and thus we get to decide what color is mainly because we are the only creatures that can.

Now this may not prove that pigeons and other animals lack a concept of color (as opposed to experiences of colors), only that they have no word for it, as well as no word for anything else. But there is no reason to think that they do have such a concept. There is no sign of it in their behavior, nor does it offer any obvious evolutionary advantage.

But that line of reasoning demands that we ask what advantage humans get from their conceptualization. To the degree that we are primates, we share in all the creaturely rewards of detecting and classifying. We, too, recognize ripe fruit in part through color cues; sometimes we might even recognize willing mates. The advantages of conceptualizing color may not be so obvious, though that is the subject of the rest of this book. Here, it is probably enough to point out that the evolutionary advantages of our ability to conceptualize anything at all are everywhere around us. They are the reason, to put it bluntly, that we experiment on pigeons instead of it being the other way around.

And they are the reason that florists are right to insist that most of their roses are red, although pigeons must often shake their heads, certain that they know better.

CHAPTER TWO

■

What is orange? Why, an orange,
Just an orange!

CHRISTINA ROSSETTI, "What Is Pink?"

Orange

IS THE NEW BROWN

The human eye can distinguish millions of shades of color, subtly discriminating small differences of energy along the visual spectrum. No language, however, has words for more than about a thousand of these, even with compounds and metaphors (for example, a color term like "watermelon red" or "midnight blue"). Most languages have far fewer, and almost no speakers of any language, other than interior designers or cosmeticians, know more than about a hundred of these.

In whatever language, the available color words cluster around a small category of what linguistic anthropologists often call basic color terms.[1] These words do not describe a color; they merely give it a name. They are focalizing words, and are usually defined as "the smallest subset of color words such that any color can be named by one of them."[2] In English, for example, "red" is the basic color term for a whole range of shades that we are willing to think of (or are able to see) as red, whereas the names we give any of the individual shades are specific to them and don't serve a similarly unifying function. Scarlet is just scarlet.

Most of the individual words for shades of red take their names from things that are that particular shade: maroon, for example, which comes from the French word for chestnut—or burgundy, ruby, fire engine, or rust. Crimson is a little different: it comes from the name of a Mediterranean insect whose dried bodies were used to create the vibrant red dye. Magenta is also different. It takes (or, rather, was given) its name from a town in northern Italy, near which Napoleon's troops defeated an Austrian army in June 1859, during the Second Italian War of Independence.

But whatever the source of these color names, all of these are just

FIGURE 10: *John Baldessari*, Millennium Piece (with Orange), *1999*

implicit adjectives, in each case modifying the withheld noun "red." Sometimes, however, the link of the referent to its color seems a bit obscure. In 1895, a French artist, Félix Bracquemond, wondered exactly what shade of red "cuisse de nymphe émue" (thigh of the passionate nymph) might refer to.[3] Unsurprisingly, that name didn't last very long, but a successful cosmetics company today does sell a lipstick color it creepily calls Underage Red.

All the other basic color terms in English are like red in that they similarly subdivide into descriptive color words mostly derived from things that are that particular shade. Green, for example, works this way. Chartreuse takes its name from a liqueur first made by Carthusian monks in the eighteenth century. And there is emerald, jade, lime, avocado, pistachio, mint, and olive. Hunter green takes its name, unsurprisingly, from a shade of green worn by hunters in eighteenth-century England. Hooker's green takes its name from . . . No. It takes its name from William Hooker, a nineteenth-century botanical artist, who developed a pigment for painting certain dark green leaves. No one is quite sure about Kelly green, beyond an association with Ireland. Perhaps it is the imagined color of what leprechauns wear.

Orange, however, seems to be the only basic color word for which no other word exists in English. There is only orange, and the name comes from the fruit. Tangerine doesn't really count. Its name also comes from a fruit, a variety of the orange, but it wasn't until 1899 that "tangerine" appears in print as the name of a color—and it isn't clear why we require a new word for it. This seems no less true for persimmon and for pumpkin. There is just orange.

But there was no orange, at least before oranges came to Europe. This is not to say that no one recognized the color, only that there was no specific name for it. In Geoffrey Chaucer's "Nun's Priest's Tale," the rooster Chaunticleer dreams of a threatening fox invading the barnyard, whose "color was betwixe yelow and reed." The fox was orange, but in the 1390s Chaucer

didn't have a word for it. He had to mix it verbally. He wasn't the first to do so. In Old English, the form of the language spoken between the fifth and twelfth centuries, well before Chaucer's Middle English, there was a word *geoluhread* (yellow-red). Orange could be seen, but the compound was the only word there was for it in English for almost a thousand years.

Maybe we didn't need another one. Not very many things are orange, and the compound works pretty well. "Where yellow dives into the red the ripples are orange," as Derek Jarman says.[4]

By the mid-1590s, William Shakespeare did have a word for it — but only just. In *A Midsummer Night's Dream*, Bottom's catalog of stage beards includes "your orange tawny beard," and later a verse in his song describes the blackbird with its "orange tawny bill." Shakespeare knows the color orange; at least he knows its name. Chaucer doesn't. Shakespeare's sense of orange, however, is cautious. His orange exists only to brighten up tawny, a dark brown. Orange doesn't make it as a color in its own right. It is always "orange tawny" for Shakespeare. He uses the word "orange" by itself only three times, and always he uses it to indicate the fruit.

Through the late sixteenth century in England, "orange tawny" is commonly used to mark a particular shade of brown (even though chromatically brown is a low-intensity orange, though no one then would have known that). The word "tawny" often appears alone; it names a chestnut brown, sometimes described as "dusky." "Orange tawny" lightens the color, inflecting the brown away from red toward yellow.

The prevalence of the compound demonstrates that orange was recognizable as a color word. The compound wouldn't work otherwise. Nevertheless, it is still surprising how very slowly "orange" on its own begins to appear in print. In 1576, an English translation of a third-century military history written in Greek describes the servants of Alexander the Great dressed

in robes, some "of crimson, some of purple, some of murrey, and some of orange colour velvet."⁵ The translator is confident that "murrey" will be identifiable — it is a reddish purple, the color of mulberries — but he needs to add the noun "colour" after "orange" for its meaning to be clear. It is not quite orange yet, but merely the color that an orange is. Still, two years later, Thomas Cooper's Latin-English dictionary could define *"melites"* as "a precious stone of orange color." In 1595, in one of Anthony Copley's short dialogues, a physician tries to ease the anxiety of a dying woman by telling her that she will contentedly pass away "even as a leaf that can no longer bide on the tree." But the image seems to confuse rather than comfort the woman. "What, like an orange leaf?" she asks, obviously referring to the color of the leaves in autumn rather than to the leaf of the fruit tree.⁶ But what is most significant about these examples is that they might be the only two sixteenth-century uses in English printed books of "orange" used to indicate the color. In 1594, Thomas Blundeville had described nutmeg losing its "scarlet" color and turning "unto the color of an orange."⁷ But this, of course, is referring to the fruit. "Orange" was still struggling to be the word for orange.

There are lots of references to the House of Orange, which still today is officially part of the name of the royal family of the Netherlands (Orange-Nassau); but this use of "Orange" comes neither from the color nor the fruit. It takes its name from a region in southeastern France still known as "Orange." The earliest settlement came to be known as Aurenja, after the local water deity, Arausio. There are no oranges in this story and nothing orange. (And although it is often claimed that orange carrots were bred to celebrate the House of Orange in the Netherlands in the seventeenth century, that is an urban legend — although it is true, according to the historian Simon Schama, that in the 1780s, during the Dutch Patriot Revolution, orange "was declared

the colour of sedition," and carrots "sold with their roots too conspicuously showing were deemed provocative.")[8]

Only in the seventeenth century does "orange," as a word used to name a color, become widespread in English. In 1616, an account of the varieties of tulips that can be grown says that some are "white, some red, some blue, some yellow, some orange, some of a violet color, and indeed generally of any color whatsoever except green."[9] Almost imperceptibly (though of course it was entirely a function of perception), orange did become the recognized word for a recognizable color, and by the late 1660s and 1670s, the optical experiments of Isaac Newton firmly fixed it as one of the seven colors of the spectrum. It turns out to be exactly what (and where) Chaucer thought it was: the "color betwixe yelow and reed." But now there was an accepted name for it.

What happened between the end of the fourteenth century and the end of the seventeenth that allowed "orange" to become a color name? The answer is obvious. Oranges.[10]

Early in the sixteenth century Portuguese traders brought sweet oranges from India to Europe, and the color takes its name from them. Until they arrived, there was no orange as such in the color spectrum. When the first Europeans saw the fruit they were incapable of exclaiming about its brilliant orange color. They recognized the color but didn't yet know its name. Often they referred to oranges as "golden apples." Not until they knew them as oranges did they see them as orange.

The word itself begins as an ancient Sanskrit word, *naranga*, possibly derived from an even older Dravidian (another ancient language spoken in what is now southern India) root, *naru*, meaning fragrant. Along with the oranges, the word migrated into Persian and Arabic. From there it was

adopted into European languages, as with *narancs* in Hungarian or the Spanish *naranja*. In Italian it was originally *narancia,* and in French *narange,* though the word in both of these languages eventually dropped the "n" at the beginning to become *arancia* and *orange,* probably from a mistaken idea that the initial "n" sound had carried over from the article, *una* or *une.* Think about English, where it would be almost impossible to hear any real difference between "an orange" and "a norange." An "orange" it became, but it probably should really have been a "norange." Still, orange is better, if only because the initial "o" so satisfyingly mirrors the roundness of the fruit.

The etymological history of "orange" traces the route of cultural contact and exchange—one that ultimately completes the circle of the globe. The word for "orange" in modern-day Tamil, the surviving Dravidian language that gave us the original root of the word, is *arancu,* pronounced almost exactly like the English word "orange" and in fact borrowed from it. But none of this actually gets us to color. Only the fruit does that. Only when the sweet oranges began to arrive in Europe and became visible on market stalls and kitchen tables did the name of the fruit provide the name for the color. No more "yellow-red." Now there was orange. And, remarkably, within a few hundred years it was possible to forget in which direction the naming went. People could imagine that the fruit was called an orange simply because it was.

Vincent van Gogh's *Still Life with Basket and Six Oranges* is in a sense a painting about the confusion (Figure 11). There is always some confusion in any figurative painting between its radical materiality (that is, the fact that it is always just paint on canvas) and the representative claim it makes (that is, the image it represents). But here the confusion, or connection, between fruit and color becomes the painting's very point. It is both a traditional still life with fruit and a radical experiment with color, but it wouldn't work exactly

FIGURE 11: *Vincent van Gogh*, Basket with Six Oranges, *1888, Private collection*

FIGURE 12: *Luis Egidio Meléndez*, Still Life with Oranges and Walnuts,
1772, National Gallery, London

the same way if it were a still life with a basket and six lemons. Lemons are
yellow; oranges are orange.

The modest kitchen scene is energized by the six balls of glowing
orange sitting in the oval willow basket on a table. The orange seems not so
much a color painted on the pieces of fruit to get their surface appearance
right but a color emanating from deep within the circular forms. They are
made not by coloring in the outlines of the six oranges but by allowing the
orange color a life curiously independent of the fruit whose name it bears.
They create a force field: the source of the orange light that dances on the blue

wall to their left. And somehow their energy simultaneously is able to redirect the blue of the wall down through the gaps of the woven basket in which they sit. The scene pulses with radiant color, proving once again that great still lives are never quite still. They animate the inanimate.

And yet how different it is from another still life with oranges. Look at Luis Egidio Meléndez's *Still Life with Oranges and Walnuts,* painted a little over one hundred years before Van Gogh's not-so-still life (Figure 12). Obviously the oranges here aren't as central as they are in Van Gogh's painting. They are set off to the sides, chromatically separated from the various stolid browns of the boxes, the barrel, the jug, the chestnuts, and even the greenish brown melon that sit on the wooden table. Meléndez's still life celebrates the solidity and seeming permanence of a world of bourgeois commodities; Van Gogh's celebrates a momentary flashing forth of glory in the simple scene. A few brown spots on Van Gogh's oranges subtly register the evanescence of the moment. "Nothing gold can stay," as Robert Frost said. But the essential difference between the two paintings is that Meléndez represents objects so as to conceal the fact that they are made of paint; Van Gogh represents objects as an opportunity to explore and extol what paint can do. Meléndez paints volume; Van Gogh paints color. Meléndez is painting oranges; Van Gogh is painting orange.

Or, rather, Van Gogh is painting orange next to blue, fascinated by the interaction of the two complementary colors. In a letter to his brother, Theo, written in 1885, he talks about the "poles of electricity" set up by placing "orange and blue next to each other, that most glorious spectrum," testing on the canvas what he had been enthusiastically reading in the color theorists with whom he had become obsessed.[11] Increasingly convinced that "the laws of colour are inexpressibly splendid," not least because "they are NOT *coincidences,*" Van Gogh allows them to play out on his canvases, as he began to es-

cape the preference for the dark and dusky shades that had initially appealed to what he called his "Northern brain."[12]

In 1883, while living in The Hague, he had begun anxiously to wonder why he was "not more of a colourist," and over the next five years he moved ever farther south in search of color: Brussels, Paris, and finally Arles, where, as he wrote to his brother, "you feel colour differently."[13] There he would fulfill his desire to become, as he would say, "an arbitrary colourist," for whom color was not a way of accurately rendering the things he painted but the very subject of the paintings themselves.[14] Their stubborn realism turns out to be largely a ruse. Van Gogh's *Basket with Six Oranges* turns the banality of the kitchen scene into something rich and strange, by making the painting about the color orange rather than about the orange fruit — and confirming this commitment with his angled signature, "Vincent," in the lower left of the canvas, taking its color from the energy of the six incandescent balls of orange that brings the painting to life.

Later he would write his brother that signing his paintings seemed to him "silly," but that in a recently painted seascape he had included "an outrageous red signature," but only because he "wanted a red note in the green."[15] It was always about the color. It is worth noting that in his wonderful letters, the adjectives indicating color often fail to agree with the nouns they are meant to qualify. It may merely be that, as a non-native French speaker, he makes insignificant and forgivable grammatical errors; but in the "ungrammatical" sentences that result, it is as if the color has taken on a life of its independent of the objects that carry it.

Color for Van Gogh does have its own reality, as the paintings insist, though he could not quite pull himself completely away from representation and the world. The word "abstract," of course, literally means "pull away

from," and Van Gogh wasn't quite ready to become an abstract painter. He was eager to loosen the grip of the object upon his use of color but not ready to release it entirely: "Instead of trying to render exactly what I have before my eyes, I use colour more arbitrarily to express myself more forcefully."[16] But there was a step beyond that he could not take. And he knew it. In 1888, he presciently wrote to his brother: "The painter of the future is *a colourist such as there hasn't been before.*"[17]

Van Gogh wasn't ready to be that colorist; he wasn't yet able to be the artist for whom color would be freed from its dependence upon any material presence other than itself. Yet somehow he knew what was coming: that there would be a new art of color; but this would be an art that could only "really begin," as the French artist and designer Sonia Delaunay would say about forty years later, "when we understand that color has an existence of its own."[18] That is, when orange no longer needs its oranges.

Looking backwards at the history of art, that independence seems inevitable. The freeing of color from depiction is one of the major story lines of twentieth-century painting. But it wasn't yet inevitable in 1927 when Delaunay wrote, and what that freedom might look like on the canvas wasn't fully imaginable in the 1880s when Van Gogh was painting. Yet color now "has an existence of its own." It has been liberated from the color of things, free to become what Oscar Wilde called "mere color, unspoiled by meaning, and unallied with definite form."[19]

In the hands of artists like Wassily Kandinsky and Paul Klee, Lee Krasner and Ellsworth Kelly, Anish Kapoor and Yves Klein (and that is just the Ks), color, which once was what allowed painting to mimic reality, came to express the reality of what painting is. For some, like Kandinsky, it provides an almost mystical vocabulary of spiritual reality; for others, like Kras-

ner, color at once registers and provokes otherwise inexpressible emotional experiences; and for still some others, like Klein, it could be just (just?) color.

It was arguably Klein who would become the most extreme version of Van Gogh's "painter of the future." Klein would himself indulge in prediction. "In the future" that Klein imagined in 1954, "people will start painting pictures in one single color, and nothing else but color."[20] Some indeed would (and some indeed already had), but his own career would make this a self-fulfilling prophecy, mainly as he devoted himself to blue, even giving his name to one of its shades, the intoxicating ultramarine pigment now known as International Klein Blue (more about which in Chapter 5). But it is easy to forget that he began with various "monochromes," as he called them. The first important one was orange.

In 1955, Klein submitted a large, orange monochrome painting for the annual exhibition at the Salon des Réalités Nouvelles in Paris. The matte orange panel, titled *Expression de l'univers de la couleur mine orange* (*mine orange* is the French term for the pigment known in English as "orange lead," the same pigment Van Gogh had used in his still life), was, however, rejected by the organizing committee, unwilling, at least in Klein's hardly disinterested account, to accept a painting that was just one solid color (*une seule couleur unie*). "You know," as Klein reported (or, better, parodied) what he was told about the jury's reasoning, "it's just really not sufficient; if Yves would agree to add at least a little line, or a dot, or simply a spot of another color, then we could show it, but a single color, no, no, really, that's not enough; it's impossible!"[21]

But the impossible was exactly what Klein sought, as when he announced in 1958 that his paintings were now "invisible" but that he would nonetheless "show them in a clear and positive manner."[22] Earlier Klein's ambition was only a little less impossible: the desire to escape all the limitations

of art by focusing only upon color. "All paintings of whatever sort, figurative or abstract, seem to me like prison windows in which the lines, precisely are the bars." Klein's monochromes are his "landscapes of freedom," paintings of pure color emptied of line. They are his Get Out of Jail Free card.

But was this all just a game, or was it a serious artistic and philosophical quest? It is often hard to tell if Klein was a conceptual artist or just a con artist. Or maybe he was always both. The monochromes with their intense, saturated color still dazzle, but monochrome painting has become a cliché of modernist art, often now an empty gesture. A large, matte orange panel might be only a large, matte orange panel. Today the major risk of what Klein called the "l'aventure monochrome" is that nobody will care. Nobody will care, that is, unless it is by Klein.

It isn't just the intense saturation of the color that makes his paintings matter; it is the crazy risk he took in his commitment to them. This is painting, not as the abstraction of reality, but as the repudiation of it — painting at its most minimal and most extreme. Color is everything; color is the only thing. In the making of a painting *of* a color *with* that color, Klein collapses the medium and the message, the object and the image, the personal and the universal, even the artist and the art. He would sometimes refer to himself as "Yves the Monochrome."[23] Van Gogh's oranges become Klein's orange, as Klein becomes Van Gogh's *colorist such as there hadn't been before.*

The problem — and there is a problem — is the danger not of monotony but of its easy repeatability. Doing it once is audacious and exhilarating. Doing it again isn't very hard, and often isn't very interesting. The first cut is the deepest; after that they start to lose their sting. Or maybe monotony is after all the problem — at least for the orange monochrome. In that case, the organizing committee of the *Salon des Réalités Nouvelles* might well have been right.

FIGURE 13: *Barnett Newman,* The Third, *1962, Walker Art Center*

Barnett Newman's *The Third* might easily be thought to be a large-scale version of Klein's salon entry that would have satisfied the jury's desire for "at least a little line, or a dot, or simply a spot of another color" to be added to the orange field — and it seems to be a better painting than Klein's (which is not, of course, the same thing as a more significant one) (Figure 13).

It, too, is a large field of flat, saturated orange color (though this one is substantially larger than Klein's: about 8½ × 10 feet to Klein's roughly

3 × 7½ feet). But Newman's has two narrow yellow bands that run top to bottom several inches in from each side edge, and at the far left the color space before the yellow vertical seems to be either unfinished or disintegrating. The two yellow "zips," Newman's name for these vertical stripes, divide the canvas into three sections, though none is proportionately "The Third" the title seems to promise. Perhaps the title implies that the central orange expanse is merely "The Third" that we are able to see completely; maybe the zips initiate two potentially equivalent spaces incompletely articulated on the canvas.

Or, just maybe, the title suggests something less formal and more profound. It could be an obscure suggestion of presence of the Divine, as in T. S. Eliot's *Wasteland:* "Who is the third who always walks beside you?" Eliot refers to the story in the Gospel of Luke about the Resurrection, where two disciples come to the sepulcher after the Crucifixion and find it empty. Dispiritedly walking back to town, they are joined by an unknown third person; they sit to eat, and only then "their eyes were opened and they knew him" (Luke 24:31, KJV). The well-read (though Jewish) Newman, who often made use of allusive, enigmatic titles, was likely to have known Eliot's poem, if not Luke's Gospel (although the only copy of Eliot's poems in the artist's library, now preserved at the Barnett Newman Foundation, is a 1920 edition, and *The Wasteland* was written in 1922). Almost certainly the idea of the mysterious presence of the divine would have appealed to him. There was always a spiritual dimension to his painting, and *The Third* might be his indication of the content to which Newman's abstraction would give form.

Not unlike Klein's expanses of color (remember the title of his orange painting: *Expression de l'univers de la couleur mine orange*), Newman's canvas expresses a no less hubristic ambition for transcendence and perhaps a no more convincing claim for the aesthetic as a domain of the spiritual. Both

painters would turn the beautiful into the sublime. And yet sometimes they both make us wearily wish for the appealing modesty of Henri Matisse's "I'm for decoration," as the French painter once said to his daughter.[24]

Klein and Newman are in fact both very good at that (at decoration, that is; not modesty). But where Klein's painting is a monochrome, Newman's is a subtle undoing of the monochrome he almost commits to. His orange no less aggressively confronts us, but it stops and starts, disrupted by the yellow zips, and even more by the chromatic scruffiness at the left edge where the orange seems to begin—or maybe end. "I have never manipulated colors—I have tried to create color," Newman once wrote, and *The Third*, whatever Newman intended the title to signify, seems to be a painting that presents us with an orange that might never have been before. No oranges were necessary as a precondition.[25]

It is probably no mere arbitrariness of choice that neither Klein's nor Newman's greatest paintings are orange: Klein's are blue, Newman's red. William Gass once called orange "acquiescent," not exactly the right quality for either of their massive artistic ambitions.[26] Blue and red are better; they are more emphatic and self-assured. Pure color, it turns out, is never entirely pure: orange can't quite escape the homeliness of carrots, pumpkins, and the no-longer-exotic oranges.

Maybe the best that can be done is something like John Baldessari's droll *Millennium Piece (with Orange)* (see Figure 10). The photograph is of an orange. Not orange, just an orange: an orange, suspended in space, freed from any physical or social context. Or maybe not. The space isn't empty; it is black. So it would be better to say that the photograph is of a black square (not the last we will see) with an orange placed in the middle. The orange glows. It energizes the black around its edges. It is still unmistakably an orange. It won't be reduced to pure color. Its resistant particularity—the slight irregularity of

its shape, its dimpled rind, and the insistent stub of its stem — proclaim it an orange. And hardly a perfect specimen. It is an ordinary orange, but an ordinary orange formally rendered abstract and iconic, not least by existing in a black square. The sly Baldessari reunites the color with the fruit that gave it its name, magically repairing the separation that must be seen as much a part of the history of the English language as a part of the history of modern art. Baldessari turns an orange into the orange and then finally into orange itself.

CHAPTER THREE

■

The pale yellow composition is not my skin;
it is only what my brothers would have me believe.
FRANCIS NAOHIKO OKA, "Blue Crayon"

Yellow

PERILS

FIGURE 14: *Byron Kim*, Synecdoche, *1991–present. Oil and wax on lauan plywood, birch plywood, and plywood, each panel: 25.4 × 20.32 cm (10 × 8 in.); overall installed: 305.44 × 889.64 cm (120¼ × 350¼ in.). National Gallery of Art, Washington*

Sometime early in 1515, Tomé Pires sent a detailed account of his three years of Asian travel to the Portuguese king Manuel I. The manuscript remained unpublished until 1550, when a section of it appeared anonymously in the first volume of Giovanni Battista Ramusio's *Delle navigatione et viaggi* (Of voyages and travels), a large collection of European travel narratives. Pires describes the Chinese people he had encountered on his journey and declares that they are "white, just like we are."[1]

And the very few Asians who visited Europe in the sixteenth century also looked "white" to European eyes. In 1582, four young Japanese aristocrats, along with two servants and a translator, left Nagasaki and traveled to Lisbon, Rome, and Madrid, returning to Japan in July 1590. The members of this so-called Tenshō embassy met with both Pope Gregory XIII and his successor, Pope Sixtus V, as well as with King Philip II of Spain. Their visit was widely reported all over Europe, and the young men were inevitably described, as in the account of their visit to Madrid in November 1584, as "white" and, a bit patronizingly, also of "very good intelligence."[2]

A few Europeans understood that Asians in fact were of different skin tones. In a compendium of Portuguese travelers' accounts translated into English in 1579, the people living near Canton are described as "tawny," looking much like those who live "in Morocco," though "all within the land are of the color like to the people of Spain, Italy, and Flanders, white and red & of good growth."[3] And the Spanish Augustinian Juan González de Mendoza wrote that some Chinese were "of brown color" and that some others, for example, the "Tartarians," looked "very yellow and not so white"; but he also insisted that the great majority of them "were white."[4]

Mendoza's is one of the few early accounts (perhaps it is the first in print) in which any Asian is described as yellow. For the most part, however, the Chinese, like the Japanese, appeared white to European eyes in the six-

teenth century, exactly as Marco Polo had described them over two hundred years earlier — and as travelers would do in the seventeenth century, like the Jesuit Matteo Ricci, who even after living in China for more than twenty-five years, still insisted that the Chinese people were "in general white."[5]

And so it remained, as scholars like Michael Keevak and Walter Demel have shown.[6] In 1785, a close friend of George Washington wrote to him about a group of Chinese sailors and commented on their various skin colors. Those from the north were lighter skinned than those from the south, he told the soon-to-be American president, but "none of them are of the European complexion." Washington wrote back with some surprise: "Before your letter was received I had conceived an idea that the Chinese . . . were white."[7]

Most educated Westerners, almost none of whom had any personal experience of East Asian people, had "conceived" the same thing. For about five hundred years — from the end of the thirteenth century to the end of the eighteenth century, they almost all believed, like Washington, that Asians "were white." Even as late as 1860, a French diplomat could still write of the Japanese that they are "as white as we are."[8]

Of course the East Asians were never actually white, any more than those of a "European complexion" are white. But soon the Chinese became yellow, which, of course, they weren't either. By the time of the publication of the magisterial eleventh edition of the *Encyclopaedia Britannica* (1910–11), a considerable range of skin colors would be recognized among the large population of China, but the encyclopedia would insist that "yellow, however, predominates."

Indeed it does, though not among the population, but in how they are described by others. The Chinese and other East Asians had slowly but unmistakably become yellow in the Western imagination, so much so that the most authoritative encyclopedia in the English language could make its care-

fully calibrated claim as a seemingly neutral assertion of fact. But it isn't that. Perhaps one might say that it is a jaundiced opinion, seeing yellow where it isn't there.

And yet "white" people had already begun to see it everywhere — and see it as a threat. The German emperor Wilhelm II is usually credited with coining the phrase "the yellow peril" ("die Gelbe Gefahr") in 1895, though it almost certainly was being used earlier. Kaiser Wilhelm, however, gave it currency, insisting on the need for "the white race" to be prepared to resist "the inroads of the great yellow race." A large oil painting with the title *The Yellow Peril* was commissioned by Wilhelm, showing white, female warriors, led by the archangel Michael, bathed in light from a radiant cross, mustering to defend Europe from the fierce storm that was thought to threaten it from the East. Wilhelm had multiple copies of the painting made, which he then sent to other European heads of state as well as to the American president William McKinley, while engravings of the image were quickly made and widely circulated in popular magazines.[9]

The large number of Chinese people arriving in the United States in the second half of the nineteenth century had already raised the specter of a dangerous immigrant crisis threatening the West, but with the Japanese military defeat first of China in 1895 and then of Russia in 1905, the perceived threat refocused and intensified. "Remember my picture," the kaiser wrote to the Russian tsar in 1907, "it's coming true."[10] Ironically, however, within seven years there would indeed be a devastating world war, though not the apocalyptic clash of civilizations that the kaiser had imagined but a war of a divided Europe, primarily pitting Germany and Austro-Hungary against Russia, France, and the United Kingdom.

But it would have been easy to envision the global conflict, which Kaiser Wilhelm felt was inevitable, breaking out along cultural fault lines.

Asians were homogenized and demonized, as Jack London infamously wrote in 1904 for William Randolph Hearst's *San Francisco Examiner,* becoming "that menace to the Western world which has been well named the 'Yellow Peril.'"[11] Already by then a cliché of xenophobia and racism, the phrase would continue to be variously deployed and variously envisioned. Asians were depicted as a numberless "horde" of faceless yellow bodies; or memorably individualized in "inscrutable" fictional villains like Fu-Manchu ("the yellow peril incarnate in one man," as his creator said); or stylized into sinister metaphors, as in Erich Schilling's striking cartoon of a grinning, slant-eyed yellow octopus, encompassing the entire globe in its grasping arms (Figure 15).[12]

To oversimplify (but not very much), Asians looked white to Western eyes mainly when they seemed to be candidates for conversion to Christianity, as with the sixteenth-century Jesuit missions to China and Japan; they became yellow only when they seemed to be a threat to Western moral values and economic interests. Imagined moral qualities somehow got mixed into the imagined color of their skin. They become yellow, but not the highly saturated, cheerful yellow we are all familiar with (think of "happy faces"), instead a yellow that seems sallow and sickly, darkened less by melanin than by misgivings: by a set of associations projecting Western anxieties and bias. Yellow is the color of corruption and cowardice, of duplicity, degeneracy, and disease. In any case, their yellow was. It was a color produced by prejudice and not by pigmentation.

Once, however, Asians "were" yellow, the color could be naturalized. It became a seemingly objective fact instead of an objectionable judgment. And then it sometimes became possible to escape the bias that had produced the color in the first place. Yellow they still were, but soon it was a yellow different in affect if not in hue.

A European and American avant-garde would come to find in Asian

FIGURE 15: *Erich Schilling*, The Japanese "Brain Trust,"
Simplicissimus 39, no. 44 (1935)

cultures an elegance, delicacy, and subtlety it both admired and imitated — and that it found lacking in its own. The poise and simplicity found in things like Japanese gardens, the tea ceremony, calligraphy, haiku, and woodblock prints all came to influence the artistic imagination of the West almost at the very moment that Japan and China became the yellow peril dominating the popular imagination. Indeed the history of artistic modernism could be written as a history of East-West cultural relations, or at least of the West's appropriation of Eastern modes and motifs: Van Gogh's fascination with Japanese prints, Ezra Pound's interest in Chinese poetry, Louis Comfort Tiffany's attraction to Japanese and Chinese styles of ornamentation, Frank Lloyd Wright's adaptation of Eastern architectural design features and philosophies. And not just individuals but whole movements — the Arts and Crafts Movement, art nouveau, art deco — were enthusiastically and self-admittedly "orientalist," as were other modernist movements only a little less explicit about their indebtedness.[13]

But even when viewed positively, Asians remained yellow. In 1888, Percival Lowell (the brother of the poet Amy Lowell) wrote an influential, if deeply ambivalent, book called *The Soul of the Far East,* which found in "the yellow branch of the human race" an all-pervasive commitment to "devices for the beautifying of life."[14] This is a culture, he argued, in which "art reigns supreme" and where every object and activity reflects a "nameless grace" (though he confessed that for him "Japanese food is far more beautiful to look at than to eat," an opinion that, had it been widely shared, might have saved the bluefin tuna from the risk of extinction). Lowell's book was published with a cover designed by a talented artist and designer, Sarah Lyman Whitman, who beautifully gives its central conception visual expression: simple and clean, it reproduces that nameless grace in the delicacy of its abstract shapes and its hand-designed letter forms, all in yellow.

Asians clearly but not inevitably became yellow, and similar stories could be told about how the indigenous population of North America became red, or Africans black, or even about how Caucasians came to be thought (or to think themselves) white.[15] The color coding of race now seems to us more or less natural—at least until we look. People are variously colored, but they never are colored with the color that putatively identifies them racially. We are all colored people; we just aren't the colors people say we are.

"Colored people" has, of course, become a derogatory term, though oddly "people of color" has not. Perhaps only in the name of the National Association for the Advancement of Colored People is the term not negatively charged, but the organization quickly became known mainly by its initials: NAACP.

The politics of color are always complicated; and often they become toxic. "Colored people" is almost always a phrase that white people have used to describe other racial groups (although in South Africa and its neighboring countries, the phrase refers specifically to people of mixed ethno-racial background). However it is used, it marks exclusions and it divides. "People of color," on the other hand, is a term that nonwhite people have chosen to describe themselves; it includes and it consolidates. It is designed to bring those people together, aimed at calling attention to their common political interests and establishing their solidarity of purpose. Remember Martin Luther King's phrase "citizens of color" in his "I Have a Dream" speech at the Lincoln Memorial in 1963. It seems that it is not only the politics of color that are complicated; so is its syntax.

But in no context does either "colored people" or "people of color" include "white" people. They don't count as colored, and yet white people certainly aren't colorless. On the other hand, neither are they white. In 1962, it suddenly dawned on the people running Crayola that the crayon they had

FIGURE 16: *Crayola crayons: Flesh and Peach*

been unselfconsciously calling Flesh since 1949 (and had earlier called Flesh Tint from the appearance of its first box of crayons in 1903) was the approximate flesh tone only of white people's flesh, and they changed the name of the color to Peach (Figure 16).

Color turns out to be a remarkably inexact index of racial identity, perhaps the least telling of the biological markers that have been used to build our taxonomies of race, and yet it is still the one we most commonly employ.

This has, like everything else, a history. European racial theory begins in the eighteenth century (before the middle of the eighteenth century "race" was a common word though almost always meant lineage), but the observation of human differences must have begun almost as soon as there were humans to observe one another. The categorization of these differences would necessarily wait for a long time, but sometime around 400 B.C.E., Greek medical science held that individuals were composed of combinations of four basic "humors": blood, phlegm, yellow bile, and black bile. These were associated with specific colors — red, white (or blue), yellow, and black.

And it didn't take much of a leap for the nascent ethnology to develop taxonomies dividing human beings into groups based then upon color,

which would soon come to be thought of as distinct "races." By 1735, Carl Linnaeus, one of the world's great systematizers, would subdivide the genus *Homo* into four species: *Europaeus albescens* (whitish); *Americanus rubescens* (reddish); *Asiaticus fuscus* (dusky); *Africanus niger* (black).[16] People became colored people, with accompanying traits of temperament. And in 1758, in the tenth edition of Linnaeus's *Systema Naturae,* published in Stockholm, *Asiaticus fuscus* was changed to *Asiaticus luridus* (pale yellow). For Europeans, Asians now officially were yellow, with all the sensationalist connotations of the English word "lurid" attaching to them.

Over the next two centuries, sociologists and anthropologists would continue to argue about color and race. How many races were there, and how was skin color distributed across them? Scientists and philosophers debated whether color was an infallible indicator of racial difference (Immanuel Kant thought yes, Gottfried Leibniz no). In any event, racial difference became color coded, sometimes benignly, but more often not.

In the complicated and often corrosive politics of pigmentation, color is almost always a social fact more than it is a visual one. But perhaps the visual one is both more interesting and more consequential in the consideration of race than we usually allow. Maybe we should think seriously about color as color, as a contemporary American painter, Byron Kim, has invited us to do. He is interested both in color and in race. Perhaps the interest in color came first, but in 1991 Kim began work on a remarkable project entitled *Synecdoche.* It is a large, rectangular grid of color tiles (or "panels," as he calls them), each measuring 8 inches by 10 inches (see Figure 14). It has been shown in various iterations as installations with different numbers of these panels. Its first major showing was at the Whitney Biennial of 1993 with 275 panels; it was featured in the Museum of Modern Art's 2008 exhibition *Color Chart: Re-*

inventing Color, 1950 to Today; and in 2009 the painting, having grown to 429 panels, was purchased by the National Gallery of Art in Washington.

In many ways *Synecdoche* represents a familiar formal gesture of contemporary art. It looks like an abstract color painting, similar in concept and design to more familiar works like Ellsworth Kelly's 1978 *Color Panels for a Large Wall* or Gerhard Richter's *256 Farben (256 Colors)* from 1974. In each of these, color is seemingly freed from context (freed to be "just" color, as Van Gogh had predicted) by the reduction of form to flat color patches inserted into a rigid grid. Color is its subject, and color appears as an object detached from representation or signification. At first glance, *Synecdoche* appears to differ from the work of Kelly and Richter only in the muteness of the color choices Kim has made.

But this is to get the painting almost entirely wrong. Color is indeed its subject, and color appears as an object, but Kim is profoundly interested in representation and signification. "Purity in color is an anachronism," he has said.[17] Abstract color is so very twentieth century, at least in the history of art. Each of Kim's panels is uniquely colored, not only in terms of the subtly differentiated tones of each one, but also in terms of the process by which it was achieved. Beginning with friends and family, and then stopping strangers on the street, Kim mixed colors to match the exact skin tones of each person who agreed to sit for him. The panels are arranged according to an alphabetical arrangement of the sitters' first names, and the full names of the sitters are displayed in an accompanying directory attached to the wall.

Color is what he paints, but here, unlike in the work of other color grid painters, it is *skin* color. So much of modern art could be understood as the belief, as the French conceptual artist Daniel Buren has claimed, that "colour is pure thought."[18] But not for Kim. "Why are you making abstract

paintings?" he once imagined himself being asked: "The 'you' meaning Asian-American artist, artist-of-color, artist-with something-to-say."[19]

Whereas painters and color theorists from Leonardo to Josef Albers have always understood that color is determined by context, for them the context is other colors. This is the basis of any number of familiar color illusions, in which a single color seems to change depending on what other colors it is placed against. But for Kim the context is not merely the other colors that determine what colors we see, but the other lives and other histories that over-determine them. Albers famously said that "color deceives continually," but the deception for Kim is not merely an optical effect.[20]

Synecdoche understands that color carries extraordinary freight in our modern world; it doesn't float free of individual experience and cultural meaning. Kim's panels could almost be thought of as 8-by-10-inch portraits, although representing, not an individual face, but a unique patch of skin. The painting's title refers to a rhetorical device by which a part of something is substituted for the whole — as in "learning your ABCs," though ideally one learns the rest of the alphabet as well. (And it is probably not irrelevant to Kim that rhetorical figures were once themselves known as "colors.")[21] In *Synecdoche* skin color stands in for an individual, and an individual for a community, and a color for a race. Kim has said of the piece, "The part of it that is most dear to me is the signage, which is composed of all the people's names."[22] These lives matter. In several senses, they bear the colors that he paints.

What may be visually most significant about the painting is not only that no two panels are exactly alike (a chromatic argument against stereotyping) but also that the range of color is so narrow. There is no green or orange or blue or purple. But also there is no yellow, red, black, or white. There are only the meticulously nuanced, almost always unnamable shades of brown,

variously tinged by pink, yellow, or orange: from the beiges and tans to coffees with and without milk to some plain and a few dark chocolates. These are our shades of difference. We may all be colored people, but in reality we aren't so very colorful.

There is an awkward moment described in *A Passage to India,* E. M. Forster's novel set in the India of the British Raj. The book is about many things, but almost all of them are inflected by color and race. Cyril Fielding is the British headmaster of a local college and a member of a restricted club for whites only. "The remark that did him most harm at the club," says Forster's narrator, "was a silly aside to the effect that so-called white races are really pinko-grey. He said this only to be cheery; he did not realize that 'white' has no more to do with color than 'God Save the King' has to do with a god, and that it is the height of impropriety to consider what it does connote."[23]

The color names that we have come conventionally to use as some inexact metaphor for race do in fact have little to "do with color," but they have everything to do with power. What "white" connotes shouldn't go without saying, even in the name of supposedly good manners—and certainly it doesn't go without being observed, except by those whose power has come to seem to them both natural and inevitable.

Another contemporary artist, Glenn Ligon, who has collaborated and shown with Byron Kim, has created a series of text-paintings that observe and in turn solicit, if not actually compel, the viewer's observation. In much of his work, texts turn into images, as appropriated phrases are repeatedly stenciled in black oil stick onto hand-painted white backgrounds. The letters thicken and blur as they move down the picture space, making them increasingly difficult and sometimes finally impossible to read.[24] In one, *Untitled (I Feel Most Colored When I Am Thrown Against a Sharp White Background)*, a line from Zora Neale Hurston's 1928 essay "How It Feels to Be Colored Me," is stenciled onto

a painted wooden panel (actually a door), but it begins to grow illegible about one-third of the way down from the smearing of the medium (Figure 17).

What begins as the proliferation of text ends as the obliteration of it, undoing the distinction between writing and erasing, between creating and negating. The black smudges from working with the oil stick finally overwhelm both the stenciled words and the "sharp white background" on which they appear. We are at first invited to read, but then the painting prevents us from doing so. All we can do is look.

Looking is unsettling. We see what is there, not what someone tells us. Words in Ligon's work are slowly removed from the system of signification that is language, and then they are rematerialized as line and color. It is oil paint on a wooden platform. Hurston's words give way to Ligon's shaping imagination. Her linguistic structure is disfigured in his visual one.

The politics of the gesture are elusive here, perhaps deliberately evasive. But they do read as politics. We are invited at first to interpret the statement as Ligon's own. The unanchored "I" of the text — "I feel most colored when I am thrown against a sharp white background" — seems to be Ligon himself. He is an African American. The quotation is unidentified and unmarked as a quotation. Even if we recognize it as Hurston's, it still seems to be something Ligon identifies with or endorses. But the visual repetition produces illegibility (just as verbal repetition produces unintelligibility; say a word over and over and see what happens). Paint triumphs over language as the letters disappear into another form of black art.

Hurston's statement obviously interests Ligon, almost certainly because of Hurston's recognition that racial identity is not essential but develops within a system of differences. Colored people are colored only in relation to the whiteness that has become normative, while whiteness is somehow exempted from the burden of being colored at all. It marks privilege, even in

FIGURE 17: *Glenn Ligon*, Untitled (I Feel Most Colored When I Am Thrown Against a Sharp White Background), *1990. Oil stick, gesso, and graphite on wood, 80 × 30 in. (203.2 × 76.2 cm). Private collection.*

the most familiar activity of the painter preparing a space on which to paint. But perhaps what also interests Ligon is the ambiguity in Hurston's sentence about what it means to "feel most colored." Is that a good feeling or a bad one? Is that to feel more fully alive, or is it to know oneself more completely at risk? Or are those the same thing? Does the "sharp white background" serve as a clearly differentiated foil against which Hurston's own black identity is highlighted and shines powerfully forth, or does it just hurt as she is pinned against it?

In either case, it is a background that Ligon makes disappear. Does he feel more or less "colored" after its disappearance? Are there other systems of difference that might matter more? Or might identity not need any system of difference to form? Or, at least, might it be better if it didn't need one? Those are all hard questions to answer, at any rate on the basis of looking at a painting.

An easier one might be: Does he object to the word "colored"?

Probably not. He is a painter, after all, and clearly, like his friend Byron Kim, remarkably sophisticated about both the material and the metaphoric usages of color. Each artist could be called "an American abstract painter of color." But is that an American of color who paints abstractly, as each is and does; or is it an American painter who paints abstract color paintings? Each is that, too. Another one of Ligon's text-paintings isn't smeared, but in it (on it?) a set of racialized color words — "black," "brown," "yellow," "red," "white" — is repeatedly stenciled in black lettering on a white surface divided down the middle like the facing pages of a book. The words appear either whole or broken up as they fit, or don't, onto what seems a line of text.

Ligon's piece might usefully be compared with Jasper Johns's well-known painting *False Start* (1959), though Johns's exuberant use of color is so very different from the austerity of Ligon's black and white. Both make use of

stenciled color names, but in *False Start* they seem randomly placed on (and sometimes covered by) irregularly shaped bursts of bold color, only twice with the color name and color patch in alignment, and never with the color of the letters corresponding to the color of the word the letters spell. Johns's painting is a release of energy seemingly originating in the color itself, bursting across the canvas and rendering the color names arbitrary and irrelevant. In Ligon's work, the color names matter, but they matter only because they turn out to be no less arbitrary or no more accurate than they are in Johns's painting. They are black letters forming words for color, or at least trying to in so far as the structure of the line allows. Sometimes they break apart as one or more letters in the word must move to the next line.

The point seems to be that skin color is not a visual reality but a cultural construction that creates and attaches meanings to colors we inaccurately see. We are all unmistakably colored people, but what colors we are and how we feel about it (or are made to feel about it) have little to do with visual information. Ligon's paintings force us to look at skin color no less intensely than Kim's *Synecdoche*. And no less than that painting, the visuals denaturalize the color codes of race, even as they contest the idea that color can ever be decontextualized or disinterested. Kim paints the colors that are there to be seen; Ligon paints the envelope of discourse that keeps us from seeing them.

None of us is color-blind, at least as the phrase is often used to insist on one's own freedom from racial prejudice. Even as a mere visual deficiency, almost no one is actually color-blind. But neither Kim nor Ligon wishes we were. They set out to teach how to see color and to recognize both how much and how little it means. We often see colors, even when they aren't there. Kim and Ligon show us what is in fact there, though that may not be what we (are willing to) see.

Color matters, and in spite of our occasional empty gestures of de-

nial ("I don't care if she is green or purple"), we know it. In 1999, Crayola changed another of its color names. Indian Red, which, like the awkwardly named Flesh Tint, had been present in the very first box the crayon maker had issued in 1903, was renamed Chestnut. The company worried that people would think the color name referred to the skin color of American "Indians" instead of to the source of the pigment from which the color came. Maybe Crayola needn't have worried about that; had Indian Red referred to skin color, surely it would have already been changed to Native American Red. But then again there are still those Washington Redskins.

Crayola, anyhow, has evolved. Now you can buy a "multicultural" pack of crayons, which, as the company says in its advertising, "meets the artistic needs of today's culturally diverse classrooms": six colors — Mahogany, Apricot, Burnt Sienna, Tan, Peach, Sepia — plus Black and White "for blending." And the crayons are advertised as "nontoxic." At least one can hope so.

CHAPTER FOUR

■

I plant my hands in the small garden—
I will grow green.

FOROUGH FARROKHAZAD, "Another Birth"

(trans. Hamid Dabashi)

MIXED
Greens

FIGURE 18: *The Green Path of Hope*

As a pigment, green is not a primary color. It can be made by mixing blue and yellow paint, so it fails the test. There are, however, other definitions of color primaries, which reflect different ways of mixing colors. Color televisions produce the range of visible colors by mixing red, green, and blue light; so in this sense green is primary. Color printers work still differently; they mix four "primary colors" — cyan, magenta, yellow, and black — to produce their color spectrum, so in this context green is not one.

But in a political sense, green has unquestionably become a primary color. It now shows up on the ballot in both primaries and general elections almost everywhere. At one time the color of nature itself, divided between the fresh greens of springtime and the moldy greens of decay, between bright emerald and dusky olive, between, as the French once said, *vert gai* and *vert perdu,* green is now the color of nature's defenders: Die Grünen (Austria), Groen (Belgium), GroenLinks (Netherlands), Federazione dei Verdi (Italy), Europe Écologie Les Verts (France), Miljøpartiet De Grønne (Norway), Strana Zelených (Czech Republic), Vihreä Liitto (Finland), Midori no Tō (Japan), Sarekat Hijau (Indonesia), Les Verts (Senegal), Ḫizb-al-Khodor (Egypt), or the Green Party (in almost every English-speaking country). Black, red, yellow, and white people (who are not of course actually black, red, yellow, or white) have all become green. They are rainbow warriors, like the name of Greenpeace's ship, dedicated to protecting the environment.

As a color on the spectrum, green is in the middle, halfway between red, orange, and yellow on one side and blue, indigo, and violet on the other. As a political party, Green is usually much further left of center. About 20 percent of people choose green as their favorite color; electorally it doesn't usually do quite as well.

In 2016, however, Alexander van der Bellen, former leader of his country's Green Party, was elected president of Austria, but for the most part

Green parties have been more effective in shaping policies than in achieving political majorities. Government investment, regulation, and construction have all gone green. Now there is green engineering, green building, green investment programs designed to have a positive environmental impact, insuring clean air and water, protecting the safety and the sustainability of our food supply, encouraging the development of renewable energy sources, eliminating toxic waste, and recycling materials to save finite natural resources. It used to be Martians who were green (at least since Edgar Rice Burroughs, best known as the creator of Tarzan, first described the "green men of mars" in his earliest science-fiction publication in 1912).[1] Today it is earthlings who are green, in their desire to save the planet.

It can hardly be a surprise that green has become the representative color for the environmental movement. It was seemingly inevitable, even though a green pond might be a worrying sign of the very problem the green movement is designed to alleviate. The English word "green," like the German *Grün*, derives from a proto-Indo-European root that means "grow"; the French *vert* and the Spanish *verde* come from a Latin root meaning "sprout" or "flourish." The etymological link of the color word with natural growth is similar in almost every language.

Although environmentalism might seem a largely noncontroversial, if urgent, commitment, it nonetheless has its critics. To some climate skeptics, it is green only on the outside and red within. The British political writer James Delingpole, for example, calls it a movement of "Watermelons," for whom the environment is merely a proxy issue for an attack on global capitalism.[2] But socialist and environmental parties have found that red and green can be as complementary in politics as they are as pigments, perhaps most notably in the alliance between the left-leaning Social Democrats and the mi-

nority Green Party that formed the government in Germany between September 1998 and September 2005.

It is, however, worth noting that green's domination of the imagery of a politicized environmentalism could easily have been otherwise. Our "green hopes" for the future could have as appropriately been "blue" ones. Two-thirds of the planet is covered by water, whose ability to sustain life is as ecologically critical as those plants that depend on it. The sky (often) appears to us as blue, and it is the medium through which the sun's energy is made available to those plants (which are green because the chlorophyll absorbs most of the electromagnetic energy in the blue and red portions of the spectrum). But reversing our angle of vision, the earth from space looks like a blue marble streaked with veins of other colors (Figure 19). Arthur C. Clarke, the great science-fiction writer, apparently once wondered, "How is it possible to call this planet 'Earth,' when clearly it is 'Ocean?'"[3]

Still, even if blue is the dominant color of the planet, the ecosystem offers a full palette of organic hues, from which we have selected green, the color of the vegetal, to stand for it all, and to carry our hopes for its survival. It is the color of sustainability. But just as easily it could have been blue.

Green, however, has become the color of our ecological concerns, although what is inevitable is only that green will also carry ideological associations other than environmentalism. There are lots of people "for whom green speaks," in Wallace Stevens's phrase, but for whom it speaks to different ends.[4] In the Iranian election of 2009, for example, green spoke for many — some thought for most — Iranians, though as a sign not of their environmental commitments but of their commitments to civil rights. It was the aspirational color of a grassroots coalition representing a variety of political interests and social aims in opposition to a government that was widely perceived as oppres-

FIGURE 19: *The "big blue marble": view of the Earth as seen by the Apollo 17 crew*

sive and corrupt.[5] This was the Green Movement (*Nehẓat-e Sabẓ*), as it came
to be known, consolidating a set of pluralist democratic values. Its support-
ers united behind the candidacy of Seyyed Mir Hossein Mousavi, a one-time
revolutionary hardliner turned reformer, who had emerged as the only serious
rival to the candidacy of the incumbent president, Mahmoud Ahmadinejad.

Both candidates declared victory following the election on June 12, 2009, but the electoral commission declared Ahmadinejad the official winner. The Iranian legislature quickly confirmed the result. Nevertheless, large public demonstrations protested the outcome, and an even larger association of reformist groups came together, giving voice to the newly articulate aspirations of a country that had long been traumatized both from without and within. In the aftermath of the election, the movement became known as the Green Path of Hope (*Rah-e Sabz-e Omid*). It used the vivid imagery of an explosion of highly saturated light green paint from an oval woven basket as a symbol of the burst of confidence and conviction that the political alliance at once represented and released (see Figure 18).

Green, as the Iranian Green Movement's founders certainly knew, has been historically associated with Muhammad. He was reputed to have worn both a green turban and a green cloak, and when he died, according to a traditional account, his body was covered with an embroidered green garment. It became the color of the Fatimid Caliphate, which ruled all of North Africa from the tenth almost to the end of the twelfth century, and green continues to be a marker of Shia Islam. The name and imagery of the Green Movement was no doubt intended in part as a link to this history, which Seyyed Mir Hossein Mousavi claimed by lineage. Indeed that is what Seyyed means: it is more a title than a name, asserting direct descent from the Prophet. The Green Path of Hope was a way of declaring that the Iranian Green Movement was neither heretical nor an anomaly but a legitimate democratic impulse finding its voice within the Islamic Republic.

It is impossible to miss the green that appears all through the Islamic world. It is noticeable almost everywhere, except of course in the desert landscape. It is on flags (for example, of Saudi Arabia, Iran, and Libya) and in mosques (as in the beautiful Great Mosque of Muhammed Ali in Cairo). Shias

often wear green wrist bracelets inscribed with verses from the Qur'an or green ribbons that have been wiped on holy shrines. It is also a prominent feature of the next world: the Qur'an says that the inhabitants of paradise will be "clothed in green silk" (76:21).

But the Green Movement in Iran was designed (in both senses of the word) to show what might grow in *this* world. A collection of Mousavi's writings is called *Nurturing the Seed of Hope,* and the movement's vibrant green represented a hopeful commitment to change and growth: the willingness to imagine an inclusive, democratic Iran that the party's pluralist, grassroots origins had prefigured.[6] The inescapable green imagery was neither selected by focus groups nor suggested by some sophisticated public relations firm. Rather, it was chosen by Mousavi's wife, Zahra Rahnavard, a distinguished artist and academic, and approved by Mousavi, who is himself an architect and an accomplished abstract painter. They both knew that color matters.

Sadly, however, the seed of hope seems to have needed a more hospitable environment in which to take root. The Green Path of Hope underestimated the willingness of the conservatives to use intimidation and terror in the face of a significant challenge to its authority. In 2011, Mousavi and his wife were placed under house arrest, where they remain today, suggesting both the success and the failure of the movement. In Iran it isn't easy being green, and it is hard to feel at all confident that it will get easier any time soon. But the seeds remain buried in the native soil, and maybe one day they will sprout.

Politics gets color-coded for obvious enough reasons. Color is instantly identifiable, highly memorable, and readily adaptable for any of the various forms and contexts in which it may be displayed. Its main disadvantage for political imagery is precisely its "vivacious versatility," in Lord Byron's words, "what is call'd mobility."[7] And that is its main advantage, too. It perhaps seems inevitable for any of the ecologically driven green parties,

but it was also available with an unrelated associative logic to express and animate the idealistic oppositional politics of the Iranian Green Movement. And on other grounds, or maybe none, it is capable of representing still different principles of solidarity—for the Panhellenic Socialist Movement of Greece, the Taiwan independence movement, the African National Congress in South Africa, and the government of the Chechen Republic in exile.

Political color is promiscuous; or, maybe better, it functions like some visible "free radical," which you may remember from high school chemistry: those molecules with an unpaired electron that enables them easily to attach themselves to other atomic structures with similarly unpaired electrons. Free radicals attach themselves with no difficulty, but, as chemists tell us, the attachments are inherently transient and unstable.

Just how unstable political color can be may be seen in the vocabulary of "red states" and "blue states" used in the United States to refer to those with either Republican or Democratic majorities. That usage now is inevitable; it seems to be an immutable fact of American political history, probably dating from the Revolution, or least the Civil War. Yet it originated only in 2000, in the disputed election between George W. Bush and Al Gore. Before that time the terms don't exist. There was of course color coding in political campaigns, but both major parties used the full panoply of American red, white, and blue to identify themselves.[8]

With the widespread availability of color television in the late 1960s, color-coded electoral maps had become a feature of the coverage of presidential election returns; but that was for differentiation, and nothing had been standardized. Neither red nor blue had yet taken sides. In Cold War America, permanently identifying one party as "red" would have been impossible without being accused of bias, so in different elections and on different networks, red and blue were variously assigned to Democrats and Republicans. For ex-

ample, on NBC in 1980, when the Republican Ronald Reagan soundly defeated the Democrat Jimmy Carter, carrying forty-four of the fifty states, one television commentator pointed to his color-coded studio map showing the massive Republican victory and said it looked like "a suburban swimming pool." On another station, the reporter commented on the "ocean of blue" that was appearing on the map as the vote count was reported, while Republican staffers watching the returns on television gleefully referred to what in another context might have been called a landslide as "Lake Reagan."[9]

Yet in the aftermath of the 2000 election no Republican victory of whatever size would ever again be described using blue imagery.

After the election, every night for thirty-six days the country anxiously followed the television coverage of recounts and court challenges before Florida finally became a "red state" and Bush became the forty-third American president. A new political imagery of red for Republicans and blue for Democrats was now fixed in the national imagination. What was once arbitrary and variable became a seemingly natural and permanent feature of political discourse in the United States — and so decisively so that now at times the name of the increasingly polarized country begins to sound ironic.

This accidental color-coding of American politics reverses the associations of red and blue that exist almost everywhere else in the world. In most countries, blue is the color of the more conservative parties (as with the Conservative Party in the United Kingdom), and red of the more liberal (as with the British Labour Party). Red has historical identifications with workers' movements and socialist and communist parties. The *bonnet rouge,* the soft red cap worn by the French revolutionaries after 1790, expressed both their fervor and their solidarity, but red had not yet invariably become the color of the left in France. Indeed, in July 1791 it was still the color of established authority. The imposition of martial law was announced by the raising of a red

flag, and fifty protesters demanding the abdication of King Louis XVI were killed in the subsequent fighting. Only then did the radicals claim the color red for themselves, appropriating its authoritarian symbolism for the color of their opposition, reversing the terms and the imagery of French politics, as they asserted "the martial law of the people against the revolt of the court."[10]

Red is a hot color. It is easily seen as the color of defiance. In your face, bold, and resolute. In France in 1848, the radicals adopted a red flag instead of the blue, white, and red tricolor (which seemed in its color imagery too agreeably accommodationist), as they did again in the spring of 1871, when they briefly controlled Paris, setting their red flag over the Hôtel de Ville. "The old order writhed in convulsions of rage at the sight of the red flag," wrote Karl Marx in 1871.[11] And the assertive red flag would become still more visible in the twentieth century in the triumphal emblems of postrevolutionary Russia and of Mao's China: the solid red flags (with a red star outlined in gold and a golden hammer and sickle in the upper left corner of the Soviet flag, and with a golden star inside an arc of four smaller stars in the upper left corner of the flag of the People's Republic of China). But the red wasn't limited to flags. There were waving red banners, large Red Armies, and the Little Red Book — all contributing in the United States to the Red Scare, as Americans through the twentieth century worried about the threat of communism.

But for all the undeniable forcefulness of red as a political color, it is a color often tinged with mourning. It registers the blood spilled by its martyrs, and it functions to keep the memory of their sacrifices alive. In 1889, in Ireland, the red flag had become the symbol of the Irish Republican Socialist Party. James Connolly, who would be executed by the British after the Easter Rebellion in 1916, wrote the lyrics to a song that became their unofficial anthem and that has been traditionally sung at the conclusion of British Labour Party conferences:

> The people's flag is deepest red;
> It shrouded oft our martyred dead,
> And ere their limbs grew stiff and cold,
> Their hearts' blood dyed its every fold.

The embrace of red as a political color almost always is driven in part by this commemorative impulse, although just how appropriate the song remains now for the British Labour Party is open to question. Indeed as early as the late 1960s, as the party first began to downplay its leftist origins, beginning inexorably to move toward the center in a bid for electoral victories, a scornful parody of Connolly's song emerged:

> The people's flag is palest pink;
> It's not as red as most think.
> We must not let the people know
> What socialists thought long ago.

Perhaps if "the people's flag" had really been pink, the conservative color would have been periwinkle. But the people's flag was red, and the oppositional color is inevitably a darker blue (two newly named shades that might well appeal to canny political consultants are Liberty Blue and Resolution Blue). Nevertheless, in whatever shade, the conservative use of the color almost always exists in relation to a politically charged red. In Taiwan, for example, blue (usually in a circular emblem of a blue sky with a white sun in the center) is the color of the dominant party, Kuomintang (KMT). The party was founded on the Chinese mainland by Sun Yat-sen and Song Jiaoren in 1911 after the Xinhai Revolution, which overthrew the last of the imperial dynasties (the Qing), and KMT was the ruling party in China from 1928 to 1949. In 1949, the Communist Party (the Red Chinese, as they were known in the Cold War West) finally won a drawn-out civil war and drove the KMT to the island

of Taiwan. On Taiwan the KMT ruled as the lone political party until reforms in the late 1980s produced a more democratic political environment, though one in which KMT leaders continue to wield great power as part of what is known as the pan-Blue coalition.

In various countries, blue faces off against red, replaying social and political divides that first took their ideological outlines and their primary colors in the French Revolution. Once the French radicals had appropriated the color red for their cause, blue became the inevitable color of the aristocracy, not least because white, the third of the traditional colors in the French political spectrum, can seem for obvious reasons defeatist (though some did adopt it for a while). Waving the white flag hardly seems an effective way to rally your troops. But blue was already the traditional color of French monarchical power. It was the color worn by the elite French guards attached to the royal family and the color of the monarchy itself, from the coronation of Charlemagne to the crests of the Valois and Bourbon kings.

Political color associations always have histories, but there are so many histories and so few basic colors that the associations of color and politics are inevitably unpredictable, arbitrary, contradictory, and insecure. Red may indeed be the people's color, the color of a radical left, the color of bloody sacrifice; but it was also, for example, the color of Tudor royal authority, expressing monarchical presence, prestige, and, above all, power. For his coronation, Henry VIII wore a shirt of crimson silk, a mantle of crimson satin edged in fur, tassels "also in crimson," as the royal account book says, a cap of crimson trimmed with ermine and gold, and an outer coat of crimson satin, as well as his crimson parliamentary robes.[12] The king's crimson was hardly the color of a people's revolution.

Similarly, blue may be the traditional color of the French monarchy, but it is also the color of many left-leaning populist political parties, from

the Democratic Alliance in South Africa, once the antiapartheid Progressive Party and now a nonracial, center-left oppositional party, to the nationalist and separatist, prolabor Parti Québécois in Canada. We know that blue blood and blue collar point in opposite political directions.

There are other colors that code political movements. Both Belgium and the Netherlands have had purple governments, ruling coalitions of red Social Democrats and blue Liberals. Brown has been the color of fascism, though, somewhat confusingly, black is the color of the Greek fascist party called Golden Dawn. In 1986 in the Philippines, a Yellow Revolution drove Ferdinand Marcos from power by massive popular protests, during which yellow flags and ribbons served as the sign of solidarity.

A series of similar nonviolent popular political events in some of the republics of the former Soviet Union have come to be known by political scientists as the Color Revolutions.[13] The so-called Orange Revolution in Ukraine was perhaps the most significant of these. In 2004 in Ukraine, the Oranges (Pomaranchevi) comprised the successful popular protest movement, which adopted the campaign colors of Viktor Yushchenko's Our Ukraine party to protest electoral fraud and government corruption and inefficiency, and successfully forced the delegitimation of a rigged election. A new vote was held in which Yushchenko was declared the winner, and he served as president until 2010. But in hindsight, it isn't so clear that "Color Revolution" was the right term for what had taken place in Ukraine. Certainly it was color-coded, but the "revolution" part now seems more wishful than real.

Nonetheless its orange remains free to be taken up by political movements of very different casts. In India now it is often the color of an aggressive Hindu nationalism (Figure 20). While in Northern Ireland and in the twenty-six traditional counties that now make up the Republic of Ireland, orange is the color of Protestants and Unionists (that is, those who want Ireland to be part of the United Kingdom). Its use as a political color there dates

from the late seventeenth and eighteenth centuries, as an expression of loyalty to William III, who became king of England and Ireland after the Glorious Revolution of 1688 and the deposition of King James II, the last Catholic monarch to wear the crown.

King William, the husband of James's daughter Mary, was a Dutchman and a Protestant. He was also the prince of Orange of the House of Orange-Nassau. The Orange of the dynastic title comes, however, as we saw in Chapter 2, not from the color but from a town in Provence, though unsurprisingly the color soon became attached to the family name—and in Ireland it became attached to a cause. To be an Orangeman in this context is to be a Protestant and to be loyal to the British crown.

FIGURE 20: *Supporters of Gujarat's chief minister and Hindu nationalist Narendra Modi, in the western Indian city of Ahmedabad.* Independent, *February 26, 2014.*

Orange is usually no more stable in its political associations than blue or red or any other political color imagery, though in Ireland orange has proven stubbornly enduring. If in Ukraine orange is already now a distant memory, in Ireland it is one that will not fade. In any other context, one might say it is a memory that is still "green," as Shakespeare says of Claudius's memory of his murdered brother (*Hamlet*, 1.2.2). It similarly remains fresh in Irish minds and hearts, whether their eyes are smiling or not.

But green is the one thing in Ireland orange can never be, though each inevitably suggests the other. Green is the contrasting color in the Irish political spectrum. It might be thought a reference to the verdant landscape of the so-called Emerald Isle, but it is also the color of a fierce nationalism formed in opposition to the Unionist and Protestant orange. "For centuries the green flag of Ireland was a thing accursed and hated by the English garrison in Ireland, as it is still in their inmost hearts," proudly said James Connolly in 1916, as he looked forward to the day that "the green flag of Ireland will be solemnly hoisted over Liberty Hall as a symbol of our faith in freedom, and as a token to all the world that the working class of Dublin stands for the cause of Ireland, and the cause of Ireland is the cause of a separate and distinct nationality."[14]

It stands also for the related cause of a separate and distinct *religion*—a Catholicism, which had become green because supposedly sometime in the fifth century Saint Patrick had used a three-leafed shamrock to teach the indigenous Irish about the Trinity. In Ireland the "wearing of the green" was never just an innocent way to celebrate Saint Patrick's Day but was always an assertion of national pride, as well as sometimes a provocation to sectarian violence. As the old ballad, written sometime after the failed Irish rebellion of 1798, has it: "They're hanging men and women for the wearing of the green."

Color theory often insists that green and red are opponent colors.[15] Irish history, however, tells us that the opponents are green and orange. In Ireland they represent the separate but forever interrelated histories of the Prot-

FIGURE 21: *The flag of the Republic of Ireland*

estant and Catholic communities on the often-troubled island. They are colors that, at least until very recently, always clash. They cannot be merely matters of aesthetic preference or color theory. They express partisan religious and nationalistic commitments, though the religious and the nationalistic do not always perfectly align. Protestants can be nationalists, and Catholics can be unionists. But usually orange is the old orange and green the old green.

Although each has now become the recognizable symbol of a political party eager to achieve power with ballots instead of bullets, the colors still represent an almost tribal set of loyalties and hatreds. The national flag of the Republic of Ireland is a tricolor of green, white, and orange: the green represents the Catholic population, the orange signifies the Protestant, and the central band of white expresses the hope that the two communities can live together in peace (Figure 21).

Visually, the central band of white serves to keep the sections of orange and green apart. Politically, that had always been a good idea. It was mainly the separation of orange and green sectarians that kept the peace between the two communities. Josef Albers, however, taught generations of art students about the inevitable interactions of color and the fallibility of our perceptions.[16] Colors are transformed by the colors around them, undoing our preexisting certainty about both what colors are and what they mean. This happens everywhere that we see color—sometimes even in Ireland.

CHAPTER FIVE

Reno Dakota
There's not an iota
Of kindness in you.
You know you enthrall me
And yet you don't call me;
It's making me blue:
Pantone two-ninety-two.

THE MAGNETIC FIELDS, "Reno Dakota"

MOODY
Blues

Colors have long been linked with human emotions. The connection existed long before Donovan's "Mellow Yellow" in 1966. In 1841, James Fenimore Cooper's *Deerslayer* imagined "red-skins" who could turn "green with envy," which is an idiom in various languages—although envious Hungarians apparently turn yellow, while those who "turn green" are angry, not unlike the Incredible Hulk.[1]

More commonly, angry people "see red," as bulls are supposedly roused to anger (but in fact it is not the color but the waving of the matador's cape, to say nothing of the barbed darts stuck in the bull's shoulders, that produces the animal's response). In Britain, though, if you are merely annoyed, you can be "browned off," an expression whose roots can be traced back to the late fifteenth century, when to be "in a brown study" meant to be pessimistic or discouraged.

It is mainly only delighted English speakers who get "tickled pink," although other familiar color phrases are widely shared across languages, usually because they are tied to observable physiological reactions. Faces sometimes turn "purple with anger" or "white with fear"; we become "red in the face" when we blush with embarrassment or heat up in rage but "blue in the face" when we are unsuccessful in convincing someone of something we care about.

Cowards, more metaphorically, show a "yellow streak," which seems inevitably to run down someone's back (except in the case of "yellow-bellies"). Optimistic people have "rosy" temperaments, while moods can also be "black," both taking their color from the medieval theory of human

FIGURE 22: *Derek Jarman in front of a screen showing* Blue *during the final mix, De Lane Lea Studios, London, 1993*

physiology in which an excess of black bile was thought to be responsible for melancholy temperaments, just as red blood dominated in those who are what we now think of as "sanguine."

Emotions obviously have their own rainbow, but of the many colors of its spectrum, blue is predominant. It has become what William Gass called "the color of interior life."[2] Bob Dylan got "Tangled Up in Blue," as well he might, given the extraordinary range of emotions and values that get associated with the color. In English, blue is both titillating (blue movies) and puritanical (blue laws); out of control (talk a blue streak) and purposefully restrained (blue penciled); startling (a bolt from the blue) and reassuring (true blue); sometimes intimidating (blue blood) though at other times condescending (blue collar); it can be joyful (my blue heaven) and gratifying (blue ribbons), and yet, as often as not, disappointed and frustrated (blue balls).

Above all, blue is sad, forlorn, depressed, and melancholic, though this bit of color-coding seems to have been made initially by Europeans.

Since the late fourteenth century, blue has been the color of dejection or despair. Most likely the connection is based upon some obscurely sensed analogy with what is medically known as cyanosis (*cyan* comes from the Greek word for blue): that is, the recognizably blue discoloration of the skin in the absence of adequately oxygenated blood. A "blue baby" is not a boy (and boys, in any case, weren't inevitably dressed in blue until the 1940s); rather, it is a newborn of either sex suffering from a potentially fatal heart condition.

In Chaucer's "Complaint of Mars," forsaken lovers with "wounded" hearts cry "blue tears," and almost five hundred years later, George Eliot in *Felix Holt* still would describe a skilled card shark as someone who "can make a man look pretty blue" after his wallet has been emptied. Occasional bouts of melancholy were often characterized as "blue devils," as in Herman Mel-

ville's "Merry Ditty of the Sad Man": "There's nothing like singing / When the blue devils throng."[3]

People have blue moods and fall into blue funks, the latter becoming colored mainly from the use of the phrase in *Tom Brown's School Days* in 1857.[4] But blue had already come to seem so inevitable in its connection to various intensities of unhappiness that it could retire as an adjective and be reborn as a noun, no longer an attribute of a feeling but the feeling itself. It became *what* you feel, not how. You were no longer in a blue mood; you were just blue.

Artists seemed unusually susceptible to it. In 1741, the English actor David Garrick admitted to his son that he was "far from being quite well," while still insisting that he was not yet "troubled with the blues"; though in 1827, the American painter and naturalist John James Audubon was willing to admit to his wife that he actually "had the blues," as he wrote while he was in Great Britain arranging for the printing of his magisterial *Birds of America*.[5]

But neither ever *sang* the blues, which only became a musical genre in the late nineteenth century in the rural American South. Invented by African Americans, the ex-slaves and sons and daughters of former slaves, the blues mixed work chants, folk songs, and spirituals to produce a music of loss and of longing. It's the other side of the coin of the joyful noise of gospel music. In 1908, an Italian American, Antonio Maggio, published a ragtime piano tune called "I Got the Blues," the first printed song with "Blues" in the title, but the first real blues songs to be published were Hart Wand's "Dallas Blues" and W. C. Handy's "Memphis Blues" in 1912, though people had been singing the blues — well, probably forever.[6] What marked these new blues songs was what musicians called "blue notes," those uncanny microtonal slides and bends that make the music resemble a human voice, though often expressing emotions too subtle for mere words.

The sounds of the blues spread from the fields and levees of the Deep

South to the cities of America — to Beale Street in Memphis to Bourbon Street in New Orleans and north to Rush Street in Chicago. And then the blues crossed racial boundaries, became both electrified and gentrified, but even then the blues still were "nothing but a good man feeling bad," as an old blues song had put it. The playwright August Wilson claimed in 1997 that he had once written the world's shortest short story, called "The Best Blues Singer in the World": "The streets that Balboa walked were his own private ocean and he was drowning."[7] That's the story. And that's the blues.

Pablo Picasso *painted* the blues. The works of his so-called Blue Period (1901–4) are somber, largely monochromatic paintings in gloomy shades of grayish blue. In the painting usually now known as *The Tragedy*, three bare-footed figures, seemingly a family dressed in rags, shiver at the water's edge (Figure 23). The man and the woman each stand with their arms crossed against the cold. The young boy reaches out with his right hand to touch the man's leg, but rather than a gesture of comfort and connection, it seems more like that of the man in Picasso's *Blind Man's Meal*, cautiously feeling for the wine jug, unable to see where it is on the table. In *The Tragedy*, the man and woman look down; the boy seems to be staring, if indeed his eyes can see at all, somewhere past the woman's right hip. Although the three figures stand together, they seem lost in themselves, isolated by and in the unnamed tragedy of the title.

The painting registers rather than represents a tragedy. There are no clues here to what has happened. Picasso just paints the sadness. Jaime Sabartés, an artist himself and one of Picasso's close friends, said that Picasso's

FIGURE 23: *Pablo Picasso,* The Tragedy, *Chester Dale Collection, National Gallery of Art, Washington, 1903*

greatness came from being "able to give form to a sigh."[8] He does it here with color. Blue. A blue sigh that is thin, empty, and cold.

Much later, Picasso would say "I started painting in blue" after hearing of a friend's suicide in Paris in the winter of 1901.[9] The claim neatly fits the chronology — Carlos Casagemas shot himself on February 17 of that year. But it doesn't quite fit the facts. For his first Paris show (with the Basque artist Francisco Iturrino) at Ambroise Vollard's gallery in the summer of 1901, Picasso showed loosely painted, often stridently colored canvases, most of which were produced in a flurry of creativity in the weeks before the opening. Like the extraordinary *La Nana*, these paintings ambitiously reconfigured the world of Edgar Degas and Henri de Toulouse-Lautrec. In the self-portrait (*Yo, Picasso*), with its confidant stare and splashes of vivid orange, the nineteen-year-old Picasso announced (both in Spanish and in paint) that there was a new sheriff in town.

Soon, however, for whatever reason, his palette changed. The blues came to dominate both the pigments of his canvases as well as own emotional state, reflecting his growing depression, and no doubt adding to it, since these new paintings did not sell as well as had the ones he had shown at Vollard's, with their more chromatically adventurous palette. When several of the muted blue paintings appeared in a group show in Paris in November 1902, the catalog described them as "cameos showing painful reality, dedicated to misery, loneliness and exhaustion."[10]

Accurate enough, but hardly an inducement to sales. Picasso continued to give form to his sighs in various cool shades of blue, but not everyone was moved. In 1905, an influential French critic, Charles Morice, acknowledged Picasso's "extraordinary gifts" but found the sentiment of his paintings not just visually uninviting but emotionally false. He disapproved of how

these early works seemed to "revel in the sadness" they depicted "without feeling it."[11] Morice saw Picasso as a mere sentimentalist, what Oscar Wilde had once defined as "one who desires to have the luxury of an emotion without paying for it."[12] For Morice and some others, Picasso's Blue Period paintings seemed the work of an immensely talented young artist but one who was indulging himself. Perhaps he was, like all sentimentalists, too willing to congratulate himself on his capacity to feel (and too eager to flatter his viewers' sense of their own) rather than engaging and prompting genuine emotions.

But now that just seems wrong. Possibly misled by Picasso's technical virtuosity, it took time for critics to recognize that the paintings did originate deep within a realm of felt grief. Or perhaps it only took time to get past the age's discomfort with feeling itself—to resist what seemed the shame of sentimentality. Later Wyndham Lewis would sneer at these Blue Period paintings as Picasso's "fit of particularly sentimental blues" (a "fit," which, for many art historians, would eventually be justified for having led Picasso back to Cézanne's own "blue" period and setting him on the road to cubism).[13] But sentimental or not, these paintings now can be seen as a legitimate form of the blues, unsparingly confronting us with his portraits of nameless Balboas drowning in their own privates oceans of sorrow and grief.

But blue isn't all about the blues. There are those blues that relieve that desolation, or that at least permit us to forget it for a while. There is a wonderful Miles Davis album from 1959 called *Kind of Blue,* and whatever kind it is, it is probably the best jazz album ever recorded. Nabokov loved the "blues," although those blues are small butterflies (*Lycaenidae:* subfamily *Polyommatinae*), many of which are actually brown. And, of course, there are the many shades of blue that reliably delight, comfort, and reassure, not just as some alternative to the blues that express our inevitable sorrows but as an

assertive indication of their limits—that they have limits. "The grief is quarantined," says the Nobel Prize–winning poet Wislawa Szymborska, "The sky is blue above."[14]

Blue is ambiguous; all colors are. The "something blue" that brides often wear as an accessory, along with something old, new, and borrowed, is not of course a sign of sadness (though divorce rates might suggest it could usefully serve as a warning of the possibility) but rather of fidelity. This tradition seems to be a bit of Victorian sentimentality, appearing in print first in 1883; yet the idea of blue as something "true" is at least two hundred years older than that.

"True blue" begins to appear as a proverbial phrase in England in the seventeenth century. John Ray's *Collection of English Proverbs,* published in 1678, lists "He's true blue, he'll never stain," which is explained: "Coventry [a city in the English Midlands] formerly had a reputation for dyeing blues; insomuch that *true blue* became a Proverb to signify one that was always the same."[15] Coventry blue stayed blue. Like true love, it did not fade. Or at least it didn't *quickly* fade, unlike so many other dyes. But true blue is often misremembered, just as true love often is. Both get imagined as more intense and vivid than they were in fact. True blue inevitably becomes "too blue," as Brian Massumi says.[16] True love? Well, we can dream.

The positive valence of blue is, however, always potentially there to be enjoyed. The great nineteenth-century critic John Ruskin said that it was a color "appointed by the deity to be a source of delight."[17] Joan Miró made a painting in 1925 with a splash of bright blue on the right of the canvas, beneath which he has written: *Ceci est la couleur de mes rêves* (This is the color of my dreams). But blue may even be more than delight and more than a dream: it can be the very color of transcendence. In Exodus 24:10, Moses, Aaron, and the elders ascend Sinai and see clear blue sapphire beneath God's feet, a

wondrous intensification of the blue sky above them. Vishnu's blue skin, the healing power of the blue Buddha, the blue turbans worn by many Sikhs, the blue stripes of the Jewish prayer shawl, and the glorious Blue Mosque in Istanbul all suggest how nearly universal is this connection with transcendence. It awakens in us "a desire for the pure, and, finally, for the supernatural," said the often mystical Kandinsky.[18] But the feeling is also validated by the colder logic of color theory. "We love to contemplate blue," Johann Wolfgang von Goethe recognized in 1810 in his work on color perception, but "not because it advances to us, but because it draws us after it."[19]

The sumptuous blues in Giotto's frescos in the Scrovegni Chapel in Padua and, on a much smaller scale, in the right panel of the Wilton Diptych (c. 1395–99), showing the blue-robed Virgin with Child surrounded by eleven blue-robed angels, demonstrate the effect (Figure 24). Each has a recognizable narrative and depends upon a well-known iconography, but whatever the story, each is essentially *about* the magnificent blue that "draws us after it." The color in each overpowers not only the narrative but also the form. In the Giotto frescoes the brilliant, undifferentiated blue is what painters and visual psychologists would call a "ground," while the somewhat more modulated blues in the Wilton Diptych color and model the figures; but in both the blue itself becomes the story. What is most important is what the philosopher Julia Kristeva has called its "chromatic joy."[20]

The blue in both is a pigment made from ground lapis lazuli, a semiprecious stone first found in what is now Afghanistan. The intense pigment came to be known as ultramarine, because it came from "beyond the sea" (which is what "ultramarine" literally means). Cennino Cennini, an early fifteenth-century painter living in Florence, calls it the color "most perfect, beyond all other colors; one could not say anything about it, or do anything with it, that its quality would not still surpass."[21] Titian, famous for his ex-

FIGURE 24: *Giotto, Scrovegni Chapel, Padua, c. 1305*

traordinary reds, also knew the perfection of this blue, as in the brilliant ultra-marine sky of his *Bacchus and Ariadne* (1520–23).

Ultramarine wasn't only a luxurious color; it was the most expensive pigment any painter had ever used, more expensive even than gold. (Not until 1826, when a synthetic version was developed in Paris, did it become widely affordable for painters.) In one sense, then, it is clear why the costly ultra-marine would be used to decorate a private chapel for a noble family or paint the Virgin Mary. Nothing could be more appropriate.

But there is something paradoxical here. This runs counter to the underlying spiritual economics that fundamentally define Christianity. It teaches that great riches come to naught (Rev. 18:17). As Peter Stallybrass has brilliantly observed, Christianity insists upon the transformation of the materially *valueless* into the spiritually *priceless*.[22] The pregnant wife of a poor carpenter turns out to be a virgin and the mother of God. The helpless infant born in a dirty manger is Christ.

The expensive pigment, however, aligns the material and the spiri-tual. It is the sign of the very worldliness that Christianity would challenge and replace. And yet the intense blue compels the eye, woos us from the world. It pulls us toward the infinite.

It is the color that does this, rather than the subject matter. In the twentieth century, Yves Klein would make that color his subject. Klein's own Blue Period made up the last half of his short, intense career.[23] He explored — and exploited, for that is what he also, always, did — the quality of the blue that excites and inspires. A series of early "Monochrome Propositions" in various bright colors gave way to paintings almost all in a rich ultramarine, a color "darkly, deeply, beautifully blue," in the words of the romantic poet Robert Southey.[24] This became not just Klein's signature color but a color that bears his name: International Klein Blue. Though it is often said that he

patented the color, what was actually patented (and not by Klein but by a French pharmaceutical company he worked with) is the polyvinyl acetate binder that contains the pigment. In William Gibson's novel *Zero History,* the marketing magnate Hubertus Bigend wears a suit of the brilliant color. "Is that Klein blue?" an employee asks, "it looks radioactive." Bigend coolly replies, "It unsettles people."[25]

In Klein's art, however, the color does something different: it seduces people. It isn't radioactive; it is radiant. International Klein Blue is a color that it is vibrant and voluptuous, ravishing and irresistible. Klein was an often self-regarding showman (think about, for example, his release of 1,001 blue balloons into the air as "aerostatic sculpture" in 1955 or, three years later at an opening, serving the guests a blue cocktail of Cointreau, gin, and a blue dye that for several days colored everyone's urine blue), but he nonetheless made gorgeous minimalist paintings. He confirms Kazimir Malevich's axiom: "Only dull and impotent artists screen their work with sincerity."[26] Klein made paintings of pure color, with the emphasis as much on the adjective "pure" as the noun. Paintings of a blue at its maximum intensity, a blue not unlike Giotto's blue or that of the Wilton Diptych, which functions as a material register of the immaterial.

Klein did not invent the monochrome (though, as with so many artists of the 1950s, he had a willed amnesia about what had come before). Credit for that should probably be given to the Russian constructivist Aleksandr Rodchenko, whose black paintings in 1918 and whose three "Pure Color" paintings in 1921 isolate a pigment. But for Rodchenko, there was no interest in transcendence; indeed his Pure Color paintings are designed to expose it as a fantasy. "I reduced painting to its logical conclusion and exhibited three canvases: red, blue, yellow. I affirmed it is all over. Basic colors. Every plane is a plane and there is no more representation." This was "the end of paint-

FIGURE 25: *Yves Klein during the filming of* The Heartbeat of France, *with hand-painted International Klein Blue, Düsseldorf, 1961–62*

ing" in both of the senses of how he used that phrase.[27] This was the complete realization of painting's telos as he understood it: the logical end point of the drive to understand what painting essentially was about. Here was painting freed from its mystifications, stripped down to its essentials, color and plane. But this was also chronologically the end of his career as a painter. After completing these paintings, he never again painted on canvas, turning to various forms of applied art.

For Klein, however, there always was more (more mystification, anyway, though not much more of his life; he died at thirty-four, after his third

heart attack). Paint was for him the portal to the infinite—at least to the infinite of his ambitions. "The blue sky," he would say, "was my first monochrome," and as a teenager he pretended to sign it. He even claimed that he hated birds "because they tried to bore holes in my greatest and most beautiful work."[28] Yet his blue on the canvas was even more lustrous and intense than the sky. It was a color we had only previously seen in dreams.

Picasso's thin blues are melancholy, almost despairing; Klein's robust ones are exuberant, almost ecstatic. From opposite directions, however, each artist comes dangerously close to something merely melodramatic and sentimental in his simplifications—and the extraordinary achievement of each largely rests on the narrowness of the escape.

Exactly as it does for Derek Jarman, the third of the twentieth century's great visual blues artists. Jarman, a British painter, poet, and filmmaker, tested positive for HIV at the end of 1986; he died of AIDS in 1994. His last film was *Blue*. It is a masterpiece.

It is not, however, an easy one to watch. In part it is because there are no images, just seventy-nine minutes of an unchanging deep blue screen. While you can look away without missing anything, you just can't look away. The blue compels your vision, and its soundtrack threatens to break your heart. *Blue* is not exactly a motion picture, but it is unquestionably a moving one.

The blue is International Klein Blue. Initially, Jarman had merely filmed one of the Klein paintings in the Tate Gallery, but he didn't like the look of the blue when it was projected on screen. As Jarman's movie reached its final production stage, Technicolor recreated the color in the laboratory.[29] The luminous field of blue suggests at once the infinite and a void. Everything and nothing. The soundtrack of the movie is a montage of words, music, and sound effects. There is no narrative, but there is a history: the history of a man

going blind; the history of a man, not living with AIDS, but, as Jarman knew, dying from it.

The soundtrack is a collection of fragments, appropriate for a body that has fallen apart. Memories: "sitting with some friends at this café," "walking along the beach in a howling gale," "at home with the blinds drawn," and mostly, and most unbearably, "in the hospital." Scraps of poems; remembered (or forgotten) quotations; diary entries; bits of philosophical musing; and the hint of a story of a boy whose name is Blue, which ends, as everything does, in death: "I place a delphinium, Blue, on your grave."[30] These are fragments that Jarman has shored against his ruin.

All that is whole is the glowing blue image on the screen (see Figure 22).

There is a soundscape of noises: words, music, chimes, waves, drips, heartbeats, all measuring the time that is running out, ticking "out the seconds, the source of a stream along which the minutes flow, to join the river of hours, the sea of years, and the timeless ocean." Into the blue, the blue that exists with "no boundaries or solutions." Different voices—Nigel Terry's, John Quentin's, Tilda Swinton's, and Jarman's own—tell Jarman's story, which is not only his own. "I hear the voices of dead friends," and he speaks for them. "I have no friends now who are not dead or dying." The truth is: none of us does.

But this is not despair. In one sense, Jarman's *Blue* can be seen as an elegy for himself, something like John Donne's *Death's Duel*, the poet's own "funeral" sermon that he preached at Whitehall shortly before he died in 1631. Jarman's film is, however, a sermon without faith—or with faith, but faith only in love and in art. And that might well be faith enough. But *Blue* also is a love story with a happy ending: "Deep love drifting on the tide forever."

It is an impossible film; it is an irresistible film. An imageless art film

about a gay artist dying, which is maybe unwatchable but also unforgettable. The paradoxes of blue itself: Picasso's blue and Yves Klein's, "the black blue of sadness" and "the fathomless blue of Bliss."

At the end, Jarman lived Picasso's blue but embraced Klein's — that deeply saturated blue that promises everything, although perhaps provides nothing but the promise. His interest in Klein had begun long before Jarman had been diagnosed with AIDS. In the spring of 1974 he had seen Klein's paintings in a show at the Tate, and enchanted by those luxurious blues, he began to think about "a blue film for Yves Klein," a film originally to be called *Bliss*.[31]

It would take another thirteen years, when Jarman's eyesight began to fail, before he would again think seriously about the project. "Blue flashes in my eye": the symptoms of the failing body; the symbols of "an open door to soul." Always the paradox. That's how it goes: "out of the blue" and "into the wild blue yonder." As Jarman said: "Blue transcends the solemn geography of human limits."

Bliss, now tentatively retitled *International Blue,* was still imagined as "the Yves Klein story in sound and jazzy be-bop" set against an unchanging blue screen, though Jarman realized that this might well make the film impossible to fund. But ironically, by the time Jarman was ready to make the film, late in 1992, the concept of an imageless screen permitted BBC Radio 3 to provide some of the needed money for the project. Now, however, it had become Jarman's own story, not Klein's. *Blue* was first shown at the Venice Biennale in June 1993 and released in London that September. On September 19, 1993, it was simulcast on BBC's Channel 4 and on Radio 3. Radio 3 listeners were invited to send in for a large International Klein Blue postcard to look at during the broadcast.[32]

Jarman thought of Klein as "the great master of blue."[33] Certainly

that is more nearly true of Klein than of Picasso, who ultimately came to care more about line than about color (that, after all, is the commitment of cubism). Klein, like Jarman, thought line to be a prison. Yet too often Klein seems either a romantic or a fraud (you can't be both). Jarman is neither. Jarman, it turns out, really is the great master of blue. "The blood of sensibility is blue," he wrote. "I consecrate myself / To find its most perfect expression." In the film it seems he has succeeded, though it is so very hard to look.

CHAPTER SIX

◾

Indigo. Indigoing. Indigone.

TOM ROBBINS, Jitterbug Perfume

DY(E)ING FOR
Indigo

Has anyone ever actually seen the color indigo? While it is impossible to know the exact colors that people see, remarkably (and yet it seems almost never to be remarked), no one, at least in English, seems to have used "indigo" as a word naming a specific color before Newton did. But Newton was convinced that the light that his prism had shattered into individual shards of color had to contain seven pure colors. So he added orange and indigo to the five he thought were "original."[1] The first took its name from a fruit (see Chapter 2), the second from a dye. Other people had already come to see the first one (or, more precisely, to see it as "orange"); people still aren't so sure about the second. But Newton saw it, or claimed he did, and he called it "Indigo" or, as he sometimes spelled it, "Indico." And the word has come to name a color that no one is really sure is there to be seen.

But the real issue may be not whether indigo actually appears in the visible spectrum. It is whether indigo is a color at all. For almost everyone, it wasn't. At least it wasn't until about 1672, when Newton decided it was. Only then did it become one of "the dyes of heaven," in Sir Walter Scott's fine phrase for the colors of the rainbow.[2] Before then, however, indigo was just a dye, and a dye not of heaven at all but one very much of the earth — or worse, as some would come to think, of hell. And even after Newton "saw" it as a color, it stubbornly remained a dye. "Every body does, or should know," as Philip Miller wrote in the eighteenth century, "that Indigo is a Dye used to dye Wool, Silk, Cloths, and stuffs, blue."[3]

Technically, a dye is a coloring agent that bonds with the molecules of the material to be colored. Pigments are also coloring agents, but they differ from dyes in that they don't bond with the material; they are small particles

FIGURE 26: *Jenny Balfour-Paul*, Indigo Dyer in San, Mali, *1977*

of color held in some suspension, forming a film that attaches itself to the surface of the substance to be colored. Pigments, one might say, are applied to materials; dyes are absorbed by them.

Both forms of colorants were first developed from natural sources, almost all no doubt discovered accidentally.[4] The root of a flowering plant and the bodies of a scale insect were the sources of two dyes (madder and cochineal) used to color things a wide range of shades of red. Glands of a sea snail were used to produce Tyrian purple, and a pigment called pink was used to color things various other colors, usually yellow, but strangely never pink. Indigo and woad (a common plant whose active chemical is the same as that in indigo, though in lower concentrations) were both used to color things an extraordinary variety of blue shades, from a "pearl" blue that was almost white to a "midnight" blue so nearly black that it was sometimes called "crow's wing."[5]

For centuries, indigo was just a dye that colored things blue, and then one day it became a color in its own right. It is odd to think about the concept of a new color, though paint companies and cosmetic manufacturers are inventing new ones all the time. Pantone "introduced" 210 "new colors" in 2016. But if colors, at least for humans, are the particular visual experiences triggered by the detection of electromagnetic waves between about 390 and 700 nanometers, there are no new colors to be seen, only new colors to be named. Any new color is just a thinner segment than has previously been recognized of an infinitely divisible continuum. It isn't new; it was always there. So why not indigo? Although inserting it into the rainbow might seem a much bolder move than painting your breakfast nook Mango Mojito. Or maybe not.

No one before Newton seems to have seen indigo in the rainbow — or to have seen it anywhere else. No one else seems to have thought that "indigo" was a color name, with the possible exception of Jean-Baptiste Tavernier, a

French merchant who traveled widely around Persia and India in the middle of the seventeenth century. In 1676, in his popular *Six Voyages,* published first in French and then quickly translated into English, as well as Dutch, German, and Italian, Tavernier writes about coming across a heterodox community of Christians, living near the River Jordan, who, he says, have "a strange Antipathy toward the Blew Colour call'd Indigo."[6]

Admittedly this sounds as if Tavernier thinks "indigo" is a color, a shade of blue. Quoted out of context, it would seem to be evidence that it was a color name. But then Tavernier says that indigo is something that the members of this sect "will not so much as touch." As Tavernier uses the word in his account, "colour" is just a synonym for "dye." These "Sabians" believed that the Jews, trying to prevent the baptism of Jesus, had "fetch'd a vast quantity of Indigo . . . and flung it into Jordan," hoping to pollute the river; and as a result, "God particularly Curs'd that Colour."[7] It is the indigo dye that is fetched, flung, and cursed by God, rather than one of the seven rainbow colors, which were the symbols of God's covenant with humanity after the Flood and the evidence of the miracle of color itself.

Newton enabled indigo to find its place as a color in the rainbow. Indigo was visible (or so he said) but immaterial. The immateriality was critical, for Newton's great achievement in thinking about color was to shift the understanding of it from matter to light. But with indigo it is hard to escape its stubborn materiality, and no less hard to think about what it means to think that it is visible — except as a wide range of shades of blue.

The name "indigo" comes from a Greek word that means "from India." What came from India was a plant, *Indigefera,* as well as a tradition of dye-making (although the etymology may ignore an even earlier history of indigo's use in the ancient Near East, as Jenny Balfour-Paul has suggested).[8] But from wherever these sprang, the plant and the tradition eventually would

make indigo the most valuable and most widely used "dyestuff" in the world, and indigo-dyed cloth almost universally beloved. The dyed cloth is wonderful, not only in the seeming magic of its appearance — the cloth emerges yellowish green from the dye bath and turns a brilliant blue as it hits the air — but also in the way the color becomes softer and subtler over time, as anyone (that is, *everyone*) knows who has had a favorite pair of faded blue jeans.

The dye had been known and used for thousands of years. Some have suggested that Herodotus, writing sometime in the fifth century B.C.E., might possibly have been referring to indigo when he describes a dye used in the Caucasus near modern-day Azerbaijan. The dye, he says, was made from crushed leaves steeped in water, producing a color as durable as the fabric itself, as if it "had been woven into it from the first."[9] But certainly in the first century C.E., the Roman Pliny in his *Natural History* explicitly mentions *indico*, which he describes as a black pigment or a dye "out of India," which diluted produces a "wonderful lovely mixture of purple and azure."[10] And by the end of the twelfth century, Marco Polo on his travels in India had witnessed, or at least had been told about, the preparation of the dye: "They procure it from a certain herb, which is taken up by the roots and put into tubs of water, where it is suffered to remain till it rots; when they press out the juice. This, upon being exposed to the sun, and evaporated, leaves a kind of paste, which is cut into small pieces of the form in which we see it."[11]

The usual "form" in which Europeans saw it was as a solid lump of dyestuff, so that one of the earliest English dictionaries in 1616 would mistakenly define "indigo" as "a *stone* brought out of Turkey, wherewith dyers use to dye blue," and that error would be often repeated over the next hundred years (Figure 27).[12]

Indigo, however, was derived from a plant, as Marco Polo had correctly reported, though he ignores — or just didn't know about — some of

FIGURE 27: *Indigo cakes*

the less pleasant, and often noxious, details of its complicated manufacture. The dye has to be extracted from one of the various indigo-bearing plants in several stages, since the dye by itself doesn't exist in nature. The harvested sheaves would indeed be submerged in water and left, not exactly to "rot," but to ferment (the subtle difference between the two forms of organic break-down being basically whether the result is considered to be desirable or not).

The fermentation process was normally encouraged by the addition of some alkaline substance to the vat, usually lye made from wood ash, although in Japan, composting was the preferred method to produce the fermented plant material.

The fermentation of the plant material releases a chemical compound, which must be separated from the plant material and then aerated to produce what is in fact the coloring agent ("indigotin"). The plant material is therefore removed and the remaining liquid churned to mix it with air. The oxidized colorant eventually settles to the bottom of the vat. The liquid is then drained or allowed to evaporate, leaving the colorant as a muddy residue. This sludge is heated to stop further fermentation, and then collected and dried to produce an easily stored or transported dye. About one hundred pounds of plant material is necessary to produce a single pound of the dyestuff.

One further step is necessary in order to turn the dried dyestuff into a usable dye. The powdered indigo has to be dissolved in an alkaline solution, usually consisting primarily of urine (ideally, as early manuals specify, to be collected from boys who have yet to reach puberty). Whatever its source, according to a contemporary craft dyer, "the more concentrated the urine you start with, the better," though the indigo must often be encouraged to its "reduction" by rubbing it by hand as it sits in the liquid.[13] In Sonnet 111, Shakespeare worries that he has been corrupted by the environment in which he earns his livelihood, afraid that his "nature has been subdued / To what it works in, like the dyer's hand." But the more one learns about what the indigo dyer "works in," skin discoloration seems to be the least of its risks.

And sometimes it was worse. A French traveler in Persia in the seventeenth century records that "the Dyers of that Countrey make a most excellent blew dye," whose quality seems to depend upon a "particular secret." As

he writes, "They put no urine to it, using Dogs-turd instead of it, which they say makes the Indigo to stick better to the things that are dyed."[14]

The disquieting aspects of producing and using the dye, however, go beyond some understandable squeamishness about the very hands-on re-purposing of human waste products, especially as the scale of manufacture increased from craft to commerce. In 1775, the naturalist Bernard Romans, in his *Concise Natural History of East and West Florida*, warned that the site of indigo production "should always be remote from" any living area "on account of the disagreeable *effluvia* of the rotten weed and the quantity of flies it draws." Clouds of insects make it "scarce possible to keep any animal on an indigo plantation in any tolerable case, the fly being so troublesome, that even poultry thrive but little where indigo is made." There is "scarce a possibility to live in a house nearer than a quarter of mile to the vats," Romans concludes, since "the stench at the work is likewise horrid."[15]

All of this "is certainly a great inconvenience," as Romans admits, but the good news was that it is "the only one this profitable business is subject to."[16] And the profits easily outweighed the inconvenience, especially as the landowners were not the ones to experience it.

Someone, of course, did. In Florida it was slaves, as it was in the West Indies and in the other indigo-producing colonies of North America. "The primum Mobile of the welfare of these countries and of the wealth of their inhabitants are the African slaves," Romans says of the plantations of East and West Florida; and he enthusiastically points to the positive economic effects that the lifting of the prohibition on slavery had on neighboring Georgia. Alone among the North American colonies, at the time of its founding Georgia had barred slavery (though less from any principled opposition to the practice than because the colony had been founded in the hope of providing a

place of employment for the English poor). In 1751, however, bowing to continued pressure from its farmers, Georgia at last began to allow "the importation and use of Negroes," and then, according to Romans, it "flourished" — though not of course the newly imported slaves.[17]

Labor-intensive cultivation of various crops seemed to demand slaves to work the land, though for Romans, it must be said, slavery was justified not only on economic grounds but also on what he saw as moral ones: "The very perverse nature of this black race seems to require the harsh treatment they generally receive," he writes. Although he realizes that the tide of opinion on the topic of slavery is slowly turning against him, he is dismissive of the opinions of Enlightenment "philosophers," like Montesquieu, who "restrain us from properly using this naturally subjected species of mankind."[18]

On the topic of the local indigenous populations he is even worse. His detailed account of the various Native American tribes in Florida ends with a prediction of the inevitability of the British taking "the disagreeable step of realizing our mock authority, by extirpating all savages that dare to remain on the East of the Mississippi." It is only the realization that is "disagreeable" to him, not the proposed action.[19]

Slavery brings out Romans's softer side. Among his justifications for the institution is that it is a kindness to the transplanted Africans. As most had been captured by other Africans in war, the trade in slaves, according to Romans, keeps alive those who otherwise "would be murdered; did we not induce their conquerors by our manufacture and money to shew them mercy."[20] The "manufacture" for this mercy was likely to be indigo-dyed cloth, and the "money" the profits made from the indigo trade. "African men, women, and children," as the brilliant anthropologist Mick Taussig has sharply observed, were being "bought with color."[21]

There is something shocking in reading Romans today, especially the blatant and unapologetic racism that irrupts from the pages of remarkably alert and detailed observations of natural history. But arguably this is preferable to the many other early accounts of indigo cultivation in which passive verbs erase the reality of the labor altogether. In most accounts of indigo production, indigo-bearing shrubs are "planted" and "grown"; sheaves are "harvested" and "fermented"; the dye is finally "extracted" and "dried."

Romans, however uncomfortably, reminds us of who it was that performed these arduous tasks. Some of his verbs are also in the passive voice, but the agents of the production are at least named, even if his verbs sometimes fail to disclose how little freedom of choice they had: the work was "performed by Negroes."[22]

No one involved in the business side of indigo cultivation was at all ambivalent about this fact. Plantation owners worried only about the supply of slaves. As a Georgia merchant wrote in 1784, "New Negroes from Africa, are, & will be for a very considerable time to come, in great demand with us."[23] The demand for slaves and indigo went hand in hand, even to the point, as another planter matter-of-factly reported, of having "changed off indigo pound for pound of negro weighed naked."[24]

In the new world, the blue dye was always dependent upon enslaved Africans. In 1757, a poem printed in the *South Carolina Gazette* celebrated the dye with gentlemanly Virgilian pretensions: "The Means and Arts that to Perfection bring, / The richer Dye of INDICO, I sing." Amid its awkward versification of various aspects of the plant's cultivation and the dye's production, it finally gets around to the need for slaves to perform the actual work. The poem acknowledges the existence of ships continuously sailing up and down "*Angola's* Coast and savage *Gambia's* Shores, / In Search of Slaves," but there is

nothing at all predatory as the poem imagines these voyages. Indeed the poem is (momentarily) concerned about the difficult working conditions the slaves will encounter. But immediately it reassures its readers that African slaves are uniquely suited to "bear the scorching Suns, and rustic Toil," since they have been "temper'd to the Heat / By situation of their native Soil." Africa has prepared them perfectly for what they will experience in the new world; such, the poet says, is the "wise and providential Care" of heaven.[25]

So much of this is appalling, but what is most offensive might be the seemingly innocent phrase "rustic toil," which is used to turn the grueling activities of the plantations into an innocent pastoral fantasy. The words completely erase the social, psychological, and physical violence of chattel slavery, even as they ignore the qualitative difference between the always arduous agricultural work depended to grow rice or cotton plantation and the still harsher activities demanded to produce indigo.

But indigo cultivation seemed to encourage idealization, as in the seventeenth-century French engraving depicted here (Figure 28). In the center, elegantly dressed in white, is the plantation owner (implausibly tall), strolling down a path with his broad hat and walking stick, as black slaves, naked to the waist, purposefully go about the master's business: cutting indigo sheaves, delivering them to the fermentation vats, churning the mixture in the vat, and carrying sacks of the still-muddy colorant to the shed, where the drying process will be completed to produce the cakes of dye.

There is work that is visible but almost no exertion; there is efficiency but no obvious coercion. The only groups of people whose effort shows at all in their movements are the two pairs of men (one set almost invisible on the far left) cutting sheaves of the indigo plant and carrying them to the vats, but they are buried in shadow, so any physical strain is impossible to see. Everyone else seems to be *comfortably* occupied, though the heavily muscled shoul-

FIGURE 28: *An indigo plantation in the Antilles, in Jean Baptiste du Tertre,*
Histoire générale des Antilles habitées par les François, *vol. 2 (Paris, 1667)*

ders and arms of the churner might be less part of an idealized body than the
evidence of the exhausting muscular effort that must have been demanded
daily. But the eye is led from the white plantation owner down the white di-
agonal of the path to the solitary indigo plant just to the right of center at the
bottom, which grows untouched and unobserved.

Nothing is visible here of Bernard Romans's account of the difficulty
and "inconvenience" of growing, cultivating, and processing indigo as it is
turned into a dye—and there is no sign of intimidation, except perhaps for
the owner's walking stick, which could so easily be turned into a switch. The
engraving gives no indication of the overwhelming stench or swarms of in-
sects that Romans mentions, no suggestion at all of the oppressive "fatigue

of a southern plantation" that Romans had noted, even if in this case Romans has silently transferred that "fatigue" to the plantation from the bodies of those who actually endured it. He does admit that it is an exhaustion that white men could not tolerate, but he seems certain that slaves do not feel it, as they are accustomed to the "similar work in their own sultry country" — two related "facts" he musters as part of his defense of the logic of slavery.[26]

Romans, even in his overt racism, is so much more honest than the engraver. Indigo plantations were punishing factories, not serene farms. The slaves lived in squalor and were often malnourished. The work was taxing and unsafe. What was most dangerous was encountered mainly in the production of the dye rather than in the cultivation of the plant. Slaves would sometimes be forced to stand in the pools of fermenting plant matter, agitating the mixture with their hands or their own marching. They were exposed not only to the extreme heat from both the sun and the fermenting material itself but also to the harmful fumes that were released. The vat was, therefore, sometimes known as the "devil's tank" (and indigo itself had been called by many the "devil's dye," although this was a name earlier given to it by European woad producers mainly to discourage the foreign competition from indigo — but the shoe fits).[27] Even when the indigo residue was at last removed from the bottom of the vat and set out to dry, then "young Negroes," as Romans says, often girls, were "employed in fanning the flies out of the drying shed, as they are hurtful to indigo," though he is unconcerned that the great swarms of disease-carrying insects, which he had earlier acknowledged were also "hurtful" to the farm animals, might in any way be hurtful to the slaves.[28]

What was true in Florida in the middle of the eighteenth century was true wherever indigo was produced on any scale. In the Caribbean and the American colonies, it was the enslaved Africans who made possible the production of the dye; in Central and South America, it was the indigenous

inhabitants who worked under various regimes of harsh regulation. And later in India, it was peasants who were abused and sometimes starved by wealthy British planters, who often forced them to plant indigo instead of food. There are lots of stories from around the world that can be told about indigo production, all different in their details but somehow all the same.

In whatever system of oppression, workers' lives were shortened — and while the workers lived, they often suffered from crippling physical ailments and severe sickness brought on by the work. Men often became impotent and women infertile. In 1860, a civil servant, testifying before a commission established to investigate the practices of indigo production in Bengal, notoriously claimed that "not a chest of Indigo reached England without being stained with human blood."[29]

There is an often-repeated anecdote about a friend coming to visit the English artist and designer William Morris at the dye works Morris had established at Merton Abbey in London in 1881. The friend announced his arrival and heard Morris's "strong cheery voice call out from some inner den, 'I'm dyeing; I'm dyeing; I'm dyeing.'"[30] But the slaves who worked on the indigo plantations in the Americas really were dying. A soldier who had served under George Washington in the Revolution afterward wrote about the "effects of the indigo upon the lungs of laborers, that they never live over seven years."[31]

Nonetheless, the worldwide desire for the remarkable blue dye allowed indigo plantations to thrive anywhere the conditions of climate and soil permitted indigo-bearing plants to grow. In the seventeenth and eighteenth centuries the plantations of the New World satisfied most of the world's desire for natural indigo.

It is, however, worth reminding ourselves that much of the demand for the dye was driven not by the indigo craze of fashion-conscious Europe

but by the need for a standardized and stable color for military uniforms. It is just one of the many harsh ironies of indigo's history that Napoleon's troops, which ultimately failed to put down the slave uprisings (1791–1803) on Sainte-Domingue (the western third of the island now split between Haiti and the Dominican Republic), wore uniforms dyed with the very indigo that had helped support the island's economy and whose cultivation had given rise to many of the intolerable conditions that provoked the revolt.[32]

However, with the loss of the colony and the supply of indigo it had provided, it became almost impossible for the French army to find a reliable source of the dye, especially after 1806, when British ships began regularly to intercept colonial imports intended for France.[33] Although the eighteenth-century British army wore red coats (dyed with madder), the British navy that ruled the waves officially dressed in blue. Its officers, from commodores to petty officers, wore indigo-dyed frock coats with differentiating forms of gold braid ornamentation as they successfully fought to keep indigo from the Grande Armée of France (Figure 29).

In 1880, a synthetic form of indigo was finally developed by a German chemist Adolf von Baeyer (a discovery that would later help win him a Nobel Prize, making him the first Jew to be so honored), and within a few decades synthetic indigo was being produced industrially. Quickly the large-scale cultivation of indigo came to an end.[34] But until then it was the natural blue dye that had come to color the clothing of both the poor and the wealthy, commoners and aristocrats, the subjugated and the free on every populated continent. In its synthetic form, indigo is still ubiquitous, mainly as the colorant for blue jeans.

But today a rich tradition of craft dyeing survives, which often allows us to be sentimental about indigo, a sentimentality no doubt encouraged by the subtle, soulful beauties of the dyed cloth. The dispiriting history of the

FIGURE 29: *James Northcote*, Edward Pellew, 1st Viscount Exmouth,
1804, National Portrait Gallery, London

indigo trade is, however, an irresistible reminder that Newton's immaterial color was actually an all-too-material dye and that its commercial production was always dependent upon coercive structures of power. And it is also significant that almost no one in the eighteenth century called the color the dye produced "indigo." In England, in fact, they usually called it Navy Blue.

CHAPTER SEVEN

■

a once-cold
arbitrary violet reveals itself
as radiance, a defining halo.

DENISE LEVERTOV, "Living with a Painting"

AT THE
Violet
HOUR

English-speaking schoolchildren nearly had to remember the order of the rainbow colors with the mnemonic ROY G. BIP. When Newton first began his optical experiments seeing the sun's white light scattered by his prism, "purple" was the name he used for the color he saw at one end of the spectrum. Later he called that color "violet-purple." Then just "violet." ROY G. BIV it became.

It was not that Newton's color discrimination became sharper over time. In fact it was never very good. It was that purple didn't fit comfortably into his theory. Purple is a color that has to be mixed from blue and red pigments, but blue and red, as colors of light, are on the opposite sides of the spectrum and so never overlap when white light gets separated into its component colors. For Newton, purple then posed a problem. Enter Violet.

Maybe it doesn't matter much what we call the colors we see. It isn't clear, in any case, that any one person sees exactly the same color another does, and all our color names are merely tentative and approximate labels for complex visual sensations. One person's violet might be another's lilac or lavender or amethyst or maybe just purple. And though industrial color manufacture has provided us now with an impressively differentiated color vocabulary, there are still many more colors, at least shades, tones, and tints, than we have words for them. The French word *violet* is often translated into English as "purple," but *pourpre* often gets translated as "purple," too — although for French speakers *pourpre* usually names a purple closer to red than *violet* does. Burgundy perhaps.

But violet seems to differ from purple in whatever language — not so much as a different shade of color than as something more luminous: perhaps

FIGURE 30: *Claude Monet*, Water Lilies *(detail)*, *1919*, *Musée Marmottan Monet, Paris*

a purple lit from within. Violet is the shimmering, fugitive color of the sky at sunset, purple the assertive, substantial color of imperial robes. Purple were the sails of Cleopatra's barge, as both Plutarch and Shakespeare tell us; but Cleopatra's eyes, as everyone seemed to notice when Elizabeth Taylor played her in the film of 1963, were violet.

And modern painting began with that luminous violet. In Paris in 1874. On April 15.

Well, not really. But if we need one, that is at least a plausible starting date. Stories of origin are almost always false. Everything always begins earlier. This did, too. But that was the day that a group of artists, who called themselves "the Anonymous Society of Painters, Sculptors, Engravers, etc.," opened the first of eight exhibitions they would organize between 1874 and 1886 as an alternative to the official Salon de Paris. Many of those who showed their work would remain anonymous. Some, of course, would not: Eugène Boudin, Paul Cézanne, Edgar Degas, Claude Monet, Berthe Morisot, Camille Pissarro, Auguste Renoir, Alfred Sisley.

These would become "the pioneers of the painting of the future," as a critic, Émile Cardon, prophesied in his review in *La Presse.* For him, however, this was intended not as a compliment to their artistry but as a condemnation of contemporary taste. Impressionism in his mind was nothing more than doodling with paint. "Dirty three-quarters of a canvas with black and white, rub the rest with yellow, dot it with red and blue blobs at random, and you will have an impression of spring."[1]

Critics were outraged by the loose, broken brushwork that made the paintings seem to many viewers more like sketches than proper paintings. In place of the ostentatiously smooth surfaces of more traditional painting, which sought with its impeccable "finish" to erase all evidence of its making, these canvases, with their "blobs" of bright color and individualized, accen-

tuated brushstrokes, announce themselves as both painted and provisional. Monet's *Impression, Soleil Levant* (Impression, Sunrise), the painting often thought to provide the name for the movement, was mocked by the critic Louis Leroy in *Charivari:* "Wallpaper in its embryonic state is more finished than that seascape."[2]

But it was really a color that offended the art world: violet.[3] Not the yellow, red, and blue that Cardon had noted but the violet that was now seemingly everywhere — at least on these canvases. Violet became the name for the shock of the new.

In 1881, Jules Claretie quoted Manet's prediction that "within three years everyone will be painting violet" (*tout le monde fera violet*) and lamented that this was all too likely to come true. Maybe it already had. An exasperated French novelist, Joris-Karl Huysmans, complained that "earth, sky, water, flesh" were inevitably now the color of "lilacs and eggplants." Faces were rendered "with lumps of bright violet paint" (*avec des grumeaux de violet intense*). Ambient light now appeared only "in harsh blue and garish lilac" (*de bleu rude et lilas criard*).[4]

It was an outrage. In 1878, Théodore Duret wrote: "In summer sunlight reflected by green foliage, skin and clothing take on a violet hue. The impressionist painter paints people in violet forests, so the public loses all control. Critics shake their fists and call the painter a vulgar scoundrel."[5] Still, violet became the color of choice. The Irish critic and novelist George Moore, thinking about why violet seemed to dominate the impressionists' paintings, replied with a shrewd insight into the psychology of artistic fashion: "One year one paints violet and people scream, and the following year everyone paints a great deal more violet." Huysmans had a simpler explanation: "Their retinas were diseased."[6]

Or maybe it was their brains. August Strindberg commented on the

purplish palette of the impressionists and wondered if perhaps they all were "mad." Cardon had speculated about possible "mental derangement" (*une maladie du système nerveux*).[7] Alfred Wolff, the art critic for *Le Figaro,* Paris's leading newspaper at the time, wasn't quite prepared to offer a clinical diagnosis but clearly recognized the possibility: it was no more likely that one could make Pissarro "understand that trees were not violet" than that one could cure a "lunatic" who believed himself to be the pope (Figure 31).[8]

Other critics were less scandalized and saw the color merely as a fashionable affectation. One sniffed that impressionism seemed to demand nothing more from an artist than painting the sky violet. The increasingly familiar bluish purple tones of the paintings regularly drew comment, almost always negative. In a review in the *Gazette des Beaux-Arts,* Alfred de Lostelot, an early defender of impressionism, noted the painters' unusual dependence on the violet color (and even conjectured wildly that some of them might be able to see ultraviolet rays). "Monet and his friends," he said, granting Monet pride of place in the movement, oddly seemed to see the whole world in violet. "Those that love the color will be delighted," he said, but he reluctantly acknowledged that most gallery-goers did not.[9]

If not nearly as ubiquitous in the paintings as the exasperated responses would suggest, violet did differentiate the palette of impressionism from any paintings seen before. And gradually people did come to "love the color." Perhaps it was a scandal, but as the narrator says in Émile Zola's novel *His Masterpiece,* it became the painters' "gay scandal" — a willful "exaggeration of sunlight" that offered welcome relief from "the black pretentious things" of the official salon.[10]

Not only did violet provide a distinctive new color for modern art, but strangely, at least for some, it offered a distinctive new color for the world. Nature itself suddenly began to appear "absolutely modern," according to

FIGURE 31: *Camille Pissarro*, Poplars, Sunset at Eragny, *1894: Oil on canvas,
28¹⁵⁄₁₆ × 23⅞ in. (73.5 × 60.6 cm). Nelson-Atkins Museum, Kansas City, Missouri*

Oscar Wilde in "The Decay of Lying," looking like "exquisite Monets and entrancing Pissarros," with landscapes and skies made up of "strange blotches of mauve" and "restless violet shadows."[11]

It is perhaps not quite as perverse an argument as it first appears, or maybe it is: nature imitating art. But the impressionists allowed — no, *trained* — our eyes to see nature differently: to see it dressed in color tones and modulations of light that, as Wilde pronounced, "did not exist till Art had invented them."[12]

This isn't a claim that impressionists made for themselves. They didn't make any claims at all. Theirs was a revolution without a manifesto. It didn't begin as a theoretical program, and to the degree that it became one, each painter acted on it somewhat differently. The paintings were its statements — along with some letters and a few interviews, though most of these were given after the painters had stopped painting as impressionists.

And the label wasn't even their own, though eventually they would adopt it. At first, they called themselves "independents," then "intransigents." Only for their third exhibition did they embrace the term "impressionists" that the critics had already used. "They are impressionists," said Jules-Antoine Castagnary in a review in *Le Siècle* in 1874, "in that they render, not a landscape, but the sensation produced by the landscape."[13]

That is what almost everyone has said about them: that their subject was the spontaneous visual experience of the world rather than the world itself. Photography could deal faithfully with the world, but only in tonal grays (see Chapter 10). Painters should deal faithfully with how they saw the world, and that included seeing it in color — and encountering it mainly out of doors.

As modern life increasingly moved indoors, modern painting moved outside. Landscape became the characteristic genre of the impressionists, but

their interest was not, as with earlier landscape painters, in re-creating the particularities of its geological, agricultural, or architectural features. They wanted, it was said, to re-create the immediate visual impression of that landscape, produced by the light in the very instant before the brain fully organized the scene.

But even this isn't exactly right. Obviously they were not painting realistic images of the world as it objectively exists. (The artist Donald Judd claimed that "the last real picture of real objects in a real world was painted by Courbet.")[14] But neither were they representing immediate visual sensations, even though Monet would say late in his life that his originality lay in his ability to record "impressions registered on my retina."[15] These are paintings by artists "drinking in the intoxicating effects of the sun," in Philippe Burty's wonderful phrase in a review published in 1874 in *La République Française.*[16] Landscapes became lightscapes. But we shouldn't underestimate either the intoxication or the fact that the artists usually returned soberly to the studio to complete their paintings.[17] They were committed to neither optics nor objectivity.

Rather, they were painting something in between. Literally. It isn't that they painted objects as we see them. They painted the luminous air and light that exists in between the eye and those objects. "I want to paint the air in which the bridge, the house, and the boat are to be found—the beauty of the air around them—and that is nothing less than the impossible," Monet said in 1895 in an interview while visiting Norway. "To me the motif is insignificant. What I want to reproduce is *what lies between* the motif and me."[18]

What "lies between" is something real, although it is transparent and insubstantial. It affects the appearance of objects, but it is not itself normally perceived. To paint it may very well seem to be "impossible," as Monet said. But it was exactly what he and the other impressionists wanted to por-

FIGURE 32: *Claude Monet,* Charing Cross Bridge, The Thames,
1903, Musée des Beaux-Arts de Lyon

tray: not objects but what Cézanne called "the atmosphere of objects" — light
and air, which demand color, not contour. The objects themselves mattered
only as they provided the particular occasions and some necessary scaffolding
for painting the in-between.[19]

And surprisingly the in-between seemed to have a characteristic
color. "I have finally discovered the true color of the atmosphere," Manet
would crow near the end of his life: "It is violet."[20] And even though Manet
rarely painted as if he really believed this (and never committed to the in-
between), Monet often painted as if it were true (Figure 32).

And it wasn't the result of retinal disease. Cataracts, however, would seriously impair Monet's color vision late in his life. He had surgery to remove them from his right eye in January 1923 at the age of eighty-two. But when he dedicated himself to painting the color of the atmosphere, his vision had not yet been affected.

Still, Manet's claim is both unexpected and unconvincing. Both he and Monet knew how much and how quickly light changes through the day. "Color," Monet said, "any color, lasts only an instant, sometimes three or four minutes at a time."[21] So although there are times when the atmosphere does enchantingly seem to be violet, these are fleeting, occurring mainly in the liminal moments between daylight and darkness. Obviously the color of the atmosphere does not remain constant. It is temporary and transient, which is the precise recognition that motivates the several series of paintings that Monet famously undertook, such as his haystacks and the paintings of Rouen Cathedral rendered in the changeable lighting conditions of the day. These are not variations on a theme but paintings with variation *as* their theme.

Yet out of the array of atmospheric variation that he captures, Monet returns again and again to violet. Unlike Manet, he doesn't believe that violet is the atmosphere's true color — it is no more or less true than any other color produced by particular light — but it isn't a completely arbitrary choice. It is, however, a choice, and it becomes for him as much a symbol as a sensation. And what permits the choice is the very thing that differentiates violet from purple: that sense of its being magically lit from within.

What is lit from *without* is usually what Monet paints, as changing conditions of illumination destabilize the very idea of color. What color are the haystacks really? What color is the cathedral at Rouen? Monet's answer is that the haystacks and cathedral are the color (or colors) they seem to be at the moment of looking. The colors they have are those created in the particu-

lar light in which they are viewed. No one color is more real than the other. In fact, "real" is exactly the wrong word for what it is.

The complexity of color—its energy and instability—is the subject of Monet's series paintings more than the objects that he painted. The paintings defy what scientists often call "color constancy": the ability of the visual system to stabilize the color of objects differently illuminated. For example, a red tomato picked from the garden in brilliant sunshine and then taken inside to the kitchen would never be perceived as having two different colors, or if we looked at it brightly lit on one side and in shadow on the other. We seem always to know instinctively what color it "really" is. But Monet's series paintings explore the varying conditions of illumination so intensely that, even with familiar objects, color constancy is impossible to achieve. When we look at these paintings, our brains are unable to correct for the distortions of light. We recognize distortion, if that is what we choose to call it, as what light inevitably does to the surface of objects. We might as well just call it "color."

Yet from all the colors in Monet's astonishing palette, it is violet that somehow became not merely *a* color of light but *the* color of light or, better, the color of the luminous itself.

It becomes, then, hard to avoid the thought that impressionism, at least as Monet inhabits it, isn't much interested in anything that can properly be called realism—not even an "ocular realism," as some have termed it, by which they usually mean a commitment to the illusionistic rendering, not of the world, but of visual experience.[22] But the closer one looks, the more impressionism seems to be something closer to abstraction's nursery than to realism's last gaudy night. Monet told Lilla Cabot Perry, a young American painter, to "try to forget what objects you have before you, a tree, a house, a field, whatever. Merely think, here is a little square of blue, here an oblong of

pink, here a streak of yellow, and paint it just as it looks to you, the exact color and shape, until it gives your own naïve impression of the scene before you."[23]

The "naïve impression" was always a bit of fake. The innocent eye is never really innocent, and both "the scene" and the process of seeing always mattered less than the color and the shape. As Monet's phrasing suggests, impressionism points the way forward to Piet Mondrian's blocks of color every bit as much (or maybe more) than it looks back, if only as far back as Manet. Monet wasn't really very interested either in nature or in vision, and violet isn't in fact the color of the atmosphere. But it is the color of his formal commitment — to painting color rather than colored objects or even our impressions of them.

That's why violet became impressionism's scandal. It is the index, as those early critics of impressionism intuited, of what is most radical and unsettling in these paintings, even if now some of these paintings have become so familiar (domesticated on greeting cards, T-shirts, and coffee mugs) that it is hard to imagine that they ever could have unsettled anyone. The vehemence of the initial negative reaction to these paintings seems baffling today. Their graceful mastery of the world now seems less challenging than charming — objectionable, perhaps, only for being a bit too easy to like.

In a sense, however, that is exactly what the critics responded to, though they misnamed it. Violet is its symptom, misidentified as a cause. It isn't just that they thought that these paintings are decorative, which they are. Or that they are superficial, which they also are. It is, rather, that the decorative and the superficial seems a betrayal of what art was supposed to be. Art, it was thought, should reveal fundamental truths about the world rather than merely indulging in tricks of the light (though those tricks turn out to be one of the fundamental truths about the world).

Color, therefore, was to be used only for *coloring in*. Then it could be what was sometimes called "moral color," confirming rather than contesting the primacy of line. But once color becomes primary, as in these paintings, rather than additive — that is, once color becomes what the paintings are essentially about — it can no longer be either moral or true. It is seductive and it is deceptive. But in spite of that — or more likely because of it — color is exactly what impressionism cared about, and that is what its critics hated. Trees shouldn't be violet, and the world should be made of something more substantial than colored "blobs."

Objects, which in realist paintings are designed to seem solid and stable, in these shimmer and dissolve. For the early critics of impressionism, the fragmented brushstrokes and flecks of paint were the disturbing evidence of the artists' weakening attachment to nature and, maybe worse, of their weakening mastery of technique. Either way, the art world was not yet ready to grant the painters their freedom from the responsibilities of representation.

The early critics weren't wrong about what they saw. The paintings, in creating their dazzling luminosity, disassemble the image, undoing its integrity and stability. Or rather, the image is alternately composed and decomposed, depending on where the viewer stands. From a distance, the paintings are clear and coherent; up close they are just streaks and smears of unruly color on canvas. For one early reviewer, this was the source of a dismissive joke about Pissarro's landscapes. "Seen up close they are incomprehensible and awful," said León de Lora in *Le Gaulois* in 1877. "From afar they are awful and incomprehensible."[24]

Yet this reversibility of perspective is calculated by the artists. It isn't just that the paintings are identifiable representational images as well as abstract arrangements of strokes of color (figurative paintings are always both) but that these paintings actively solicit our shifts of perspective. They are pic-

tures *and* they are paintings, and they insist on being both of these things. But they insist just a little bit more on being paintings.

They offer a ravishing image and lure the viewer in toward them. But paying close attention disorganizes the world they seemingly present. Only by keeping your distance, one might say, does the world stay in focus. In most aspects of our life, it is the other way around: attentiveness is rewarded with clarity, and distance distorts and disfigures. But here we recognize the world only when we misrecognize the painting, or at least when we decide not to look carefully at it.

León de Lora was wrong about Pissarro, but he had something partially right. Our perception of the paintings is trapped into toggling back and forth, but between a recognizable world of familiar objects and the blobs and strokes of color by which that world is pictorially composed. And the toggling is where the action is: it is the evidence of the painter's control. This is art, not nature. This is art, not optics. This is art declaring, not exactly its dominion over nature and optics (that is something art never really has, no matter what painters and critics sometimes claim), but its indifference to both — recognized in the "arbitrary violet" that had seemingly been chosen as the color of the atmosphere.

We often think of painting as a window. In 1877, in the *Gazette des Lettres*, Amédée Descubes-Desgueraines said that the impressionists painted the world "as if seen through a window suddenly thrown open."[25] That is the illusion they encouraged. But most good painting is not a window. In fact, it is much more like a wall. It keeps us from what is "out there" rather than reveals to us what is, though for so long so much painting professed to do just that.

What seems to be light is really paint. It is paint pretending — or, maybe better, pretending to pretend — to be light. And it is oil paint. That should never be forgotten. Monet could have painted with watercolors, a

medium arguably better suited to rendering evanescent effects of light than the opacity of the oil paints he used. But he hardly ever did. (Both Pissarro and Cézanne, it should be noted, often painted with them.) For Monet, it was, as the Russian poet Osip Mandelstam would later write, always "the thickness of oil / warmed by the lilac brain."[26]

You cannot miss the tension between the solidity of the pigment and the immateriality of the light it is asked to represent (any more than you can avoid the gap between the time needed to apply the paint and the seeming "instantaneity," in Monet's word, of the scene). And this marks a big step in the history of painting as it moves in the direction of recognizing paint as its real subject. Violet was achieved by glazing cobalt blue with madder red, at least until a cobalt violet pigment, invented by the French chemist Jean Salvétat in 1859, became generally available to artists around 1890. But whatever the pigment, violet was materialized and set to work to become the color of the immaterial air.

Monet, however, was not yet ready completely to sever painting from the task of painting something (any more than Van Gogh had been). It still remained nominally in the service of some quasi-realistic illusion, even if this was, in Monet's case, only the sparkling illusion of the atmosphere. The world for Monet and the impressionists was largely a pretext for the exploration of color, but they weren't ready totally to give themselves up to what Kandinsky would later call its "free-working."[27] Neither, it should be said, was Kandinsky. But Monet would eventually come close.

Monet would turn from painting things in the light to painting the light of things and ultimately to painting the light itself. At the end, the lily pond at Giverny provided a structureless structure for displaying almost pure forms of luminosity—as color struggled to separate itself from shape (see Figure 30).

In his extraordinary paintings of water lilies there are few spatial clues for a viewer to rationalize the shallow space. There is neither a horizon line nor any boundary of the pond. The edges of the painting—where the image stops—seem completely arbitrary. The world is presented as a kaleidoscope of colored patches.

The simile isn't fanciful. The kaleidoscope was designed for "the inversion and multiplication of simple forms," as its inventor David Brewster said in 1819.[28] The first kaleidoscopes worked by setting two mirrors at an angle in a tube filled with colored objects with an eyepiece at one end. The mirrors fragment and multiply the shards of color, functioning in the tube almost exactly as the sky and the water do in Monet's water lilies. Patterns of color bounce back and forth between what Marcel Proust called the "magic mirror" of water and sky, creating gorgeous intensities of luminous color.[29]

Eventually artists would push these hints of abstraction all the way. There would be no more need for the lily pond. Color could be just color, and paint could unashamedly be paint—and light, it should be said, would itself come to be no longer dependent upon its usual sources and supports, freed to be only itself, as in the installations and projections of Dan Flavin or James Turrell (Figure 33).

But first there was the need for Monet and his "lilac brain." The subsequent history of modern art—at least that history in which color triumphs over line—knows its debt to him, just as the other history, in which line wins out, recognizes its debt to Cézanne. Flavin, even before he *was* Flavin, so loved the Museum of Modern Art's two water lilies paintings that when they were heavily damaged in a fire in April 1958, he sent the museum a donation in the hope of preserving whatever scraps of the canvases survived.[30]

And yet it is almost always Cézanne who in the conventional histories of art gets the credit for setting modern art on its way, maybe because

Monet seems too frivolous compared to the austere Cézanne — or maybe it is just that color does. But this fact alone attests to how much we need Monet and the "previously unimagined, unrevealed, all-surpassing power of the palette," as Kandinsky said while standing before one of Monet's haystack paintings.[31] Monet initiates a different history of modern art than the one we usually relate.

Both histories, of course, are true, at least to the degree that any history can be said to be true. Certainly, say, in Pierre Bonnard, André Derain, and Henri Matisse; Mark Rothko, Ellsworth Kelly, and Georgia O'Keeffe; Helen Frankenthaler, Sam Francis, and Joan Mitchell; and Jasper Johns, Bridget Riley, and Gerhard Richter, we can see the outline of a history of modern art that derives from Monet. But outlines are, of course, exactly what Monet taught us to distrust, beginning in Paris in 1874. On April 15.

FIGURE 33: *James Turrell*, Skyspace Piz Uter, *Zuoz, Switzerland, 2005*

CHAPTER EIGHT

■

Black is the most essential color.

ODILON REDON

BASIC
Black

There is probably no more celebrated dress than the black satin sleeveless sheath that Audrey Hepburn wears in the opening scene of the 1961 film *Breakfast at Tiffany's*. It is the most famous Little Black Dress of all time, even though it is full length. It is also the most expensive. In 2006, one of the three versions that Givenchy designed for the movie sold at a Christie's auction in London for £467,200.

At the beginning of the film, Hepburn, as Holly Golightly, wears the evening dress as she exits from a New York City taxi on an empty Fifth Avenue in front of Tiffany's. It is about 5:00 A.M. (and she has not risen early). Her hair is in a high bun with a small tiara in front; she wears a rope of pearls, long black gloves, and big sunglasses. She stares up at the engraved name Tiffany and Co. above the closed doors and walks to the store window. She stands there, looking at the jewels, as she eats a pastry and drinks her morning coffee from a paper cup.

That's her breakfast at Tiffany's.

The sophistication is a masquerade; she is playing dress-up. A beguiling waif, Holly Golightly is a more knowing and determined Eliza Doolittle, reinventing herself as a sophisticated New Yorker. She was born Lulamae Barnes, in Tulip, Texas (a real town on Farm Road 2554, twelve miles north of Bonham in north-central Fannin County, with a population today of forty-four). She got married when "she was going on fourteen" to the local horse doctor. She spent her days paging through "a hundred dollars' worth of magazines," as her practical husband says, "looking at show-off pictures" and "reading dreams."[1] At fifteen, she ran away from him and from rural Texas, to try to live those dreams before they turned to ashes in her mouth.

FIGURE 34: *Audrey Hepburn in* Breakfast at Tiffany's *(1961)*

The black dress is the stuff of those dreams, even if the transformation it effects is not even skin-deep. "She's a phony," one character says, but "she's a real phony. Because she honestly believes all the phony junk she believes."[2] "Crap" is the word used by the narrator of Truman Capote's novella.

The black dress, however, is certainly worth believing in. It isn't "crap" or "phony junk." It is an essential item in virtually every woman's closet. And women more sophisticated than Lulamae completely believe in it. It would become "sort of a uniform for all women of taste," as *Vogue* proclaimed in 1926. "When a little black dress is right, there is nothing else to wear in its place," said Wallis Simpson, the American socialite whom King Edward VIII married in 1936, but only after abdicating the British throne to be able to wed her.[3] Now that's a dream Lulamae Barnes might have dreamed. All for love and an LBD.

By 1936, the LBD was already a fashion staple, having been popularized in the 1920s in large part by Coco Chanel's iconic "Ford" design (Figure 35).

With the Little Black Dress, the color of funerals became the color of fashion, though fashion now made democratic — functional, accessible, and black — available both to the Duchess of Windsor and to Lulamae Barnes. "Ford" had become a fashion term, not just an automotive one. "A Ford is a dress that everyone buys," said Elizabeth Hawes, an American stylist who had begun her career as a sketcher, pretending to be a buyer at the Paris fashion shows in order to copy the designs for American manufacturers.[4] But two urban legends intersect in the story of the Chanel "Ford."

As matters of fact, the Chanel dress was no more the first LBD than the Model T was available to a customer in "any color that he wants, so long as it is black."[5] In 1908, when the Model T was first produced, the car was available in red, blue, gray, and green — but not black. In 1912, it was available only in blue with black fenders. Not until 1914 did black become its sole available

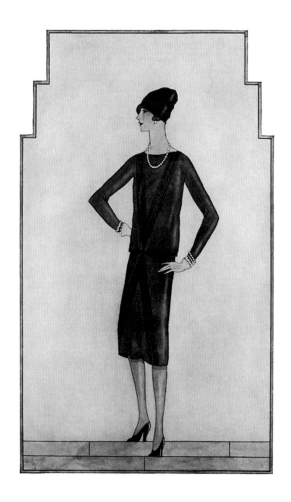

FIGURE 35: The Chanel "Ford" — The Frock That
All the World Will Wear, *Vogue, October 1926*

color, and it stayed that way until 1926, when, ironically, Ford reintroduced color choices in the very year Chanel identified her black dress with Ford's once exclusively black cars. And Chanel was not, in any case, the dress's first designer. Another Parisian designer, Jean Patou, had some seven years earlier introduced the iconic dress, referring to it as one of his "Fords," though like the car itself, his simple design came in different colors, though all "alike in line and cut."[6]

Little black dresses, however, were well known long before they became associated with Parisian couturiers. Around the turn of the twentieth century, Henry James had repeatedly imagined women wearing one. In his novel *The Awkward Age,* published in 1899, the willful Duchess comments on the appearance of Carrie Donner: "Look at her little black dress—rather good, but not so good as it ought to be."[7] And in 1902, in *The Wings of the Dove,* Milly Theale's "difference," her *je ne sais quoi*, is unmistakably marked "in the folds of the helplessly expensive little black frock that she drew over the grass as she now strolled vaguely off."[8] Lulamae Barnes wants to be more like Milly than Carrie. She wants seemingly effortlessly to produce the effect she so self-consciously strives for. And it starts with the dress. But Milly Theale is "really rich"; Lulamae is not. She is a "working" girl, a fact she tries to make even herself forget. But that's the beauty of the LBD. It is the dress of pure possibility. It allows everyone to imagine that social gaps can be narrowed and perhaps, if only for a moment, closed.

That is what black clothing has always done. It performs a sort of social alchemy. But it doesn't always happen from the top down. In Renaissance Italy and Spain, black became Europe's most fashionable color rather than just the obligatory color of mourning.[9] Priests, monks, and friars had long dressed in black robes as signs of humility and penitence, as well as of their lack of interest in the things of this world. But by the late fourteenth century,

black had become worldly. Wealthy merchants had begun to wear black, no doubt in part to give the impression of sober probity, but also because sumptuary regulations (laws that restricted certain luxury goods, including fabrics and dyes, to specific social classes) prevented them from wearing the rich reds and purples allowed to the aristocracy. The luxurious blacks that were initially produced for these prosperous merchants were soon adapted by aristocrats, sometimes, as is often said, as conspicuous acts of prolonged grieving but usually only because the splendid black fabrics served as brilliant foils for the gold and furs that proclaimed their position and power.

Goethe, in his book on color, had remarked that in the Renaissance "black was intended to remind the Venetian nobleman of republican equality."[10] Perhaps it was so intended, but the reality, of course, was that it served to remind everyone else of the nobleman's superiority — a superiority proclaimed in subtle but unmistakable marks of distinction, which asserted in fabric, tone, and design what the color alone might have effaced. In the portraits of Renaissance painters like Hans Holbein, Bronzino, Titian, Velázquez, and Anthony van Dyke, it is clear that black had obviously taken its place atop the social ladder.

By the mid-1800s, when the widespread use of black in clothing actually did begin to blur the social distinctions that earlier dress codes were designed to secure, the new fashion latitude was not always looked upon as a positive sign of social progress. The nephew of the nineteenth-century translator of Goethe's color theories wrote a strange book of decorating and fashion "hints," in which he lamented not only that "Englishmen wear the same dress at an evening party and at a funeral" but also that "many a host who entertains his friends at dinner has a butler behind his chair who is dressed precisely like himself." And "to add to this confusion, the clergyman who rises to say grace might, so far as his apparel goes, be mistaken for either."[11]

It *is* confusing. Black is a color worn equally by mourners and monarchs, melancholics and motorcycle enthusiasts. It's the color favored both by beatniks (remember those?) and by Batman. By ninjas and by nuns. By fascists and by fashionistas. Hamlet, Himmler, and Hepburn all wore black. So did Martin Luther and Marlon Brando — and Fred Astaire. It is a color that can be both recessive and excessive: the color of abjection and of arrogance, of piety and of perversity, of restraint and of rebelliousness. It's the color of glamour, and it is the color of gloom.

Yet whatever fashion statement it is intended to make (or merely because it can make so many), black clothing is everywhere. Culture weaves the ambivalence lying at the heart of the color into its different dress codes. In 1846, Charles Baudelaire saw the ubiquitous black clothing on the streets of his Paris as "the inevitable uniform of our suffering age, carrying on its very shoulders, black and narrow, the mark of perpetual mourning." Maybe it is true, as he said, that "all of us are attending some funeral or another."[12] Certainly all ages suffer, and our various black outfits signify how we respond. They mark how defiant or despairing, or merely indifferent, we feel in the face of that fact.

Black, however, is always the dominant color, and always provides our stable point of reference. Every year some new color is proclaimed "the new black" — and every year the old black continues to be what is most in style. "When I find a color darker than black, I'll wear it," Coco Chanel is reputed to have said. "Until then, I'll wear black." The sentiment was laconically echoed by Wednesday Addams, the proto-Goth daughter on the 1960s television comedy *The Addams Family:* "I'll stop wearing black when they invent a darker color."

Seemingly now they have. A British molecular engineering firm, Surrey NanoSystems, has developed a super-black material, named Vanta-

black, that is darker than any previously known color, and to which the company has controversially granted exclusive artistic rights to the sculptor Anish Kapoor.[13] But it is, as yet, too expensive to be used for clothing. So the old black still will have to do.

Yet, however dark black might be, ambivalence surrounds it. It is there in the language we use to name it. Latin needed two words for the color: *ater* and *niger*. Ater is the dull black, niger the one that shines, marking the difference, say, between soot and obsidian. In English there is just "black," but somewhere in its past the same distinction lies. Like Latin, Old English has two words marking a similar difference: *sweart* and *blaec*. The visual quality they distinguish is brilliance rather than hue. But complicating this further is that *blaec* has an Old English twin (or maybe cousin), *blac*. Understandably, the two words are not always carefully differentiated, even by Old English speakers and scribes. To the degree that this pair can be distinguished at all, *blaec* means more or less what we today mean by black, but *blac* means pale, shining, and sometimes even white. Both words come from the identical Indo-European root that means "to burn," which explains the oddity: one word is used for the carbonized material remaining after a fire, one for the fire itself.

So in the beginning, at least in the linguistic beginning, black was both dull and shiny, dark and light, black and white. None of the older words for "black" was designating exactly what we now think of as a color; none was a chromatic label for a discrete visual experience that is autonomous and abstract. Those older words describe some more complex lived experience, which explains why "black" and "bleach" can be etymologically related — and which should make us wonder how it has happened that we so easily imagine sharply polarized worlds, in which, as Jorge Luis Borges says of the black-and-white chessboard, the "two colors hate each other."[14] But they never were

opponents; they were partners. "Black night, white light, inwound as one," the poet Joaquin Miller wrote.[15] And, in any case, colors don't hate.

But the ambivalence is even more fundamental. Forget, for a moment, our words for it. Is black a color or not?

The answer, we are usually told, is that it is not. It is the absence of color: the visual experience we have when none of the visible wavelengths of electromagnetic energy (that is, those between about 400 and 700 nanometers) is received by the eye. Things appear black when they absorb (rather than reflect) this energy. Or at least when they absorb most of it. If all of the light waves were absorbed, we would not see anything. There would seem to be nothing there. This is what excites Kapoor about Vantablack, which apparently absorbs more than 99 percent of the light waves: "Imagine walking into a room where you literally have no sense of the walls—where the walls are or that there are any walls at all. It is not an empty dark room, but a room full of darkness."[16] But black is also the visual experience when there is nothing there to absorb the light or there is no light to be absorbed. Black is the absence of color, and it is also the color of absence. As the Mexican painter Frida Kahlo punned in her diary, "Nothing is black; really, nothing is black."[17]

A physicist might say the same thing (but it would not be a pun). Physicists usually do think nothing is black. In fact they think that there are no colors at all. There is only energy. The human visual system detects and processes particular wavelengths of energy, and we give color names to the visual experiences of this processing. So they are willing to call those colors. But none of these wavelengths corresponds to black.

For a physicist, then—well, at least for a physicist thinking about physics—it makes sense to say that black is not a color. For almost anyone else (even, say, for a physicist attending a funeral), of course it is. Almost all people would agree that a black suit has a color—it doesn't make sense to think of

the suit as colorless — and that black (in whatever language) is the color it is. But out of respect for the physicists, it can be granted that black is a different kind of color than the seven we have already discussed. Those seven are chromatic, which really means only that they are the constituent colors of light that we see in the rainbow. Black is achromatic, which means that it is a color that can't be seen anywhere among the gradations of color that appear between red and violet. So there are (at least) two different color scales: one the spectral colors of light, and the other the tonal colors existing from white to black, which includes all the shades of gray that can be made by their mixing.

Yet still we see black as an exclusively visual aspect of the appearance of things, just as we see green as the color of peas and emeralds and see blue as the color of blueberries and sapphires. Perhaps confusingly (though confusion about black seems inescapable), blackmail, black humor, and black markets are not among the things that we see as black. And, oddly, neither is an airplane's black box (which, it turns out, is orange). But the letters of the words you are now reading on this page are unmistakably black, not green or blue; and so are ravens and crows, and almost all of a clarinet — and panthers, and thirty-six of a piano's eighty-eight keys. And the night sky is black.

Though just what that last sentence means is difficult to determine. What is it that we are seeing that looks black when we look up at night? What is the thing of which its blackness is a primary visual characteristic? The sky? Or the space beyond? Or nothing at all? A nothing that has no color? Or the color of nothing? The "nothing that is not there," in Wallace Stevens's words in "The Snow Man," or "the nothing that is"? Or are we just seeing black?

If we are not exactly sure what it is that we are seeing *as* black, we are nonetheless confident that it *is* black. It is the color of the night sky, seemingly just as blue is the color of the sky that we see on a cloudless day. But there is a difference between the blue sky and the black one. The blue of the blue sky

fits reasonably neatly into our conventional understanding of how colors are produced. It is an effect of the scattering of sunlight by the molecules of the atmosphere in such a way (a phenomenon known as Rayleigh scattering) that the shorter wavelengths of the light, which correspond to blue and violet, are mainly what get absorbed and are then radiated throughout the sky. But, at whatever time of day, once one is about eleven miles above the earth (in what is known as the mesosphere), our sky appears black because there is nothing there to scatter the light.

On the earth, the sky at night appears black, though not because there is nothing to scatter the light, but because there is not enough light to scatter. Even the billions and billions of stars in space (some of you will remember that as a quotation from Carl Sagan) do not determine or even affect the color of the night sky. Their light appears only as shimmering points set in a limitless field of black, though perhaps we might describe that field, in Milton's phrase, just as "darkness visible" (*Paradise Lost*, 1.63), not really a color at all.

But we see it as color. We see it as black. Though maybe this has nothing to do with sight. At the very least, we *think* of it as a color. It is black—not the absence of color (nor, as some think the combination of all colors), but an individual color like all the others, though perhaps as the color before the others existed. It is our name for the darkness that, in almost all creation mythologies, was there "in the beginning." Genesis tells us, "In the beginning God created the heaven and the earth. And the earth was without form, and void; and darkness was upon the face of the deep. And the Spirit of God moved upon the face of the waters. And God said, Let there be light: and there was light. And God saw the light, that it was good: and God divided the light from the darkness. And God called the light Day, and the darkness he called Night" (Gen. 1:1-5, KJV).

The creator called the darkness Night. We call it black. We are told—
and we believe—that it was there in the beginning. It is our ground zero. The
nineteenth-century French surrealist poet Arthur Rimbaud claimed that he
had "invented the colors of the vowels," and in his sonnet "Voyelles," he as-
signed the color to each: "A noir, E blanc, I rouge, U vert, O bleu."[18] Critics
have usually assumed that the relation between letter and color was merely
arbitrary. But "A" is *noir;* "A" is black. That's the color of beginning.

Painters, however, were not always so sure, though the very first
painters used carbon blacks derived from charred wood and bone for the
images they drew on cave walls. But once other pigments were available, black
became just another color of the palette, and a secondary one at that, used to
color things that were black and for outlines and shadows. Yet painters gradu-
ally found in it something more energetic and complex. There was no longer
a question whether it was a color, only of how dominant a color it could be. In
certain hands it was powerful and primary, "a force," as Matisse said.[19] Look
at Caravaggio, Georges de La Tour, Rembrandt, Francisco Goya, J. M. W.
Turner, and Manet (particularly his wonderful portrait of Berthe Morisot).

And perhaps above all, look at Kazimir Malevich, with his *Black
Square* (Figure 36). Squares, actually; he painted three of them, the first in
1915, which he backdated to 1913, and the last in 1929 or 1930, though none of
these is precisely a square. (He seems to have referred to the painting just as
"Four-cornered Figure.") A black quadrangle on a white ground, the initial
version was exhibited in 1915 in the Gallery Dobychina in Petrograd (the once
and future Saint Petersburg). It was hung high near the ceiling across one of
the corners of the room, just as a religious icon might be displayed in a Rus-
sian home.[20]

The once-smooth matte black paint has now faded and cracked,
and an earlier Malevich abstraction has been discovered beneath it. But the

FIGURE 36: *Kazimir Malevich,* Black Square, *1913,*
The State Tretyakov Gallery, Moscow

painting demands to be seen as a radical beginning. Symbolically, though not
in fact chronologically, it is the first of his "suprematist" paintings. This ac-
counts for its backdating. Malevich placed the painting carefully in the art
gallery and placed it just as carefully in the history of art: at the beginning of
a new kind of painting, whenever it was actually first painted.

Malevich was not the only one for whom a black painting generated an exaggerated concern about artistic priority. Black seems to do that. In 1966, Barnett Newman wrote a letter to an art critic who had written a piece in *Vogue* about Ad Reinhardt's black paintings: "That you chose to write on Reinhardt is your affair but to have discussed Reinhardt in a whole article without mentioning my black painting, *Abraham*, the first and still the only black painting in history. . . . He never would have painted the black paintings if he had not seen my black painting."[21]

Newman at least had the good sense not to mail the letter. And in fact he was wrong. Not about Reinhardt: Reinhardt's first black painting was indeed made after Newman's, painted in 1953, four years after Newman's *Abraham*. And not even about Malevich, since his painting, after all, is not exactly a black painting but a painting of a black (not quite) square on a white background. But wrong about his own painting being "the first." Malevich's contemporary Aleksandr Rodchenko (who had also scooped Yves Klein) made a series of eight black paintings in 1918, thirty-five years before Newman's *Abraham*. When Newman belatedly learned about these, he insisted to friends that they were really a very dark brown.[22]

Clearly there is something about black. Malevich, too, had anxiously claimed priority for his black square, though priority in his own artistic development. His *Black Square* needs to come first, so it can be understood as the point of origin of something radically new, as "the first step of pure creation." Painting is no longer to be an imitation of something in the world. It is now, as Malevich said, "an end in itself," though of course that end was a beginning.[23] Malevich pointed the way, but as the first director of the Museum of Modern Art, Alfred H. Barr Jr., said, "Each generation must paint its own black square."[24]

Yet this beginning also has a precedent, not merely some thirty years earlier but almost three hundred. In 1617, an English polymath—physician,

philosopher, astrologer, mystic, mathematician—named Robert Fludd, a graduate of Oxford with a BA, MA, and MD, and the son of a not inconsequential official in Queen Elizabeth's court, published the first volume of his most ambitious work: *Utriusque cosmi maioris scilicet et minoris metaphysica, physica atque technica historia* (The metaphysical, physical, and technical history of both worlds; that is, the macrocosm and the microcosm).

It is a remarkably learned (if largely unreadable) synthesis of ancient wisdom and contemporary thought about the natural world and the cosmos, about the human and the divine. Today Fludd has largely been forgotten, but in the middle of the seventeenth century it was seriously proposed that his writings should replace those of Aristotle in the curriculum of both Oxford and Cambridge Universities.

In an early chapter there is an unusual engraving, though it will probably look somewhat familiar (Figure 37). It is a matte black, quadrilinear figure set within a white border, which could itself be understood, in Malevich's phrase, as representing "the zero of form." Fludd, however, is more forthcoming than Malevich about what it represents—even *that* it represents. Each of its sides is labeled *Et sic in infinitum* (And so on to infinity). It is not an abstraction. It is, like every other one of the sixty or so engravings in Fludd's book, an image of *something*. This one is the image of how Fludd imagined the originary chaos existing before the creation of the world. Not the darkness of death or of demons but the black of infinite possibility. It is a representation of what Milton would call "the womb of nature," of the infinity of "dark materials" available "to create more worlds" (*Paradise Lost*, 2.911, 996).

Malevich doesn't annotate his square, and its rigorous formal austerity might easily suggest that, unlike Fludd, he has abandoned both representation and narrative for a realm of pure form referring to nothing but itself. The painting, hanging in the position of a Russian icon, could be understood

Et sic in infinitum.

CAPUT V.

De tenebris & privatione.

UGUSTINUS *contra Manicheos* asserit, privationem nihil aliud esse, quàm tenebras, quæ definiuntur lucis absentia. Sed si rectè consideretur tenebrarum significatio, illam latiùs quàm privationis vocabulum se extendere percipiemus. Nam, teste *Moyse*, *tenebræ super faciem abyssi fuerunt*, priusquam lux seu forma crearetur: privatio verò nominari non potest, nisi respectu cujusdam positionis, hoc est, ubi est alicujus formæ præcedentis absentia. Quare, ut cum *Augustino* consentiam, *omnis privatio est tenebræ*, hoc est, formæ lucidæ

FIGURE 37: *Robert Fludd,* Utriusque cosmi maioris scilicet et minoris metaphysica physica atque technica historia *(Oppenheim, 1617), 26*

as a deliberately provocative, uncompromisingly nonreferential icon of the new modernist credo: art for art's sake.

But that may be to miss the point (or just to get the paint). A younger Russian artist, Varvara Stepanova, saw the *Black Square* as a metaphysical rather than a minimalist gesture: "If we look at the square without mystical faith, as if it were a real earthly fact, then what is it?" she asked.[25] For Stepanova, it was something almost exactly like Fludd's image: not a modernist insistence upon the inescapable materiality of the art object, but a mystical image of the void that was there "in the beginning." The *Black Square* is, then, not exactly nonrepresentational, but a "non-objective representation," in Malevich's phrase: the representation of what existed before creation, before there was anything to represent.[26] The painting is Malevich's own act of "absolute creation," the division of the darkness from the light, a creation, like God's in Genesis, not *ex nihilo,* out of nothing, but out of the dark pre-existing matter that required light and form—that first "beginning," which wasn't exactly that.[27]

Malevich seems much more like his distant precursor Fludd than he does his most obvious modern successor, Ad Reinhardt, whose austere, subtly nuanced black paintings had made Newman so very anxious. Or at least Malevich seems more removed from the painter Reinhardt said he was. "The religion of art is not religion. / The spirituality of art is not spirituality," Reinhardt wrote, insisting that he "wanted to eliminate the religious ideas about black."[28] Yet then again, Reinhardt said that he wanted to eliminate almost everything from his paintings—color, gesture, reference, personality. His great paintings could be taken as compelling evidence of the power of negative thinking. But for all the self-conscious renunciation, he never succeeded in fully eliminating the religious ideas, which is no doubt why he so often insisted he had. Religious ideas about black just won't go away, either the posi-

tive or the negative ones. Malevich had his painting hung in the Gallery Do-
bychina as an icon—because it was one, the black square showing what was
there at the beginning and showing the act of creation that gives it form.

Black. But, maybe surprisingly, matte black, that is, the dull not the
shiny version. *Ater* not *niger; sweart* not *blaec*. But that, too, was by design.
Malevich (and also Reinhardt) carefully leached the oil from his paints, thin-
ning the black, precisely so that it would not produce a lustrous black surface.
A shiny black would reflect its surroundings, but the black he wanted was a
black that was only itself, the black that was there before there was anything
to reflect. Fundamental. Essential.

Really basic black.

What was there in the beginning and what might be there at the end.

When Malevich died, mourners carried banners printed with his
Black Square. His ashes were taken in a railroad car marked with the *Black
Square* to the village outside of Moscow where the family of Malevich's wife
lived and where a small cube with the *Black Square* had been created by his
friend Nikolai Suetin to mark his burial place.[29] The monument was destroyed
during World War II, when still another darkness covered the earth.

When Reinhardt died, Thomas Merton, the poet and Trappist monk
(and arguably the most influential American Catholic of the twentieth cen-
tury), wrote to the poet Robert Lax to tell him of their college friend's much-
too-early death at fifty-three. "He walked off into his picture," said Merton,
consoling himself that "Ad is well out of sight in his blacks."[30] But maybe
we all walk out of sight into that black. Supposedly the last words of the
nineteenth-century French novelist Victor Hugo were: "I see black light."[31]

Of course he did: the darkness visible. Black is the color of both our
beginnings and our ends—and it is the dark color of Lulamae Barnes's Little
Black Dress and the color of her brightest dreams.

CHAPTER NINE

■

Not yet have we solved the incantation of this whiteness.
HERMAN MELVILLE, Moby-Dick

White

LIES

W hite is the mixture of all colors." This is the first of its lies. Newton's prism had indeed shown how "white" light could be divided into a continuum of more or less distinguishable colors, which could then be refocused back through the prism to reconstruct the original white light. But, first of all, the light was never what almost anyone would normally call white. And, second, the idea of white as a combination of all colors, though true for light, isn't true for pigments, as anyone who has ever mixed paints together will know.

What then is white? Is it, as has been asked about black, even a color at all? For physicists, the answer (just as for black) is typically no. Colors for physicists are merely the bands of visible light produced by specific wavelengths of electromagnetic energy (this last bit is what they have added to Newton's account). "White" light consists of the totality of these component colors. But if white is what the component colors of light combine to produce, that would seem to make white something different from any one of them, which is part of the way they justify denying that white is a color.

And yet in this case the sum seems much more like its parts than, say, water is like the elements of which it is composed. That is, white is more like red or green than water is like a molecule of oxygen or two of hydrogen. Still, the similarity of the whole to its parts in the case of white isn't quite enough, at least for the physicists, to override the logic of their exclusion, although for the rest of us the obvious similarity accounts for the fact that generally we are unimpressed by their reasoning.

Little is gained by the refusal to consider white a color — or black or gray. We could — should — say that these are achromatic colors, which have

FIGURE 38: *Frank Stella*, The Whiteness of the Whale, *1987*

lightness though not saturation or hue, but in most contexts the technical distinction isn't of much use. For almost all purposes, it makes sense to consider them colors. So, for the purpose of this book, white is a color—and not just one that we see but one onto which we load symbolic meaning. We do that with all colors, but with none more intensely than white. White is the color of unspotted purity and of complete absolution, of blank pages and clean starts. But that is the second of its lies.

White is also the color of ghosts. Of skulls and bleached bones. Of maggots. White literally "appalls" (etymologically the word means to make pale). Instead of promising a future or forgiving a past, this white terrifies or disgusts. It "stabs us from behind with the thought of annihilation," as Herman Melville says in *Moby-Dick*.[1]

This might be the third of its lies, although it is really just another version of the one before. Each is the lie that white means anything at all. Colors don't mean. The painter Ellsworth Kelly alleged that "color has its own meaning."[2] Maybe that's true. But color doesn't tell us what that meaning is. We tell the color; and whatever we say it means, we make it mean, and we make it mean without much help from our visual system.

Melville knew that, too. He doesn't tell the lie. He just reports it, though hardly straightforwardly. *Moby-Dick* is a "strange" and "ungainly" book, as Melville himself admitted in a letter in 1850 to Richard Henry Dana, particularly so if it is taken to be about Captain Ahab's monomaniacal quest for the great white whale. It is more than 500 pages long in whatever edition you read it (or more likely don't read it—but do). It would be a wonderful adventure story if it were 150 pages, but there are all those tedious digressions about whales and whaling that keep the story at bay. In a novel of 135 chapters, Ahab doesn't appear until chapter 28 and we don't see Moby Dick until chapter 133. A third of the book has passed before someone cries, "There she blows!"

The novel is one of those "large loose baggy monsters," as Henry
James termed various long and unwieldy nineteenth-century novels.[3] In so
many ways it's excessive. And yet, it's not the adventure story but the excess
that makes it a great novel. But a great novel about what if not about a whale
hunt? Maybe about excess. Particularly about the excess of meaning that at-
taches to white.

Chapter 42 is called "The Whiteness of the Whale." It's tempting just
to include it here in its entirety. Ishmael, the novel's narrator, admits that it
"was the whiteness of the whale that appalled" him, and the paragraph that
follows is a single extraordinary (excessive?) sentence, with clause piling
upon clause, each joined by a semicolon, tracing the positive associations of
white across time and cultures as a sign of beauty, innocence, majesty, joy,
fidelity, and holiness. Four hundred and thirty words of a 470-word sentence
breathlessly compile evidence of how white is associated "with whatever is
sweet, and honorable, and sublime" — until the inevitable "yet" comes, in-
deed comes twice: "*yet* for all these accumulated associations . . . there *yet*
lurks an elusive something in the innermost idea of this hue, which strikes
more of panic to the soul than that redness which affrights in blood" (160).
The "innermost idea of this hue" is what Ishmael's story must explain, or
"else," he says, "all these chapters might be naught" (159).

Not to understand this enigmatic whiteness is, then, not to under-
stand Ishmael, not to understand Ahab, not to understand the multihued,
multicultural crew of the *Pequod*, not to understand the white whale — not,
that is, to understand the novel at all. But what we are invited to understand is
that whiteness *is* an enigma. "The whiteness of the whale" is "a dumb blank-
ness, full of meaning" (165). But the fullness of meaning is a function of that
unresisting blankness, an emptiness that allows (encourages?) us to imagine
meaning in it. We invest it with meaning, but the meanings are all our own.
The "innermost idea of this hue" is that it doesn't have an innermost idea.

White becomes our symbol of symbols precisely because of this vacancy. It reminds us that symbolic meanings are never natural or inevitable. Take, for example, green, a nearly universal symbol of fertility and rebirth for obvious reasons. But it is also a symbol for jealousy and envy. In China it is a symbol of infidelity; in the United Kingdom it's the color of "awareness ribbons" for childhood depression, kidney cancer, workplace safety, and open records for adoptees. You can make similar lists of unpredictable and even contradictory symbolic associations for every color. Color symbolism is unsystematic and multivalent. In the case of white, what Ishmael calls its "indefiniteness" just makes the arbitrariness of its associations more obvious than with other colors.

For Ahab, the whiteness of the whale is the symbol of its malevolence, a mark of "that tangible malignity which has been there from the beginning" (156). But if the white whale swims "before him as the monomaniac incarnation of all those malicious agencies," it is Ahab's monomania that incarnates it so. On to "the whale's white hump," he has "piled . . . the sum of all the general rage and hate felt by his whole race from Adam down" (156). That's a lot of piling, and sometimes a white whale is just a white whale (Figure 39).

And sometimes a white lamb is just a white lamb. But we pile symbolic meanings on it, too, though obviously different ones than those Melville's white whale carries. White is the color of the mystic lamb, the symbol for Christ's sacrifice for the salvation of humankind. "Behold the Lamb of God," says the apostle John, "which taketh away the sin of the world" (John 1:29, KJV). But in Francisco de Zurbarán's remarkable painting of the *Agnus Dei,* the meticulous rendering of the animal's body uncomfortably reminds us that this particular lamb has not chosen its sacrificial role (Figure 40).

Zurbarán, in fact, painted six versions of the painting. In one (now in San Diego) there is a halo over the lamb's head and the inscription TAMQUAM

21. — ROSCOFF. — La Baleine échouée en Décembre 1904. — Long. 20 mèt. — Circonf. 13 mèt.
Baillière, édit. — Roscoff.

FIGURE 39: *"Does the Whale's Magnitude Diminish?— Will He Perish?"*
Dead whale on the beach in Brittany, 1904

AGNUS (as a lamb), making this symbolism unmistakable: this is Jesus, who was "led as a sheep to the slaughter; and like a lamb dumb before his shearer, so opened he not his mouth" (Acts 8:32, KJV). In the version now in the Prado in Madrid, there is only the lamb, but even in the ones with some explicit indication of its intended meaning, the lamb itself is so carefully observed and meticulously rendered that it cannot be fully absorbed into the simile. As a symbol, Zurbarán's *Agnus Dei* seeks to unite the world of the spirit and the world of the flesh, but the astonishing proficiency of the painting itself pries the two realms apart. It just cannot be forgotten that this is not Christ the

FIGURE 40: *Francisco de Zurbarán*, Agnus Dei, *1635–40,*
Museo Nacional del Prado, Madrid

Savior but a living lamb that won't be saved. Zurbarán is simply too good a
painter.

Symbols are objects or images that stand for something else. But it
is the something else that really matters. The symbol should give way effort-
lessly to the thing that is symbolized. The symbol matters only because what
is symbolized matters more. But Zurburán's lamb resists. It won't give up its
hold on us, not because the artist makes us sympathize with the lamb he has
painted but because he has painted that lamb so perfectly. Symbols can't sur-
vive that painterly perfection.

With Melville it works the opposite way. Melville's artistry at first

seems to insist that the whale is a symbol. "Of course he is a symbol," wrote
D. H. Lawrence. "Of what? I doubt if even Melville knew exactly."[4] But what-
ever Moby Dick may be thought to symbolize, Ishmael, the novel's narrator,
is a reluctant participant in the creation of the symbolism. Ishmael focuses
our attention on the whale itself. In seventeen chapters of seeming interrup-
tions of the narrative, the whale is methodically described, anatomized, and
classified. Ishmael conscientiously provides us with "the plain facts, historical
and otherwise" about the mammal. He keeps its physical being before us. He
insists on the materiality of the whale, preventing it from being easily under-
stood "as a monstrous fable, or still worse and more detestable, a hideous and
intolerable allegory" (172). That would never do.

But the more Ishmael insists on those plain facts, the more this weak-
ens the grip they have on us. They are all too easy to skip over. We get impa-
tient for the story that is put on hold. And in any case, they don't take us very
far toward understanding the creature that gives the novel its title. The whale,
defined "by his obvious externals," as Ishmael says, is *a spouting fish with a
horizontal tail.* There you have him" (117). But do we? First of all the central
fact is wrong: the whale is not a fish; it's a mammal. We know that; Ishmael
does, too. He, however, willfully rejects Linnaeus and instead "calls upon holy
Jonah to back" him (117). But second, wherever the whale fits in the taxon-
omy of living creatures, its "obvious externals" hardly let us "have him" (117).
Even Ishmael comes to realize that "dissect him how I may, then, I but go skin
deep. I know him not and never will" (296).

Skin deep, the novel seems to insist, is never enough. Melville
famously said: "I love all men who dive."[5] But maybe skin deep is as far as we
can go. Surfaces may be just "pasteboard masks," as Ahab says (140). But what
are the realities that we think we will find below? Beneath the skin, as Ish-
mael's cetology makes clear, is nothing metaphysical, just more messy mat-

ter: blubber, bones, and blood. Ahab is usually certain that he knows better, but even he at times worries that "there's naught beyond" (140). And Melville seems pretty sure that we are just making it all up.

In his response to a letter from Nathaniel Hawthorne's wife, Sophia, Melville gently refused her "highly flattering" but allegorical reading of the book. "You, with your spiritualizing nature, see more things than other people, and by the same process, refine all you see so that they are not the same things that other people see," he wrote back to her, "but things which while you think you but humbly discover them, you do in fact create them for yourself."[6]

There are no fixed meanings for the enigmatic and elusive whale or for its whiteness, except for the ones we provide. "It is all in all what mood you are in," says Ishmael: "if in the Dantean, the devils will occur to you; if in that of Isaiah, the archangels" (295). Perhaps that's easier to say about a whale than about a lamb, since the symbolic connections in the whale's case are not so deeply inscribed in the culture. Zurbarán's Prado painting antici-pates and even welcomes what will be "piled" on his lamb, and it is only his breathtaking artistry that keeps so much of our focus on the tethered animal.

A whale is different. Not that it is entirely free of theological asso-ciations: there's Job's whale and there's Jonah's. But the whale in Melville's novel is burdened with meanings that are unconnected to its actual being. Ishmael keeps that being before our eyes, allowing the meanings to be seen as the product mainly of Ahab's own fanatical meaning-making. Melville himself seems so much less convinced, and the whale of course doesn't care. It's indif-ferent. The malevolence is all Ahab's own. The whiteness of the whale, while not exactly an inkblot to be read, is a provocative blankness to be inscribed.

In various languages, the word for "white" is related to the English word "blank": Spanish *blanco* and French *blanc*, most obviously. Even in En-

glish, the word "blank" retained a similar color sense well into the eighteenth century. It meant not just "empty" or "vacant," as today, but also was a color word meaning pale or white. Chalk was "blank." Birds were often described as "blank," particularly young falcons; and even Milton's pale moon is "blank" in *Paradise Lost* (10.656). Melville's whale is "blank" in both of its English senses. White and empty. A blank canvas upon which we can paint anything we wish. Not an allegory, which always comes prepainted.

And yet white itself, we know, is not blank. It is not an innocent color, although it is normally the color of innocence. Not that it is actually capable of "imparting some special virtue of its own" (159), but the color has absorbed the meanings imposed upon it. "Though your sins be as scarlet," promises Isaiah, "they shall be as white as snow" (Isa. 1:18, KJV), though modern city dwellers know how short-lived that particular whiteness is. One could hope that innocence would be more durable. But the fantasy is nonetheless pervasive. White is innocent, good, and pure.

Or so they say. No doubt the particular meanings attaching to white and black, light and dark, can be traced all the way back to the lizard brain: to the ancient terrors of the night and the uncertainties about whether the sun would rise again. But the sun easily gets transformed into the Son, radiant in his white robes: "shining, exceeding white as snow; so as no fuller on earth can white them" (Mark 9:3, KJV).

And that leaves black to bear the burden of its putative opposition: dark, stained, impure, sinful.

It is obvious where this dualism leads, especially if we only see "skin deep." If *Moby-Dick* is the great American novel, perhaps it is because Melville understands all this so clearly. "Melville knew," said Lawrence: "He knew his race was doomed. His white soul, doomed. His great white epoch doomed."[7]

But maybe what Melville knew was that he needed to refuse the dual-

ism of white and black that underwrites the corrosive racism in (not "of")
the novel. Ishmael matter-of-factly reports that white's "pre-eminence" in
the world of colors "applies to the human race itself, giving the white man
ideal mastership over every dusky tribe" (159). But that "mastership" is hardly
"ideal," and in any case cannot be justified on chromatic grounds. Colors
should just be optical facts. But by 1851, when *Moby-Dick* was published, a
decade before the American Civil War, Melville certainly knew that it was
much too late for that.

A century later, Optic White would be the name of the signature
color of the fictional Liberty Paint Company in Ralph Ellison's *Invisible Man*
(1952). It is a color described as "the purest white that can be found," but a
color that is made by the addition of ten drops of black paint to the white
paint, serving Ellison as a symbol of the fantasy of white racial purity and
privilege. "If It's Optic White, It's the Right White" is the company slogan,
echoing a familiar sardonic bit of Afro-American social commentary: "If
you're white, you're right."[8]

Fifty years later still, Optic White would become, presumably with
no irony, the name of a tooth-whitening product made by Colgate. That seems
unobjectionable enough, even if it would be nice to think that marketing
people read novels. But cosmetic companies do make skin-whitening prod-
ucts, bleaching creams that reduce the melanin in the skin, and so whitening
brings us full circle, back to the very dualism Melville wanted to — but knew
he couldn't — escape. If you're white, you're right; if you're black, get back.

Even in seemingly benign contexts in which white might plausibly
appear to be only an optical fact, disquieting values easily sneak in. The deeply
rooted classicism of European culture had always revealed itself in its stig-
matization of color: "chromophobia," in David Batchelor's useful word.[9] Its
ideals of beauty were derived "historically" from its encounters with the ruins
of Rome and, even more, of Greece, as eighteenth-century Europe embraced

the aesthetic standards of proportion, simplicity, balance, and grace it found in the architectural and sculptural survivals (standards that then would re-appear in the austerity of a twentieth-century modernism). Refinement and rationality became their credo, refinement and rationality traced back to the Greeks, refinement and rationality — but always without color.

Somewhere behind all this was the belief in the supremacy of classi-cal art founded not on its successful imitation of nature but in its perfecting of it. And the perfection was located not only in its grandeur, proportion, and repose but also in its whiteness. For "the perfect images of antiquity," as the first great scholar of classical art, Johann Joachim Winckelmann, confidently asserted in 1764, white was their perfect color: "Since white is the color that reflects the most rays of light, and thus is most easily perceived, a beautiful body will be all the more beautiful the whiter it is."[10]

Renaissance artists had taken this to be true, imitating what they thought to be the practice of the ancients. On their example and, later, on Winckelmann's prestige, the idea that classical sculpture was necessarily white because it expressed what Walter Pater would call "the colourless, un-classified purity of life" was established as a fact.[11]

This was the source of the neoclassicism of the eighteenth century, as in the beautiful white marble statues of Antonio Canova. But the fact may be less indisputable than has been assumed. The classicism that gave rise to it might merely be a kind of class-ism. In 1810, Goethe, who greatly admired but never met Winckelmann, claimed that it is only "men in a state of nature, uncivilized nations, children," who "have a great fondness for colours in their utmost brightness."[12] Civilized adults should not so easily be distracted from essential truths by such seductive gratifications. Only if it's white is it right.

The reality, however, was that classical statuary was not inevitably white. Now we know that, and it is possible that Winckelmann knew it, too. Scholars have confirmed that these statues often were colored but that their

original paint and gilt has been lost to time. In Euripides' play about Helen of Troy, Helen complains that she has suffered because of the jealousy of Hera but understands also that her own beauty is partly to blame. She tells the Chorus that she wishes she could erase it, "the way you would remove the color from a statue."[13] The gleaming marble that seems so essential to classical and neoclassical sculpture, and that has given form to our idea of the beautiful, is seemingly just one more of white's proliferating lies.

Is there, then, some truth that *can* be told by white? Other, that is, than the truth that it lies? Though that one, it must be said, is hardly insignificant.

There is a least one person who looks for its truths and tells them. Again and again. The American artist Robert Ryman has made a career painting white and painting with white. White is both his subject and his medium. There are no truth claims in his art, except for the many muted, subtle, experiential truths of how paint may be applied to a surface. These are no stories, no images, no allusions, no metaphors. Just paint on surfaces. Different whites, applied differently, applied to different supports, and then differently mounted. But never a pure white, whatever that might mean; only the many impure whites that tell us, like Ellison's "optic white," that white's purity is a lie. Only whiter shades of pale, and paler shades of white. And, of course, the evidence of Ryman's obsession with the color (Figure 41).

Ryman is no less obsessive than Melville's Ahab, but he's obsessive about his white as material rather than metaphor. It's paint. It is remarkable what he does with the white paint, what he makes the white paint do. But he doesn't make it mean anything or let it mean anything; and so his white doesn't lie.

The price of its honesty may be the austerity of the visual field of Ryman's paintings: the absence of the exhilaration of color. But to call these white paintings, for all their severely restricted chromatic effects, "taciturn,"

FIGURE 41: *Robert Ryman*, Untitled #17, *1958. Oil on stretched cotton canvas,*
54¾ × 55 in. (139.1 × 139.7 cm). The Greenwich Collection Ltd.

as some art critics have done, crucially misses the point. They don't speak,
even laconically. They don't speak at all. Language is the domain from which
the lies come from. The truths are visual. They come from the color, not the
color *of* something and not a color that *means* something. Just the color. Just
white, which repeatedly serves Ryman as a self-imposed restraint demanding
all the artistic energy and intelligence that make these paintings "too perfect
for words," as another critic has said.[14]

That's it exactly.

Ryman's white is a white freed from language and symbolic mean-
ings. The paintings are saturated with color, not with significance. "The
painting should just be about what it's about, and not other things," Ryman

said.[15] And this is about white. This is white that really is an "optic white," precisely because it's *not* about "other things." It's not symbolic. Symbols must be learned before they can be recognized. This white asks only to be seen. It's a white that is neither classical nor Christian — a white that is unburdened with anything other than Ryman's artistry.

The paintings aren't *about* anything, except about his taking pains and giving pleasure, about what can be made and what will endure.[16] This might be the only solution to the mystifying "incantation" of whiteness: to peel away the film of significance from the color in order to see it just as it is, though for most of us there isn't any such unmediated seeing to be done. It is almost always impossible to keep color from being tinted with other things. But certainly Ryman tries.

Ryman's contemporary Frank Stella once impishly said that he merely "tried to keep the paint as good as it was in the can."[17] But both Stella and Ryman always make the color better, better by understanding what color is and what it is not — and helping us understand. For them, it is what is there on the canvas, before our eyes, not what we think is supposed to be there before we have looked. But clearing our vision is not very easy. It takes time.

For about twelve years, Melville's *Moby-Dick* served as the organizing focus of Stella's artwork.[18] Between 1985 and 1997, Stella created 275 pieces in a variety of media: sculpture, relief, painting, collage, engraving, and lithograph. Each took its title either from one of the novel's 135 numbered chapters or the three additional unnumbered sections. He told a newspaper reporter that after seeing some whales at an aquarium, "I decided to go back and read the novel, and the more I got into it, the more I thought it would be great to use the chapter headings of the novel for the titles of the pieces."[19]

The allusive titles no doubt invite us to "read" Stella's abstract creations, seeking their meaning in some relation to the novel's details and its

deeper implications. But it's not exactly clear how much he "got into" *Moby-Dick*—or out of it. Stella obviously had read the book—at least well enough to know the names of its chapter titles, but his work is not a reading of *Moby-Dick* or a set of illustrations of the novel (which might well be the most often illustrated novel of all time). It isn't really an artistic response to it. His interest is in forms and colors, not words and meanings. The work is no more about *Moby-Dick* than Monet's water lilies are about flowers. It is about art. There's nothing more in it than what meets the eye, although an awful lot does.

The exuberant grandeur of these pieces marks a sharp turn from the cool glamour of Stella's early paintings and prints. Geometry gives way to gesture. Squares to swirls. Protractors to pinwheels. In *The Whiteness of the Whale* we see the curvilinear wave and whale shapes that reappear throughout his series, but also other irregular forms painted yellow, orange, red, blue, gray, and black in between (see Figure 38). White, instead of being the familiar background on which "real" color sits, is forced to the foreground here, but as an indistinct white area, mapped out with squiggles and lines. It looks as if it wants to recede to the familiar place where it "belongs," but it can't.

The title of the piece tells us that this white form must be the whale, but even Stella doesn't seem so sure: "I have one piece titled after the famous chapter, *The Whiteness of the Whale,* in which at least the *wave* is all white," he said to the reporter. Maybe he just misspoke, or the reporter misheard— or maybe it just isn't very important which shape is white. "I keep trying to make pieces that are black and white but they always get very colorful," he said about his creative process. Nothing here about whales or the incantation of whiteness.

But maybe it's better that way: at least trying to keep the color "as good as it was in the can" and just leaving it to "its own meaning." Otherwise it lies.

CHAPTER TEN

Gray is the sad world
Into which the colours fall.
DEREK JARMAN, Chroma

Gray

AREAS

FIGURE 42: *Nicéphore Niépce, enhanced and retouched version of the oldest surviving photograph,* View from the Window at Le Gras, *c. 1826*

"Photographs," said Susan Sontag, "really are experience captured."[1] The "really," however, poses a problem. "Experience captured," yes, but for a long time it was an experience captured only in shades of gray. Is that "really" the way experience looks? What happened to its color?

John Berger, the brilliant art critic (whose recent death has robbed the world of one major source of its conscience), more accurately has said that photographs "are records of things seen."[2] He's right. It is precisely that they are the *records* — not the images — of those things, at least if they are in black and white (to say nothing of their other usually unremarked formal conventions: their reduced scale and two-dimensionality). Yet from the moment of the invention of photography, the striking absence of color from its images was almost always ignored. Even later, when high-quality color photography had become possible, most of the great modern photographers still eschewed color for their serious work. William Eggleston, who could be said to have given color photography respectability with his 1976 exhibition at New York's Museum of Modern Art, recalls with some delight a comment made to him by the French photographer Henri Cartier-Bresson: "You know, William, color is bullshit."[3]

Most were not as forthright. Still, it seems to be what most serious photographers thought. They could have shot their pictures in color, but usually they didn't: Cartier-Bresson, of course, but also Edward Weston, Ansel Adams, Edward Steichen, Berenice Abbott, Alfred Stieglitz, Diane Arbus, Walker Evans (who in fact did take color photographs, though not for his often heartbreaking recording of rural poverty but only, with some obvious irony, for his commercial work for *Fortune*) — and later Richard Avedon, Irving Penn, Mary Ellen Mark, and Robert Adams. "*The mirror with a memory,*" in Oliver Wendell Holmes Sr.'s elegant definition of photography, was pretty much color-blind.[4]

From the beginning, however, almost no one noticed. Photography shows us "the perfect image of nature," as Louis Daguerre, one of the technology's inventors, proclaimed in 1839.[5] And a century later, Paul Valéry would say that photographs show us "what we would see if we were uniformly sensitive to everything that light imprints upon our retinas, and nothing else."[6] The photographic image is "perfect," and the precision of the new technology perfects our inadequate visual system.

But for all of photography's celebrated perfection, capturing the color of the world didn't seem to be a part of it, and that limitation was rarely even remarked upon. Samuel Morse, the inventor of the telegraph and an early enthusiast for the new technology, was among the very few who even thought to comment, praising the exactness of the photograph's "definition," but acknowledging that it appeared "in simple chiaroscuro, and not in colors."[7] But he reported this merely as a fact rather than as a flaw.

There was no color. What is usually identified as the oldest surviving photograph (though its inventor called it a "heliograph"—a sun drawing) is known as *View from the Window at Le Gras* (see Figure 42). A blurry, grainy image fixed on a pewter plate in 1826, it is a view from the attic window of the country house of Joseph Nicéphore Niépce, a Frenchman, who had been for well over a decade experimenting with various ways of preserving projected images on light-sensitive materials. The original, now in the Harry Ransom Humanities Research Center at the University of Texas, is virtually indecipherable. The image can be made out only in the copy made by Eastman Kodak for Helmut Gernsheim in 1952, and then improved by Gernsheim with watercolor—so what is often reproduced, as here, is not exactly what it is usually claimed to be.[8]

Niépce seems to have been attempting to capture this exact image from the window for at least ten years. In 1816, he described it in a letter to

his brother: the view over the courtyard of the estate, with the loft of a dove-cote on the left, the slanting roof of a barn hovering in the center, with a pear tree rising between and behind them, and a wing of the country manor on the right, all set against a horizon. Niépce's photograph, however, is a ghostly abstract of planes and shadows. And although Niépce claimed that his technique was "eminently suitable for rendering *all the delicate tones of nature,*" those delicate tones are only shades of gray.[9]

They are not even what they are usually said to be: "black and white." Zebras are black and white. Photographs are not. Hyphenation maybe helps a bit: "black-and-white." But not enough. "Black *to* white" might be a more accurate term, recognizing the infinite gray scale of the color tones existing between black and white that so-called black-and-white photographs depend upon. But what they are is gray. "Gray" photography is what it should be called. That is what it is.

For a long time the grays were enough. No one seemed to care that there was no color. People continued to discuss photography as a technology perfectly recording what was seen and even able to reveal what the unaided eye was incapable of seeing (as in Eadweard Muybridge's remarkable studies of motion). The twentieth-century French film critic André Bazin said that photography is the "true realism"; it gives "significant expression to the world both concretely and its essence."[10]

"Its essence" is the key term here (though "concretely" might well raise its own questions). The world's essence, though, seemingly was gray. Color was not essential to it, or to its representation. Color was understood as something secondary, decorative, maybe deceptive, and always distracting, so its absence could be imagined as a purification of the world that photographers sought to record. Photography was seen as a form of mechanical drawing: "the pencil of nature," as an early experimenter with the technology

called it.[11] In the long history of the contest in the visual arts between the claims of line and the claims of color, photography was initially placed on the side of line. Color doesn't matter.

The world, however, isn't gray (and it is certainly not black and white). Of course, for a long time there wasn't a reliable technology to generate color photographs. Unsurprisingly, some people noticed the lack of color, and some tried in various ways to provide it: hand-coloring photographs, using toners that could bind with the silver grain to color the black and white or, most significantly, attempting to produce durable color photos almost from the moment photography was developed. The first color photograph was made in 1861, but there wasn't a widely available color film until the 1930s with the introduction of Kodachrome.

But initially these were all curiosities. Black-and-white photographs were almost always what people saw, and their absence of color was not thought to be deserving of comment. It was just a matter of fact—but of course that is exactly what it is not. Perhaps the most salient "fact" about "reality" is that "it comes in color," as the great photographer Pete Turner insisted in 2010: "Maybe that's exactly what makes it bearable. So why don't we shoot it that way?"[12]

Although at first the obvious answer was simply that they couldn't, even once they could, most photographers didn't. And many still don't. By the 1960s, color had replaced black and white as photography's default condition, but even then black and white didn't go away. In fact, the near ubiquity of color both for family pictures and for advertising newly encouraged the use of black and white for art photography. Many photographers and art critics began to insist (defensively?) that black-and-white photographs allowed a control of tone and precision of detail impossible with color film. This may sound a bit like the early protests about the use of sound from defenders of

silent movies. But many photographers did—and still continue to—insist that "black and white are the colors of photography," as Robert Frank said, and that its gray scale can successfully stand in for the rest of the colors, without their distractions.[13]

It is, of course, now a choice—and probably too easily becomes a cliché. Black and white becomes a self-conscious gesture, either retro or artsy: a simulacrum of authenticity, an assertion of artistic seriousness, and, too often, an affectation, designed to produce what the poet Stephanie Brown calls "a nostalgia for feelings we never had."[14] Black and white becomes a "look." When Paul Simon first recorded his song "Kodachrome" in 1973, buoyed by the charm of the color effects possible with the new film stock, he sang: "Everything looks worse in black and white." By the time he recorded the song for *The Concert in Central Park* in 1982, however, he was singing: "Everything looks *better* in black and white." Along with sepia (which just adds brown tones to the gray scale of the original print), it had become the color of our memories. Not of *what* we remember but the color of memory itself, which is always, at least in part, a kind of amnesia.

This may even be the case (or at least became the case) when the memories were of recent nightmares: the black-and-white photographs of the rural poverty of the Dust Bowl, the images of the internment of Japanese Americans, or the scenes of inhumanity recorded as Allied soldiers liberated the Nazi concentration camps. These pictures are gray. And if their grayness authenticates their veracity, over time it works to sequester their images securely in the past. Once *color* becomes the predictable formal condition of photography, monochrome photographs begin to lend their subjects a comforting patina of age, robbing the image of much of its historical specificity, as it becomes merely past. Their modulated gray tones remove the image from lived experience, thereby weakening our moral engagement with their con-

tent. The gray scale releases their images' hold on us or, rather, forges a different one. An image that was designed to show "now," often demanding a moral or a political response, becomes the idiom of "then," mainly triggering emotional and aesthetic ones.

Think about one of the best-known black-and-white photographs, maybe the single best known: Dorothea Lange's portrait of a careworn itinerant farmworker, now usually known as *Migrant Mother* (Figure 43).

Lange's famous photograph was taken at a campsite for migrant pea pickers in Nipoma, California, in March 1936. Lange, who had worked for a long time in San Francisco as a portrait photographer, was at that time employed by the Resettlement Administration (later renamed the Farm Security Administration). This was a New Deal governmental agency, much of whose work involved relocating families from the dust bowls of the American Southwest to relief camps in California. Lange was hired, along with other photographers (including Walker Evans and Gordon Parks), to work in the agency's "Historical Section," a photodocumentary project designed to record the administration's activities and build popular support for them.

Migrant Mother was one of a series of six photographs Lange took of a woman and her children.[15] The success of the picture has made the image impossible to avoid and yet hard to see clearly through the sheen of its now-iconic status. It has become the great cliché of the Depression: the carefully composed dignity of a family's poverty. The two older children frame their mother as they burrow behind her head, avoiding the camera's intrusion, and the infant on her lap is swathed in a dirty blanket. The light on her forearm leads the viewer up to her pinched face. The deep-set eyes of the thirty-two-year-old woman (Lange had asked her age, not her name) stare off to her right, her brow furrowed, the fingertips of her right hand anxiously touching the corner of her turned-down mouth.[16]

9058-C

FIGURE 43: *Dorothea Lange*, Migrant Mother, *1936*,
Candid Witness *series, George Eastman House*

Maybe it is just too good a photograph. Picture perfect. Posed and flawless (the stray thumb on the tentpole at the lower right was later edited out of the image). Remember that Lange had been an extremely successful portrait photographer for San Francisco high society. Roy Striker, who was also a photographer and Lange's boss at the Farm Security Administration, said of this portrait: "She has all the suffering of mankind in her but all of the perseverance too. A restraint and a strange courage. You can see anything you want to in her. She is immortal."[17] You can, and she is: determined, distracted, disaffected, dignified, defensive, distressed, defiant. Her eyes narrow and focus somewhere in the middle distance, but what she is feeling we don't know; we can't know.

We do know, however, that the woman later felt betrayed by the photograph. In an article in the *Los Angeles Times* in 1978, when she was at last identified as Florence Owens Thompson, she said: "I didn't get anything out of it. I wish she hadn't of taken my picture. . . . She didn't ask my name. She said she wouldn't sell the pictures. She said she'd send me a copy. She never did."[18]

Lange's memories were different: "I saw and approached the hungry and desperate mother, as if drawn by a magnet. I do not remember how I explained my presence or my camera to her, but I do remember she asked me no questions." But she "seemed to know," said Lange, "that my pictures might help her, and so she helped me. There was a sort of equality about it."[19]

This may be what every photojournalist thinks — what every photojournalist *must* think. But whatever "sort of equality" there was here (and without doubt Lange overestimated it), the picture is deeply affecting, however much it might be exploiting the vulnerability of its subject and however hard it is obviously working to be affecting.

The gray scale is part of that effort (not that Lange had a real choice

in 1936). The organization of the sharp contrasts of her black and white are one of the striking formal facts of the portrait. The effect would be different in color. And we unconsciously register that difference as we look back at the photograph. Color would individualize what the grays universalize. Color would make specific what the grays have made "immortal." And once immortal, the poignant family scene exists outside of history, outside of the reach of any reform that it might have been intended to spur.

Color might produce a politics, whereas the grays now solicit mainly our sentimentality. The original photograph was designed to do both, but it can't any longer. It isn't merely that the Great Depression is now behind us, so that any political response is now irrelevant. If we know anything these days, it is that the poor are always with us and always suffer. The image could be of a migrant family at a refugee camp today in too many desperate places around the world. It is specifically that the gray scale now locates and seals this portrait in a past, leaving us only with its formal autonomy. This allows or even encourages either a purely aesthetic response or a predictable emotional one, annulling its own political ambitions. Surely this explains why James Agee thought that it "might not be a bad idea" for *Let Us Now Praise Famous Men*, that remarkable record of Depression sharecropper families in the American South, with his text and Walker Evans's black-and-white photographs, to be printed on newspaper stock, since it "would crumble to dust in a few years."[20] This would have been perhaps the only way to prevent the inevitable aestheticization of the images, which in fact has occurred.

Look at another *Migrant Mother*, a picture taken on the Greek island of Lesbos in 2016, as thousands of migrants fled the chaos of the Middle East, traveling from any number of war-torn countries to Turkey and then hoping to make their way to somewhere in Europe.

Doug Kuntz's *Migrant Mother* comes from the same impulse as

FIGURE 44: *Doug Kuntz*, Migrant Mother, *2016*

Lange's photograph to record and to witness, from the same awareness that suffering should not be ignored and should be alleviated — and from the same understanding of the compositional and iconographic resources available from many thousands of images of the Madonna and Child. This mother's wide-eyed anxiety instead of Lange's mother's narrow slits of wary exhaustion suggests that this mother is relatively new to the burdens of dislocation and vulnerability. Her earrings (or maybe it is only the one we can see) are still in place, her mascara has run but must have been relatively recently applied, and she is wearing a brightly colored scarf. Her children look well fed. The Mylar warming blankets announce both her recent arrival on Lesbos and the presence of aid workers to greet her.

The point isn't that one photo is better than the other (though Kuntz's work should certainly be better known) or that one mother has suffered more or longer and is therefore more deserving of our concern. It is that color here says that our concern might still matter, that this scene exists in a "now" that has many possible futures, whereas black and white says, to us anyhow, that it exists in a "then" that can have no future at all. Once gray no longer has to be the color standing in for all the colors that photography was unable to reproduce, it becomes the color only of a past cut off from the flow of time.

But sometimes gray is only gray. Here's the work of another too-little-known contemporary photographer: Ursula Schulz-Dornburg (Figure 45).

Dornburg has been making extraordinary pictures for several decades. ("Making," not "taking," is almost always the right verb for photography.) She has various series of photographs, all in black and white, usually images of once-purposeful buildings — bus stops and train stations — now uninhabited and poignantly testifying both to human enterprise and to entropy. She focuses on the interplay of architecture and landscape. The pictures provide evidence both of what resists time and of what is lost to it: evidence, that is, of both desire and decay.

FIGURE 45: *Ursula Schulz-Dornburg,* Abandoned Ottoman Railway Station (#28),
2003, From Medina to Jordon Border, Saudi Arabia *series, Tate Collection*

Color would be wrong in these pictures. Too distracting. Or maybe,
in fact, too satisfying. The narrow band of gray tones without any sharp
graphic contrasts registers everything that matters here, withholding even
the comfort (or maybe it would be the mockery) of a clear blue sky. Color
would be too noisy. Gray is not the sound of silence but its color.

The scene demands the silence of its midtone grays: an isolated

building now uninhabited, empty for decades, made of bricks that will eventually crumble and become part of the desert sands. Color would be a cheat. Or, rather, any other color would be a cheat. These are in fact color photographs, but the color is just various shades of gray. The economy of these pictures, their spare formalism, does something unusual with the gray scale of black-and-white photography. It makes it a color rather than having it substitute for colors that are not present or solicit feelings that are not felt.

But it is rare that gray is not something other than itself.[21] Black-and-white photography succeeded in making it the color of colors, though metaphorically it is often the exact opposite: the color of colorlessness. Gray is humdrum, anonymous, bland, nondescript; it is dreary, dull, drab, and disappointing. A state of mind, a mode of being, the color of both inner and outer conformity. It's the color of the comfortable, though complacent, gray-toned world of the movie *Pleasantville* (1998), the black-and-white world of a fictional 1950s television show into which the film's central characters, two siblings, Jennifer and David (played by Reese Witherspoon and Toby McGuire), are magically transported. Pleasantville is a world that is clean and safe, limited and predictable. There are no challenges and almost no surprises. And there is no world outside. Geography lessons at school focus only on the street names of the town, and you learn that "the end of Main Street is just the beginning again."[22]

And there is no color. Or, there is no color until Jennifer seduces Skip, the captain of the basketball team. On his drive home afterward, still obviously dazed by the experience, suddenly Skip sees "against a gray picket fence, on a black and white street in a black and white neighborhood, A SINGLE RED ROSE IS BLOOMING" (Figure 46).

Slowly more and more color begins to appear in Pleasantville (and in *Pleasantville*). Initially the color appears only as details are added to interrupt

FIGURE 46: *Still from* Pleasantville, *1998*

its gray-toned world—red brake lights, a pink bubble, a green car. And eventually it differentiates whole characters, who themselves become "colored" as they embrace emotion, while those who don't remain gray and anxiously attempt to preserve their gray world. "No Coloreds" signs begin to appear around town, as the film suggests a racial politics that it never develops (most notably by a trial scene with the "coloreds" seated upstairs in the courtroom, an allusion to the trial scene in the 1962 film *To Kill a Mockingbird*). Eventually color takes over the whole town, as a sign of the world of wonder and possibility, as well as of complexity and challenge, that the black-and-white world of Pleasantville had been denied.

Pleasantville falls into color.[23] It is sign of the loss of an unearned and unsatisfying innocence, signaled in the film, as is only right, by a bite of an apple (and fleetingly reinforced in a detail in Bill Jonson's painting on

his soda shop's window showing a partially eaten apple with a serpent coiled around the piece of fruit). Color comes at a price (at one time literally—in RKO's 1938 film *Carefree*, Ginger Rogers and Fred Astaire's song-and-dance number "I Used to Be Color Blind" was supposed to be the single scene shot in color in an otherwise black-and-white movie, but the witty idea was abandoned because of the cost involved). In *Pleasantville*, which was shot in color and then digitally manipulated to produce the effects of black and white, the price is the loss of innocence and simplicity, but a price that is paid without complaint.

The interplay of black and white and color works differently in the film *The Wizard of Oz* (1939), where the "real" world of Kansas is rendered in sepia-tinged grays before Dorothy and Toto are swept away into the dreamscape of Technicolor. But no less than in *Pleasantville*, the gray is a judgment. Not, however, a judgment on conformity but a statement on the unremitting harshness of daily life that has abraded the color from the world, leaving only the gray, windswept plains and the ashen existence of their population. "The sun and wind had taken the sparkle from [Auntie Em's] eyes and left them a sober gray," as L. Frank Baum says in the novel on which the film was based: "They had taken the red from her cheeks and lips, and they were gray also." That's the way Kansas is described: gray lives lived on "the great gray prairie," in "a house as dull and gray as everything else," where even blades of grass, as the novel says, were burnt by the sun until they "were the same gray color to be seen everywhere." And it was only Toto who saved Dorothy "from growing as gray as her other surroundings," and Miss Gulch, of course, is trying to take the dog away.[24]

It is an oppressive gray sameness, broken only when all that gray is "gathered" and "unleashed," in Salman Rushdie words, in the tornado that transports Dorothy "somewhere over the rainbow" into a world of fantas-

tic color: a world of ruby slippers and the yellow brick road that leads to the Emerald City.[25]

And, nonetheless, always Dorothy wants to go home.

In the novel, the Scarecrow wonders about this determination. "I cannot understand why you should wish to leave this beautiful country and go back to the dry, gray place you call Kansas," he says to her. The answer is only that Kansas is home. "No matter how dreary and gray our homes are," says Dorothy, "we people of flesh and blood would rather live there than in any other country, be it ever so beautiful. There is no place like home."

Both the novel and the film work very hard to make us believe that, but maybe even Dorothy doesn't. Certainly her answer does not convince the Scarecrow: "Of course I cannot understand it," he said. "If your heads were stuffed with straw, like mine, you would probably all live in the beautiful places, and then Kansas would have no people at all. It is fortunate for Kansas that you have brains."[26]

Or maybe just as fortunate for Kansas that those living there have never been to Oz, or even to California. Maybe it was different in 1899, when the novel was written, than in 1939, when the film came out. Some people have thought that the novel was a disguised political allegory about monetary policy (the yellow brick road as the Gold Standard!).[27] Far-fetched, perhaps. But in 1939 maybe it was not so far-fetched to see the film as a not-so-disguised allegory about the Depression: the gray landscape of the Dust Bowl giving way to the bright promise of Oz, or the only somewhat less fantastical California. (Baum himself had moved from a depressed — if not yet Depression — North Dakota to Chicago and then to Hollywood in 1910.) And Kansas migrants did head west in great numbers in the second half of the 1930s after years of drought and dust storms, which had turned their once-green farmland gray. Rushdie suggests that the song "Over the Rainbow" could be

"the anthem of all the world's migrants."[28] But even if they sing of that place "where troubles melt like lemon drops," most still dream of going home.

Dorothy doesn't choose to leave Kansas, but it wasn't really a choice for the real Kansans who did. Dorothy is unwillingly ripped from her home, however dreary and gray it may be. But the tornado, an all-too-familiar weather phenomenon in Kansas, is just one of the many unpredictable and irresistible forces that uproot people and set them out on perilous roads (very few of which are yellow bricked) to escape the misery that home can become.

Dorothy is an unwilling migrant — almost all are — who finds herself in a new land of color. But unlike almost all other migrants, she does return home. (In the film, unlike the novel, she has, of course, actually never left. In the film, there's no place *but* home.) Dorothea Lange's migrant mother stayed in California, and Kuntz's migrant family is still looking for a refuge in an increasingly unwelcoming Europe and the United States. Dorothy, however, does find herself safely back in Kansas as the film turns back to reality — and back to its initial monochrome.

But the Scarecrow's earlier bewilderment about why anyone would want to live in Kansas remains. It is hardly dismissed or discredited by the film's return to the bleak grayness of the Kansas plains. Gray is still the color of dust and disappointment. Although in 1939, gray was also still the usual color by which the world was represented in film and photography, the Technicolor world "over the rainbow" holds out a promise that we might have other lives, lived in other places, but places that we might one day come to call "home."

Notes

∎

Color Matters
An Introduction

1. The phrase is best known from Thucydides, who is quoting a "Hymn to Apollo." See his *History of the Peloponnesian War*, 3.105.

2. William Gladstone, *Studies on Homer and the Homeric Age*, vol. 3 (Oxford: Oxford University Press, 1858), 488.

3. Rolf Kuschel and Torben Monberg, "'We Don't Talk Much About Colour Here': A Study of Colour Semantics on Bellona Island," *Man* 9, no. 2 (1974): 238.

4. Edward Sapir, *Language: An Introduction to the Study of Speech* (San Diego, CA: Harcourt, Brace, 1921), 14.

5. William Wordsworth, "My Heart Leaps Up When I Behold," in *William Wordsworth: The Major Works*, ed. Stephen Gill (Oxford: Oxford University Press, 2008), 246.

6. John Keats, "Lamia," in *Complete Poems*, ed. Jack Stillinger (Cambridge, MA: Harvard University Press, 1982), 357.

7. Benjamin Haydon, *The Autobiography and Memoirs of Benjamin Haydon*, ed. Tom Taylor, vol. 1 (New York: Harcourt, Brace, 1926), 269.

8. Thomas Campbell, "To the Rainbow," in *The Poetical Works of Thomas Campbell*, vol. 1 (London: Henry Colburn and Richard Bentley, 1830), 216.

9. James Thompson, "Spring," in *The Complete Poetical Works of James Thompson*, ed. J. L. Robertson (London: Henry Frowde, 1908), 10.

10. Vladimir Nabokov, *The Gift* (New York: Vintage, 1991), 6.

11. Isaac Newton to Henry Oldenburg, December 21, 1675, Cambridge University Library, MS Add. 9597/2/18/46-47.

12. Elizabeth Barrett Browning, "The Lady's Yes," in *Selected Poems of Elizabeth Barrett Browning*, ed. Margaret Foster (Baltimore: Johns Hopkins University Press, 1988), 150.

13. Leonardo da Vinci, *Treatise on Painting*, trans. John Francis Rigoud (1877; re-

print, Mineola, NY: Dover, 2005), 101. Leonardo's "treatise" was compiled by Francesco Melzi, a student of Leonardo's, in about 1540.

14. Josef Albers, *The Interaction of Color: Fiftieth Anniversary Edition* (New Haven: Yale University Press, 2013).

15. Isaac Newton, "Of Colours," Cambridge University Library, MS Add. 3995, 15.

16. See David Batchelor's brilliant *Chromophobia* (London: Reaktion, 2000).

17. Fairfield Porter, *Art in Its Own Terms: Selected Criticism, 1935–1975,* ed. Rackstraw Downes (Boston: MFA Publications, 1979), 80. Herman Melville, *Billy Budd, Sailor (An Inside Narrative),* ed. Michael Everton (Peterborough, ON: Broadview, 2016), 107. The narrator, however, wonders where "the orange tint ends and the violet tint begins," but that's clearly not the problem, since yellow, green, blue, and indigo come between them.

18. Colm Tóibín, "In Lovely Blueness: Adventures in Troubled Light," in *Blue: A Personal Selection from the Chester Beatty Library Collections* (Dublin: Chester Beatty Library, 2004), [5].

CHAPTER ONE
Roses Are Red

1. James Joyce, *A Portrait of the Artist as a Young Man* (1916; reprint, New York: Viking, 1965), 12.

2. Democritus, "Fragment (α)," quoted in John Mansley Robinson, *An Introduction to Early Greek Philosophy: The Chief Fragments and Ancient Testimony with Connecting Commentary* (New York: Houghton Mifflin, 1968), 202.

3. Diogenes Laertes, *Lives and Opinions of the Eminent Philosophers,* trans. R. D. Hicks, vol. 2 (Cambridge, MA: Harvard University Press, 2014), 449.

4. Newton uses the phrase first in "A Letter of Mr. Isaac Newton . . . containing his New Theory about Light and Colors," which appeared in *Philosophical Transactions of the Royal Society* 6 (1671–72): 3075.

5. Isaac Newton, *Opticks; or, A Treatise of the Reflexions, Refractions, Inflexions and Colours of Light* (London, 1704), 90.

6. Newton, *Opticks,* 90.

7. Newton, *Opticks*, 111. Objects are able to "suppress and stop in them a very considerable part of the Light. . . . For they become coloured by reflecting the Light of their own Colours more copiously, and that of all other Colours more sparingly."

8. Some people think that the mind is just a mystification of the neural activities of the brain. But for a series of interesting essays considering the difference, see Torin Alter and Sven Walter, eds., *Phenomenal Concepts and Phenomenal Knowledge: New Essays on Consciousness and Physicalism* (New York: Oxford University Press, 2007).

9. See Mazviita Chirimuuta, *Outside Color: Perceptual Science and the Puzzle of Color in Philosophy* (Cambridge, MA: MIT Press, 2015).

10. Galileo Galilei, "The Assayer" ["Il saggiatore," 1623], in *Discoveries and Opinions of Galileo*, ed. and trans. Stillman Drake (New York: Random House, 1957), 274.

11. Walter Benjamin, "Aphorisms on Imagination and Color," in *Selected Writings, Vol. 1: 1913–1926*, ed. Marcus Bullock and Michael W. Jennings (Cambridge, MA: Harvard University Press, 1996), 48.

12. There is a famous thought experiment by the Australian philosopher Frank Jackson in which he imagines a brilliant scientist named Mary who knows everything possible about how and why we experience color but who has never herself experienced it, and Jackson considers what (if any) new knowledge Mary would have if she were suddenly exposed to colors. See "What Mary Didn't Know," *Journal of Philosophy* 83 (1986): 291–95. See also the collection of essays responding to Jackson: Peter Ludlow, Yujin Nagasawa, and Daniel Stoljarm, eds., *There's Something About Mary: Essays on Phenomenal Consciousness and Frank Jackson's Knowledge Argument* (Cambridge, MA: MIT Press, 2004).

13. Bertrand Russell, "Knowledge by Acquaintance and Knowledge by Description," in *The Problems of Philosophy* (Oxford: Oxford University Press, 1998), 25. Mark Johnston could be credited with the term "revelation theory"; see his influential "How to Speak of the Colors," *Philosophical Studies* 68 (1993): 221–63. See also Galen Strawson, "Red and 'Red,'" *Synthese* 78 (1989): 193–232. Color has become an important and highly contested topic for philosophy, arguably triggered by C. L. Hardin's *Color for Philosophers: Unweaving the Rainbow* (Indianapolis, IN: Hackett, 1988).

14. Ellen DeGeneres, quoted by Terence McCoy, "The Inside Story of the 'White Dress, Blue Dress' Drama That Divided a Planet," *Washington Post*, February 27, 2015.

15. For color as a con job, see Harry Kreisler, interview with Christof Koch, "Consciousness and the Biology of the Brain," March 24, 2006, Institute of International Studies, University of California at Berkeley, transcript, 4.

16. Jonathan Cohen, *The Red and the Real: An Essay on Color Ontology* (Oxford: Oxford University Press, 2009), 29, 28.

17. For a sophisticated and provocative argument differentiating the idea of having color vision from seeing colors, see Michael Watkins, "Do Animals See Colors? An Anthropocentrist's Guide to Animals, the Color Blind, and Far Away Places," *Philosophical Studies*, 94, no. 3 (1999): 189–209.

18. Mohan Matthen, *Seeing, Doing, and Knowing: A Philosophical Theory of Sense Perception* (Oxford: Clarendon, 2005), 163–64, 202.

CHAPTER TWO
Orange Is the New Brown

1. Brent Berlin and Paul Kay, *Basic Color Terms: Their Universality and Evolution* (Berkeley: University of California Press, 1969). This influential work has provoked a large bibliography of qualification, critique, and reconsideration; see, e.g., Don Dedrick's thoughtful *Naming the Rainbow: Colour Language, Colour Science, and Culture* (Dordrecht: Kluwer, 1998).

2. Quoted by Luisa Maffi and C. L. Hardin, *Color Categories in Thought and Language* (Cambridge: Cambridge University Press, 1997), 349.

3. Félix Bracquemond, *Du Dessin et de la couleur* (Paris: Charpentier, 1885), 55.

4. Derek Jarman, *Chroma: A Book of Colour* (London: Century, 1994), 95.

5. Claudius Aelian, *A Registre of Hystories conteining Martiall Exploites of Worthy Warriours, Politique Practises of Civil Magistrates, Wise Sentences of Famous Philosophers, and other matters manifolde and memorable*, trans. Abraham Fleming (London, 1576), 88.

6. Anthony Copley, *Wits, Fittes, and Fancies* (London, 1595), 201. The book is an unacknowledged adaptation of a similar jest book by Melchor de Santa Cruz, *Floresta española* (Madrid, 1574).

7. Thomas Blundeville, *M. Blundevile his exercises: containing sixe treatises* (London, 1594), 260.

8. Simon Schama, *Patriots and Liberators: Revolution in the Netherlands, 1780–1813* (New York: Alfred A. Knopf, 1977), 105.

9. Charles Estienne, *Maison Rustique, or The Countrey Farme*, trans. Richard Surflet and rev. Gervase Markham (London, 1616), 241.

10. For a smart and supple essay on "a world before 'orange'" and a world after oranges, see Julian Yates's "Orange," in *Prismatic Ecology: Ecotheory Beyond Green*, ed. Jeffrey Jerome Cohen (Minneapolis: University of Minnesota Press, 2013), 83–105.

11. Vincent Van Gogh, Letter 534, October 10, 1885, in *Vincent Van Gogh: The Letters: The Complete Illustrated and Annotated Edition*, ed. Nienke Bakker, Leo Jansen, and Hans Luijten, 6 vols. (London: Thames and Hudson, 2009), 3:290.

12. Van Gogh, Letter 450, mid-June 1884, and Letter RM 21, May 25, 1890, *Letters*, 3:156, 5:320.

13. Van Gogh, Letter 371, August 7, 1883, *Letters*, 2:399.

14. Van Gogh, Letter 663, August 18, 1888, *Letters*, 4:237.

15. Van Gogh, Letter 660, August 13, 1888, *Letters*, 4:235.

16. Van Gogh, Letter 663, August 18, 1888, *Letters*, 4:237.

17. Van Gogh, Letter 604, May 4, 1888, *Letters*, 4:76.

18. Sonia Delaunay, in *The New Art of Color: The Writings of Robert and Sonia Delaunay*, ed. Arthur A. Cohen (New York: Viking, 1978), 8. Quoted by Phillip Ball, *Bright Earth: Art and the Invention of Color* (Chicago: University of Chicago Press, 2003), 301.

19. Oscar Wilde, quoted in *Oscar Wilde: The Critical Heritage*, ed. Karl E. Beckson (London: Routledge and Kegan Paul, 1970), 69.

20. Yves Klein, quoted in Hannah Weitemeier, *Yves Klein (1928–1962): International Klein Blue* (Cologne: Taschen, 1995), 9.

21. Klein, quoted in *Yves Klein (1928–1962): A Retrospective*, ed. Pierre Restany, Thomas McEvilley, and Nan Rosenthal (Houston: Rice University, Institute for the Arts, 1982), 130.

22. Klein, quoted in David W. Galenson, *Conceptual Revolutions in Twentieth-Century Art* (Cambridge: Cambridge University Press, 2009), 170.

23. Yves Klein, *Overcoming the Problematics of Art: The Writings of Yves Klein*, trans. Klaus Ottmann (New York: Spring, 2007), 185.

24. Henri Matisse, quoted in Hilary Spurling, *Matisse the Master: A Life of Henri Matisse: The Conquest of Colour, 1909–1954* (London: Hamish Hamilton, 2005), 428.

25. Barnett Newman, *Barnett Newman: Selected Writings and Interviews*, ed. John O'Neill (Berkeley: University of California Press, 1990), 249.

26. William Gass, *On Being Blue: A Philosophical Inquiry* (Boston: David R. Godine, 1975), 75.

CHAPTER THREE
Yellow Perils

1. Giovanni Battista Ramusio, *Delle navigationi et viaggi*, vol. 1 (Venice, 1550), 337v ("bianchi, si como siamo noi").

2. The wording here comes from the translation of a newsletter recorded in *Calendar of State Papers Foreign, Elizabeth*, vol. 19 (London: His Majesty's Stationary Office, 1916), 137.

3. Bernardino de Escalante, *A discourse of the nauigation which the Portugales doe make to the realmes and prouinces of the east partes of the worlde . . .* , trans. John Frampton (London, 1579), 21.

4. Juan González de Mendoza, *The historie of the great and mightie kingdome of China . . .* , trans. Robert Parke (London, 1588), 2–3. González de Mendoza had not traveled to China, and he based his descriptions on the journals of Miguel de Luarca.

5. Marco Polo describes both the Chinese and the Japanese as white. See Ramusio's translation and edition of Marco Polo's travels, included in *Delle navigationi et viaggi*, vol. 2 (1559), 16v, 50v; and see Matteo Ricci, *De Christiana expeditione apud Sinas suscepta ab Societate Jesu* [Of the Christian mission to China by the Society of Jesuits], expanded and trans. Fr. Nicolas Trigault (Augsburg, 1615), 65 ("Sinica gens fere albi coloris est").

6. See Michael Keevak's essential *Becoming Yellow: A Short History of Racial Thinking* (Princeton, NJ: Princeton University Press, 2011), to which we are much indebted; and Walter Demel, "Wie die Chinese gelb wurden," *Historische Zeitschrift* 255 (1992):

625–66, and an expanded version in Italian, *Come i chinese divennero gialli: Alli origini delle teorie razziali* (Milan: Vita e Pensiero, 1997). See also D. E. Mungello, "How the Chinese Changed from White to Yellow," in *The Great Encounter of China and the West, 1500–1800*, 4th ed. (Lanham, MD: Rowan and Littlefield, 2012), 141–43.

7. George Washington, "Letter to Tench Tilghman," in *The Writings of George Washington from the Original Manuscript Sources*, ed. John C, Fitzpatrick, vol. 28 (Washington, DC: US Government Printing Office, 1940), 238–39.

8. Marquis de Moges, *Souvenirs d'une ambassade et Chine et au Japon, 1857 et 1858* (Paris: Hachette, 1860), 310 ("aussi blancs que nous").

9. For a reproduction of the painting and an account of its allegory, see the London *Review of Reviews* (December 1895): 474–75. On "The Yellow Peril," see Keevak, *Becoming Yellow,* chap. 5, esp. 124–28. Keevak reproduces the engraving as it appeared in *Harper's Weekly* in 1898. See also Stanford M. Lyman, "The 'Yellow Peril' Mystique," *International Journal of Politics, Culture, and Society* 13 (2006): 683–747; Richard Austin Thompson, *The Yellow Peril, 1890–1924* (New York: Arno, 1978); and John Kuo Wei Tchen and Dylan Yates, eds., *Yellow Peril! An Archive of Anti-Asian Fear* (London: Verso, 2014).

10. Quoted in Keevak, *Becoming Yellow,* 128.

11. Jack London, *"Revolution," and Other Essays* (New York: Macmillan, 1910), 282.

12. Sax Rohmer, *The Insidious Dr. Fu-Manchu* (New York: McBride, Nast, 1913), 23. See also Christopher Frayling, *The Yellow Peril: Dr. Fu-Manchu and the Rise of Chinaphobia* (London: Thomas and Hudson, 2014).

13. See, e.g., Zhaoming Qian, *Orientalism and Modernism: The Legacy of China in Pound and Williams* (Durham, NC: Duke University Press, 1995), and R. John Williams's chapter "The Teahouse of the American Book," in *The Buddha in the Machine: Art, Technology, and the Meeting of East and West* (New Haven: Yale University Press, 2014), 13–44.

14. Percival Lowell, *The Soul of the Far East* (Boston: Houghton, Mifflin, 1888), 37, 113.

15. See, e.g., Nancy Shoemaker, *A Strange Likeness: Becoming Red and White in Eighteenth-Century North America* (New York: Oxford University Press, 2004); Nell Irvin Painter, *The History of White People* (New York: W. W. Norton, 2010); and

Frank M. Snowden Jr., *Before Color Prejudice: The Ancient View of Blacks* (Cambridge, MA: Harvard University Press, 1983).

16. Carl Linnaeus, *Systema Naturae* (Leiden, 1735).

17. Byron Kim, "Ad and Me," *Flash Art* (International Edition), no. 172 (1993): 122.

18. Daniel Buren, "Interview with Jérôme Sans," in *Colour: Documents of Contemporary Art,* ed. David Batchelor (Cambridge, MA: MIT Press, and London: Whitechapel, 2008), 222.

19. Byron Kim quoted in Ann Tempkin, ed., *Color Chart: Reinventing Color, 1950 to Today* (New York: Museum of Modern Art, 2008), 188.

20. Josef Albers, *The Interaction of Color* (New Haven: Yale University Press, 1963), 1.

21. See Jacqueline Lichtenstein, *The Eloquence of Color: Rhetoric and Painting in the French Classical Age,* trans. Emily McVarish (Berkeley: University of California Press, 1993). Kim, it might be noted, was an English major as an undergraduate at Yale.

22. Byron Kim, *Threshold: Byron Kim, 1990–2004,* ed. Eugenie Tsai (Berkeley: University of California Press, Berkeley Art Museum, and Pacific Film Archive), 55.

23. E. M. Forster, *A Passage to India* (London: Edward Arnold, 1924), 65.

24. For a brilliant account of Ligon's work, see Darby English, *How to See a Work of Art in Total Darkness* (Cambridge, MA: MIT Press, 2007), 201–54.

CHAPTER FOUR

Mixed Greens

1. Norman Bean [Edgar Rice Burroughs], "Under the Moons of Mars," serialized in *All-Story Magazine,* February–July 1912 (published in book form in 1917).

2. James Delingpole, *Watermelons: The Green Movement's True Colors* (New York: Publius, 2011).

3. Arthur C. Clarke, quoted in James E. Lovelock, "Hands Up for the Gaia Hypothesis," *Nature* 344 (1990): 102.

4. Wallace Stevens, "Repetitions of a Young Captain," in *The Collected Poems of Wallace Stevens* (New York: Vintage, 1954), 309.

5. Hamid Dabishi, *The Green Movement in Iran* (New Brunswick, NJ: Transaction, 2011). See also Misagh Parsa, *Democracy in Iran: Why It Failed and How It Might Succeed* (Cambridge, MA: Harvard University Press, 2016), 206–43.

6. Seyyed Mir-Husein Mossavi, *Nurturing the Seed of Hope: A Green Strategy for Liberation*, ed. and trans. Daryoush Mohammad Poor (London: H and S Media, 2012). Thanks to Hamid Dabishi for reading and commenting on this section.

7. George Gordon, Lord Byron, *Don Juan*, ed. T. G. Steffan, E. Steffan, and W. W. Pratt (1824; reprint, London: Penguin, 1996), canto 16, stanza 97, p. 551.

8. Campaign buttons for both Richard M. Nixon and John F. Kennedy in 1960, for example, were red, white, and blue, as they were for both Republican and Democratic candidates in every American election through the twentieth century.

9. See Tom Zeller, "Ideas and Trends: One State, Two State, Red State, Blue State," *New York Times*, February 8, 2004.

10. Jean Jaurès, *Histoire socialiste de la Révolution française*, 4 vols. (1901–4; reprint, Paris, Éditions Sociales, 1968), 2:700, quotes an entry from Pierre-Gaspard Chaumette's memoir from June 20, 1792, reporting on a meeting he had attended at which a red flag with this inscription was displayed but apparently not unveiled until August 10.

11. Karl Marx, *The Civil War in France: Address of the General Council of the International Working-Men's Association* (London, 1871), 21.

12. Maria Hayward, *Dress at the Court of Henry VIII* (Leeds, UK: Maney, 2007), 44.

13. Lincoln A. Mitchell, *The Color Revolutions* (Philadelphia: University of Pennsylvania Press, 2012).

14. James Connolly, "The Irish Flag" [*Workers' Republic*, April 8, 1916], in *James Connolly: Selected Writings*, ed. Peter Berresford Ellis (London: Pluto, 1997), 145.

15. The notion of opponent colors was first suggested by a German scientist named Ewald Hering, who in 1892 had observed that if we look at a red circle for sixty seconds and then switch our gaze to a plain white space, we see an afterimage of blue-green circle in the white area, and noted also that we do not see reddish greens (or yellowish blues) in the world but we do see yellowish greens, bluish reds, yellowish reds, and so on. These two ideas led him to hypothesize a notion of color opponency (red-green, yellow-blue, white-black) as a kind of neural color-mixing by the visual

system, as an alternative (or addition) to the traditional understanding of the operation of the color channels provided by the rods and cones of the retina.

16. Josef Albers, *The Interaction of Color: Fiftieth Anniversary Edition* (New Haven: Yale University Press, 2013).

CHAPTER FIVE
Moody Blues

1. James Fenimore Cooper, *The Deerslayer; or, The First Warpath: A Tale*, vol. 1 (Philadelphia: Lea and Blanchard, 1841), 176.

2. William Gass, *On Being Blue: A Philosophical Inquiry* (Boston: David R. Godine, 1975), 75–76. See also Maggie Nelson's *Bluets* (Seattle: Wave, 2009), and Carol Mavor's *Blue Mythologies: Reflections on a Colour* (London: Reaktion, 2013).

3. Geoffrey Chaucer, "The Complaint of Mars," l. 8. George Eliot, *Felix Holt: The Radical*, vol. 1 (Edinburgh: William Blackwood and Sins, 1866), 122; Herman Melville, "Merry Ditty of the Sad Man," in *Collected Poems*, ed. Howard Vincent (Chicago: Packard, 1947), 386. The poem was left unpublished at the time of Melville's death in 1891.

4. Thomas Hughes, *Tom Brown's School Days* (Cambridge: Macmillan, 1857), 257.

5. David Garrick to Peter Garrick, July 11, 1741, in *Letters of David Garrick*, ed. David M. Little and George M. Kahrl, vol. 1 (Cambridge, MA: Harvard University Press, 1963), 26; John James Audubon to Lucy Audubon, December 5, 1827, in *The Audubon Reader*, ed. Richard Rhodes (New York: Everyman Library, 2015), 213.

6. See Peter C. Muir, *Long Lost Blues: Popular Blues in America, 1850–1920* (Champaign: University of Illinois Press, 2010), 81.

7. Jackson R. Bryer and Mary C. Hartig, eds., *Conversations with August Wilson* (Jackson: University Press of Mississippi, 2006), 211.

8. Jaime Sabartés, *Picasso: An Intimate Portrait*, trans. Angel Flores (New York: Prentice Hall, 1948), 67.

9. Pablo Picasso, quoted in Richard Wattenmaker and Anne Distel, *Great French Paintings from the Barnes Foundation: Impressionist, Post-Impressionist, and Early Modern* (New York: Alfred A. Knopf, 1993), 192.

10. Marilyn McCully, ed., *Picasso: The Early Years* (Washington, DC: National Gallery of Art, 1997), 39.

11. Charles Morice, review of a show at the Serrurier Gallery in *Le Mercure de France*, March 15, 1905, 29 ("délecter à la tristesse"; "sans y compatir").

12. Oscar Wilde, "Epistola: In Carcere et Vinculis," in *The Complete Works of Oscar Wilde*, ed. Ian Small, vol. 2 (Oxford: Oxford University Press, 2005), 140.

13. Wyndham Lewis, "Picasso," *Kenyon Review* 2, no. 2 (1940): 197.

14. Wislawa Szymborska, "Seen from Above," in *Map: Collected and Last Poems*, trans. Clare Cavanaugh and Stanislaw Barańczak (New York: Houghton Mifflin Harcourt Mariner, 2015), 205.

15. John Ray, *A Collection of English Proverbs* (London, 1678), 230.

16. Brian Massumi, *Parables for the Virtual: Movement, Affect, Sensation* (Durham, NC: Duke University Press, 2002), 21.

17. John Ruskin, *Lectures on Architecture and Painting* [Edinburgh, 1853], in *The Complete Works of John Ruskin*, ed. E. T. Cook and Alexander Wedderburn, vol. 12 (London: George Allen, 1904), 25.

18. Wassily Kandinsky, *Complete Writings on Art*, ed. Kenneth C. Lindsay and Peter Vergo (Boston: Da Capo, 1994), 181.

19. Johann Wolfgang von Goethe, *Theory of Colours* [1810], trans. Charles Locke Eastlake (1840; reprint, Mineola, NY: Dover, 2006), 171.

20. Julia Kristeva, *Desire in Language: A Semiotic Approach to Literature and Art*, ed. Leon S. Roudiez (New York: Columbia University Press, 1980), 224.

21. Cennino d'Andrea Cennini, *The Craftsman's Handbook* [Il libro dell'arte], trans. Daniel V. Thompson (New York: Dover, 1954), 36.

22. Peter Stallybrass, "The Value of Culture and the Disavowal of Things," in *The Culture of Capital: Properties, Cities, and Knowledge in Early Modern England*, ed. Henry Turner (New York: Routledge, 2002), 275–92.

23. In 1957, Klein wrote, "L'époque Bleue fait mon initiation" (The Blue Period was my initiation); Yves Klein, *Le Dépassement de la problématique de l'art*, ed. Marie-Anne Sichère and Didier Semin (Paris: École nationale supérieure des beaux-arts, 2003), 82.

24. Robert Southey, *Madoc* (London: Clarke, Beeton, 1853), 40.

25. William Gibson, *Zero History* (New York: Putnam, 2010), 19–20.

26. Kazimir Malevich, "From Cubism and Futurism to Suprematism: The New Realism in Painting" [1915], in *Essays on Art, 1915–1933,* ed. Troels Andersen, vol. 1 (London: Rapp and Whiting, 1969), 19.

27. Aleksandr Rodchenko, "Working with Mayakovsky" [1939], quoted in *Art of the Twentieth Century: A Reader,* ed. Jason Gaiger and Paul Wood (New Haven: Yale University Press, 2003), 101.

28. Yves Klein, quoted in Gilbert Perlein and Bruno Cora, eds., *Yves Klein: Long Live the Immaterial!,* exh. cat. (Nice: Musée d'Art Moderne and d'Art Contemporaine, and New York: Delano Greenidge Editions, 2000), 88.

29. Thank you to the film's producer, James Mackay, for this information and other accounts of the film's production; to Keith Collins, who has been so very generous with Derek Jarman's notebooks, the script of *Blue,* and additional materials; and to Donald Smith for so many kindnesses that enabled the writing of this section.

30. This, like so much of what is heard in the film, appears both in the chapter "Into the Blue," in Derek Jarman, *Chroma: A Book of Colour* (London: Century, 1994), 103–14, and in the text used for *Blue,* which was created both from Jarman's chapter and other materials from his diaries. All quotations used here appear in both.

31. Journal entry; see Tony Peake, *Derek Jarman: A Biography* (Minneapolis: University of Minnesota Press, 2011), 362, 472.

32. See Peake, *Derek Jarman,* 526–27.

33. Jarman, *Chroma,* 104.

CHAPTER SIX
Dy(e)ing for Indigo

1. Isaac Newton, draft of "A Theory of Light and Colours," MS Add. 3970.3, fol. 463v, Cambridge University Library: "The originall or primary colours are Red, yellow, Green, Blew, & a violet purple; together with Orang, Indico, & an indefinite varietie of intermediate gradations."

2. Walter Scott, *Marmion* [1808], canto 5, in *The Poetical Works of Sir Walter Scott* (Edinburgh: Robert Cadell, 1841), 132.

3. Philip Miller, "Anil," in *The Gardeners Dictionary*, vol. 1 (1731; reprint, London, 1735), 67–68.

4. See Victoria Finlay, *Color: A Natural History of the Palette* (New York: Ballantine, 2002).

5. See Jenny Balfour-Paul, *Indigo: Egyptian Mummies to Blue Jeans* (London: Archetype, 2007), 140. Anyone who writes about indigo is heavily indebted to Balfour-Paul's work, as of course are we, and not least for the wonderful photograph introducing this chapter that she has generously allowed us to use.

6. Jean-Baptiste Tavernier, *The Six Voyages of John Baptista Tavernier*, trans. John Phillips (London, 1678), 93.

7. Tavernier, *Six Voyages*, 93.

8. See Jenny Balfour-Paul, *Indigo: Egyptian Mummies to Blue Jeans* (London: Archetype, 2007), esp. 11–39; see also Victoria Finley, *Color: A Natural History of the Palette* (New York: Random House, 2002), 318–51; and Catherine E. McKinley: *Indigo: In Search of the Color That Seduced the World* (London: Bloomsbury, 2011).

9. Herodotus, *The Persian Wars*, trans. A. D. Godley, vol. 1 (Loeb Classical Library 117; Cambridge, MA: Harvard University Press, 1920), 257. Given that he is describing figures painted on wool clothing, it seems unlikely that this is actually a reference to indigo.

10. Pliny the Elder, *The Historie of the World: Commonly called The Natural Historie*, trans. Philemon Holland (London, 1603), book 35, chap. 27, 531.

11. Marco Polo, *The Travels of Marco Polo, the Venetian*, trans. William Marsden (London: John Dent, 1926), 302.

12. John Bullokar, *An English Expositor, Teaching the Interpretation of the Hardest Words Used in our Language* (London, 1616), sig. I3r.

13. Sharon Ann Burnston, "Mood Indigo: The Old Sig Vat, or Experiments in Blue Dyeing the 18th Century Way," http://www.sharonburnston.com/indigo.html.

14. Jean de Thévenot, *The Travels of Monsieur de Thevenot into the Levant*, trans. Archibald Lovell (London, 1687), part 2, 34–35. See also Jenny Balfour-Paul, *Indigo in the Arab World* (London: Routledge, 1997), 99–101.

15. Bernard Romans, *A Concise Natural History of East and West Florida* [1775], fac-

simile ed., ed. Rembert W. Patrick (Gainesville: University of Florida Press, 1962), 139.

16. Romans, *Concise Natural History*, 139.

17. Romans, *Concise Natural History*, 103.

18. Romans, *Concise Natural History*, 105, 107.

19. Romans, *Concise Natural History*, 75.

20. Romans, *Concise Natural History*, 108.

21. Michael Taussig, *What Color Is the Sacred?* (Chicago: University of Chicago Press, 2009), 136. See his chapters "Color and Slavery" and "Redeeming Indigo," 130–58, to which we are indebted.

22. Romans, *Concise Natural History*, 136.

23. Quoted in James A. McMillan, *The Final Victims: Foreign Slave Trade to North America, 1783–1810* (Columbia: University of South Carolina Press, 2004), 4.

24. Quoted in W. W. Sellers, *A History of Marion County, South Carolina: From Its Earliest Times to the Present* (Columbia, SC: R. L. Bryan, 1902), 110.

25. See Hennig Cohen, "A Colonial Poem on Indigo Culture," *Agricultural History* 30 (1956): 41–44. For a richly textured account of the complex set of collaboration and coercions that determined the cultivation of indigo in the American South, see Amanda Feeser's wonderfully named *Red, White and Black Make Blue: Indigo in the Fabric of South Carolina Life* (Athens: University of Georgia Press, 2013).

26. Romans, *Concise Natural History*, 106.

27. See Balfour-Paul, *Indigo*, 56–57, and Michel Pastoureau, *Blue: The History of Color*, trans. Markus I. Cruse (Princeton, NJ: Princeton University Press, 2001), 124–33. Pastoureau's appealing and wide-ranging cultural histories of various colors are, of course, indispensable resources for research.

28. Romans, *Concise Natural History*, 138.

29. See Elizabeth Kolsky, *Colonial Justice in British India: White Violence and the Rule of Law* (Cambridge: Cambridge University Press, 2010), 58.

30. *Scribner's Magazine*, July 1897, 92, quoted in E. P. Thompson, *William Morris: Romantic to Revolutionary* (New York: Pantheon, 1977), 102.

31. James Roberts, *The Narrative of James Roberts, a Soldier Under Gen. Washington*

in the Revolutionary War, and Under Gen. Jackson at the Battle of New Orleans, in the War of 1812 (Chicago: Printed for the author, 1858), 28.

32. See Taussig, *What Color Is the Sacred?*, 136–37; see also Laurent Dubois, *The Story of the Haitian Revolution* (Cambridge, MA: Harvard University Press, 2004), 21–28.

33. See Balfour-Paul, *Indigo*, 58, and Pastoureau, *Blue*, 158–59.

34. See Anthony S. Travis, *The Rainbow Makers: The Origins of the Synthetic Dyestuffs Industry in Western Europe* (Bethlehem, PA: Lehigh University Press, 1993).

CHAPTER SEVEN
At the Violet Hour

1. Émile Cardon, "Avant le Salon: L'exposition des révoltés," *La Presse*, April 29, 1874, 2–3. See Dominique Lobstein, "Claude Monet and Impressionism and the Critics of the Exhibition of 1874," in *Monet's "Impression Sunrise": The Biography of a Painting* (Paris: Musée Marmottan Monet, 2014), 106–15.

2. Louis Leroy, "L'Exposition des impressionnistes," *Le Charivari*, April 25, 1874, 80, reproduced in *Monet's "Impression Sunrise,"* 111. On the relation of the painting to the term "Impressionist," see Paul Tucker, *Claude Monet: Life and Art* (New Haven: Yale University Press, 1995), 77–78.

3. See Oscar Reutersvärd, "The 'Violettomania' of the Impressionists," *Journal of Aesthetics and Art Criticism* 9, no. 2 (1950): 106–10.

4. Jules Claretie, *La Vie à Paris, 1881* (Paris: Victor Havard, 1881); the quotation is often attributed to Claude Monet, but Claretie is discussing "M. Edouard le révolutionnaire Manet" (225–26). Joris-Karl Huysmans, "L'Exposition des indépendants en 1880," in *L'Art Moderne* (Paris: V. Charpentier, 1883), 182.

5. Théodore Duret, "Les Peintres impressionnistes" [1878], translated in *Monet: A Retrospective*, ed. Charles F. Stuckey (New York: Park Lane, 1985), 66.

6. George Moore, "Decadence," *Speaker* 69 (September 3, 1892): 286, and see also Moore, *A Modern Lover*, vol. 2 (London, 1883), 89; Huysmans, *L'Art moderne*, 183 ("Leurs rétines étaient maladies").

7. August Strindberg is quoted in Reutersvärd, "'Violettomania,'" 107, as is Cardon, whose comment appeared in his "Avant le Salon," 3.

8. Alfred Woolff, review of the second Impressionists' show in 1876 in *Figaro*, April 3, 1876, quoted in John Rewald, *The History of Impressionism*, 4th ed. (New York: Museum of Modern Art, 1973), 368.

9. Alfred de Lostelot, "Exposition des oeuvres de M. Claude Monet," *Gazette des Beaux-Arts* 28 (April 1, 1883): 344.

10. Émile Zola, *His Masterpiece*, trans. Ernest Alfred Vizetelly (London: Chatto and Windus, 1902), 122.

11. Oscar Wilde, "The Decay of Lying," in *Oscar Wilde: The Major Works of Oscar Wilde*, ed. Isobel Murray (Oxford: Oxford University Press, 1989), 233.

12. Wilde, "Decay of Lying," 233.

13. Jules-Antoine Castagnary, "L'Exposition du boulevard des Capucines: Les Impressionistes," *Le Siècle*, April 29, 1874, 3.

14. Donald Judd, "Some Aspects of Color in General and Red and Black in Particular," *Artforum* 32, no. 10 (1994): 110.

15. Quoted in Claude Roger-Marx, "Les Nymphéas de M. Claude Monet," *Gazette des Beaux-Arts*, 4th ser., 1 (June 1909): 529, imagining or recording a conversation with the painter. This long review of the exhibition at Durand-Ruel is translated by Catherine J. Richards in Charles F. Stuckey, ed., *Monet: A Retrospective* (New York: Beaux Arts Editions, 1985), 267.

16. Philippe Burty, "Exposition de la Société anonyme des artistes," *La République Française*, April 25, 1874, 2.

17. Canvases have multiple layers of paint, and according to art critic Octave Mirbeau, writing in the literary journal *Gil Blas* (June 22, 1889), a painting might take up to "sixty sessions" before it was finished. See Robert Herbert, "Method and Meaning in Monet," *Art in America* 67 (September 1979): 91–108.

18. Claude Monet, quoted in John House, *Monet: Nature into Art* (New Haven: Yale University Press, 1986), 221.

19. *Joachim Gasquet's Cézanne: A Memoir with Conversations*, trans. Christopher Pemberton (London: Thames and Hudson, 1991), 220.

20. Jules Claretie, in *La Vie à Paris, 1881* (Paris: Victor Havard, 1881), 226, reports the observation as something Manet excitedly said to some friends, though the observation has often been attributed to Monet, no doubt because of the prominence of violet in his palette. See, e.g., Philip Ball's usually reliable *Bright Earth: Art and the Invention of Color* (Chicago: University of Chicago Press, 2001), 184, 347n15.

21. Quoted in Ross King, *Mad Enchantment: Claude Monet and the Painting of the Water Lilies* (London: Bloomsbury, 2016), 178, from a conversation reported by René Gimpel, *Diary of an Art Dealer,* trans. John Rosenberg (London: Hodder and Stoughton, 1966), 57–60.

22. The phrase, now often used by art historians, seems to have been given currency, if not coined, by Michael Fried, *Manet's Modernism; or, The Face of Painting in the 1860s* (Chicago: University of Chicago Press, 2003), 22, though he uses it with greater precision and effect than many of those who have picked it up from him.

23. Quoted by Lilla Cabot Perry, "Reminiscences of Claude Monet from 1899–1909," *American Magazine of Art* 18, no. 3 (1927): 120.

24. León de Lora, *Le Gaulois,* April 10, 1877, quoted in T. J. Clark, *The Painting of Modern Life: Paris in the Art of Manet and His Followers* (Princeton, NJ: Princeton University Press, 1984), 20.

25. A. Descubes [Amédée Descubes-Desgueraines], "L'Exposition des Impressionistes," *Gazette des Lettres, des Sciences et des Arts* 1, no. 12 (1877): 185.

26. Osip Mandelstam, "Impressionism," in *The Complete Poetry of Osip Emilevich Mandelstam,* trans. Burton Raffel (Albany: State University of New York Press, 1973), 209.

27. Wassily Kandinsky, *Concerning the Spiritual in Art,* trans. M. T. H. Sadler (1914; reprint, New York: Dover, 1977), 50.

28. David Brewster, *The Kaleidoscope: Its History, Theory, and Construction* (London: J. Murray, 1819), 135. See Jonathan Crary, *Techniques of the Observer: On Vision and Modernity in the Nineteenth Century* (Cambridge, MA: MIT Press, 1990), 116.

29. Marcel Proust, "The Painter; Shadows—Monet," *Against Sainte-Beuve and Other Essays,* trans. John Sturrock (Harmondsworth, UK: Penguin, 1988), 328.

30. Carol Vogel, "Water Lilies, at Home at MoMA," *New York Times,* March 5, 2009.

31. Wassily Kandinsky, quoted in John Hollis, *Shades — Of Painting at the Limit* (Bloomington: University of Indiana Press, 1998), 67.

CHAPTER EIGHT
Basic Black

1. Quotations from *Breakfast at Tiffany's,* screenplay by George Axelrod, from a novella by Truman Capote, are from http://www.dailyscript.com/scripts/Breakfast atTiffany's.pdf. The film was released by Paramount Pictures in October 1961. The novella was published in *Esquire* in November 1958 and then in book form as *Breakfast at Tiffany's: A Short Novel and Three Stories* (New York: Random House, 1958).

2. Axelrod, *Breakfast at Tiffany's.*

3. Wallis Simpson, often quoted and possibly apocryphal, but see Greg King, *The Duchess of Windsor: The Uncommon Life of Wallis Simpson* (London: Aurum, 1999), 416.

4. Elizabeth Hawes, *Fashion Is Spinach* (New York: Random House, 1938), 58.

5. Henry Ford's oft-cited quotation ("Any customer can have a car painted any color that he wants, so long as it is black") appears in his *My Life and Work* (written with Samuel Crowther [New York: Doubleday, Page, 1922]), 72. Ford says that he announced the policy at a meeting in 1909 but admits, "I cannot say that anyone agreed with me." For the subsequent color history of the Model T, see Bruce W. McCalley, *Model T Ford: The Car That Changed the World* (Iola, WI: Krause, 1994).

6. Hawes, *Fashion Is Spinach,* 58. See also Valerie Steele, *The Black Dress* (New York: HarperCollins, 2007); Amy Edelman, *The Little Black Dress* (New York: Simon and Schuster, 1997); and Anne Hollander, *Seeing Through Clothes* (New York: Viking, 1978).

7. Henry James, *The Awkward Age,* ed. Patricia Crick (Harmondsworth, UK: Penguin, 1987), 91.

8. Henry James, *The Wings of The Dove,* ed. Millicent Bell (Harmondsworth, UK: Penguin, 2008), 133.

9. See Michel Pastoureau, *Black: The History of a Color,* trans. Jody Gladding (Princeton, NJ: Princeton University Press, 2009), 100–104; and John Harvey, *Men in Black* (London: Reaktion, 1995), 74–82.

10. Johann Wolfgang von Goethe, *Theory of Colours* [1810], trans. Charles Locke Eastlake (1840; reprint, Mineola, NY: Dover, 2006), 181. See John Harvey, *The Story of Black* (London: Reaktion, 2013), 242–44.

11. Charles Locke Eastlake, *Hints on Household Taste in Furniture, Upholstery, and Other Details*, 2nd ed. (London: Longmans, Green, 1869), 236.

12. Charles Baudelaire, "Salon of 1846," in *Baudelaire: Selected Writings on Art and Artists*, trans. E. Charvet (Cambridge: Cambridge University Press, 1972), 105.

13. Brigid Delaney, "'You Could Disappear into It': Anish Kapoor on His Exclusive Rights to 'the Blackest Black,'" *Guardian*, September 25, 2016.

14. Jorge Luis Borges, "The Game of Chess," in *Dreamtigers*, trans. Mildred Boyer and Howard Morland (Austin: University of Texas Press, 1964), 59.

15. Joaquin Miller, *As It Was in the Beginning: A Poem* (San Francisco: A. M. Robinson, 1903), 4.

16. Anish Kapoor, as told to Julian Elias Bronner, "Anish Kapoor Talks About His Work with the Newly Developed Pigment Vantablack," 500 Words, *Artforum.com*, April 3, 2015.

17. Frida Kahlo, quoted in *Into the Nineties: Post-Colonial Women's Writing*, ed. Ann Rutherford, Lars Jensen, and Shirley Chew (Armidale, Australia: Dangaroo, 1994), 558 ("nada es negro, realmente nada es negro").

18. Arthur Rimbaud, "Voyelles," in *A Season in Hell* [1873], trans. Patricia Roseberry (London: Broadwater House, 1995), 56 ("A black, E white, I red, U green, O blue"). "Voyelles" was first published in 1871.

19. Henri Matisse, *Matisse on Art*, ed. Jack Flam (Berkeley: University of California Press, 1995), 166.

20. Aleksandra Shatskikh, *Black Square: Malevich and the Origin of Suprematism*, trans. Marian Schwartz (New Haven: Yale University Press, 2012), 105.

21. Quoted in Yve-Alain Bois, "On Two Paintings by Barnett Newman," *October* 108 (2004): 8. Used there by permission of the Barnett Newman Foundation. The italics for *Abraham* are not in the letter.

22. Bois, "On Two Paintings," 10.

23. Kazimir Malevich, *Essays on Art, 1915–1933*, ed. Troels Andersen (London: Rapp and Whiting, 1968), 26.

24. Alfred H. Barr Jr., "U.S. Abstract Art Arouses Russians," *New York Times,* June 11, 1959.

25. Varvara Stepanova, quoted in Margarita Tupitsyn, *Malevich and Film* (New Haven: Yale University Press, 2003), 9.

26. Malevich, quoted in *Artists on Art: From the 14th–20th Centuries,* ed. Robert Goldwater and Marco Treves (London: Pantheon, 1972), 452.

27. Malevich, *Essays on Art,* 25.

28. Ad Reinhardt, *Art as Art: The Selected Writings of Ad Reinhardt,* ed. Barbara Rose (Berkeley: University of California Press, 1975), 68, 75.

29. Gilles Néret, *Malevich* (Cologne: Taschen, 2003), 94.

30. Thomas Merton and Robert Lax, *A Catch of Anti-Letters* (Lanham, MD: Rowan and Littlefield, 1994), 120.

31. André Maurois, *Olympio; ou, La vie de Victor Hugo* (Paris: Hachette, 1954), 564.

CHAPTER NINE
White Lies

1. Herman Melville, *Moby-Dick,* ed. Hershel Parker and Harrison Hayford, 2nd ed. (New York: W. W. Norton, 2002), 165. All further quotations from the novel are from this edition and are cited parenthetically.

2. Ellsworth Kelly, "On Colour," in *Colour,* ed. David Batchelor (London: Whitechapel, and Cambridge, MA: MIT Press, 2007), 223.

3. Henry James, *The Novels and Tales of Henry James, Vol. 7: Tragic Muse,* vol. 1 (New York: Charles Scribner's Sons, 1908), x.

4. D. H. Lawrence, *Studies in Classic American Literature,* ed. Ezra Greenspan, Lindeth Vasey, and John Worthen (Cambridge: Cambridge University Press, 2003), 146.

5. Herman Melville to Evert Duyckinck, March 3, 1849, in *The Letters of Herman Melville,* ed. Merrell R. Davis and William H. Gilman (New Haven: Yale University Press, 1960), 79.

6. Melville to Sophia Hawthorne, January 8, 1852, in Davis and Gilman, *Letters of Melville,* 146.

7. Lawrence, *Studies in Classic American Literature*, 133.

8. Ralph Ellison, *Invisible Man* (New York: Random House, 1995), 217–18.

9. See David Batchelor, *Chromophobia* (London: Reaktion, 2000).

10. Johann Joachim Winckelmann, *History of the Art of Antiquity*, trans. H. F. Malgrave (Los Angeles: Getty, 2006) 194–95.

11. The phrase refers specifically to the Parthenon frieze by Phidias and appears in Walter Pater's essay on Winckelmann, published in 1867 in the *Westminster Review* and then in his *Renaissance: Studies in Art and Poetry* [1873], ed. Donald J. Hill (Berkeley: University of California Press, 1980), 174.

12. Johann Wolfgang Goethe, *Theory of Colours* [1810], trans. Charles Lock Eastlake (1840; reprint, Mineola, NY: Dover, 2006), 199.

13. See Deborah Tarn Steiner, *Images in Mind: Statues in Archaic and Classical Greek Literature and Thought* (Princeton, NJ: Princeton University Press, 2001), esp. 55n155.

14. Roberta Smith, "In 'Robert Ryman,' One Color with the Power of Many," *New York Times*, September 24, 1993.

15. Robert Ryman, "Robert Ryman in 'Paradox,'" segment from PBS series *art:21*, Season 4, aired November 18, 2007.

16. The best account of Ryman's paintings may well be Christopher Wood's "Ryman's Poetics," *Art in America* 82 (January 1994): 62–70.

17. "Questions to Stella and Judd," interview by Bruce Glaser, *Art News* 65, no. 5 (1966), as quoted in *Theories and Documents of Contemporary Art: A Sourcebook of Artist's Writings,* ed. Kristine Stiles and Peter Selz (Berkeley: University of California Press, 1996), 121.

18. See Robert K. Wallace, *Frank Stella's* Moby-Dick: *Words and Shapes* (Ann Arbor: University of Michigan Press, 2000); and Elizabeth A. Schultz, *Unpainted to the Last:* Moby-Dick *and Twentieth-Century American Art* (Lawrence: University Press of Kansas, 1995).

19. Stella, "1989: Previews from 36 Creative Artists," *New York Times*, January 1, 1989, compiled by Diane Solway, emphasis added.

CHAPTER TEN
Gray Areas

1. Susan Sontag, *On Photography* (1977; London: Penguin, 1979), 3.

2. John Berger, "Understanding a Photograph," in *Selected Essays,* ed. Geoff Dyer (New York: Vintage, 2003), 216.

3. Augusten Burroughs, "William Eggleston, the Pioneer of Color Photography," *T Magazine,* October 17, 2016.

4. Oliver Wendell Holmes, "The Stereoscope and the Stereograph," *Atlantic Monthly,* June 1859, 739.

5. Louis Daguerre, "Daguerreotype," in *Classic Essays in Photography,* ed. Alan Trachtenberg (New Haven: Leete's Island Books, 1980), 12.

6. Paul Valéry, *The Collected Works in English of Paul Valéry, Vol. 11: Occasions,* trans. Roger Shattuck and Frederick Brown (Princeton, NJ: Princeton University Press, 1970), 164.

7. Samuel Morse, quoted in "Notes of the Month: Photogenic Drawing," *United States Democratic Review* 5, no. 17 (1839): 518.

8. See Shawn Michelle Smith, *The Edge of Sight: Photography and the Unseen* (Durham, NC: Duke University Press, 2013), 1–2.

9. Joseph Nicéphore Niépce, quoted in Helmut and Allison Gernsheim, *L. J. M. Daguerre: The History of the Diorama and the Daguerreotype* (New York: Dutton, 1968), 67, emphasis added.

10. André Bazin, "The Ontology of the Photographic Image" [1945], in *The Camera Viewed: Writings on Twentieth-Century Photography,* ed. Peninah R. Petruck, vol. 2 (New York: E. Dutton, 1979), 142.

11. William Henry Fox Talbot, *The Pencil of Nature,* 6 vols. (London: Longman, Brown, Green, and Longmans, 1844–46).

12. Pete Turner, pers. comm., April 23, 2010.

13. Robert Frank, quoted in Nathan Lyons, ed., *Photographers on Photography: A Critical Anthology* (New York: Prentice Hall, 1966), 66.

14. Stephanie Brown, "Black and White," *American Poetry Review* 34, no. 2 (2005): 2.

15. Five of the photos are now in the Farm Security Administration collection at

the Library of Congress. The sixth, a long shot, she seems to have kept, and it is now in the Oakland Museum of California. The sixth picture appears without comment, along with the other five from the series, in an article by Lange's second husband, Paul Taylor, "Migrant Mother: 1936," *American West* 7, no. 3 (1970): 41–47.

16. Her name was not known until October 1978, when, after having been contacted by a local reporter, she wrote a letter to the *Modesto Bee* identifying herself as Florence Owens Thompson.

17. Roy Stryker, *In This Proud Land: America, 1935–1943, as Seen in the FSA Photographs* (Greenwich, CT: New York Graphic Society, 1973), 19.

18. "'Can't Get a Penny': Famed Photo's Subject Feels She's Exploited," *Los Angeles Times*, November 18, 1978.

19. Dorothea Lange, "The Assignment I'll Never Forget: Migrant Mother," *Popular Photography* 46, no. 2 (1960): 42–43, 81.

20. James Agee, quoted in William Stott, *Documentary Expression and Thirties America* (New York: Oxford University Press, 1973), 264.

21. See David Batchelor's *The Luminous and the Grey* (London: Reaktion, 2014), 63–96.

22. Gary Ross, dir., *Pleasantville* (Larger Than Life Productions / New Line Cinema, 1998); *Pleasantville: A Fairy Tale by Gary Ross* (1996), http://www.dailyscript.com/scripts/Pleasantville.htm.

23. On cinematic "falls into color" and so much more, see David Batchelor's splendid *Chromophobia* (London: Reaktion, 2000), esp. 36–41.

24. L. Frank Baum, *The Wonderful Wizard of Oz* (Chicago: George M. Hill, 1900), 12–13.

25. Salman Rushdie, *The Wizard of Oz* (London: British Film Institute, 1992), 17.

26. Baum, *Wonderful Wizard of Oz*, 44–45.

27. See Ranjit S. Dighe, ed., *The Historian's "Wizard of Oz": Reading L. Frank Baum's Classic as a Political and Monetary Allegory* (Westport, CT: Praeger, 2002).

28. Rushdie, *Wizard of Oz*, 24.

Illustration Credits

■

The photographers and the sources of visual material other than the owners indicated in the captions are as follows. Every effort has been made to supply complete and correct credits; if there are errors or omissions, please contact Yale University Press so that corrections can be made in any subsequent edition.

Fig. 2: Flickr/Roberto Faccenda

Fig. 3: From *Newsday*, September 5, 2016 © 2016 Newsday/Thomas A. Ferrara. All rights reserved. Used by permission and protected by the Copyright Laws of the United States. The printing, copying, redistribution, or retransmission of this Content without express written permission is prohibited. www.newsday.com.

Fig. 4: Courtesy of R. B. Lotto and D. Purves; image courtesy of BrainDen.com

Fig. 5: Reproduced by kind permission of the Syndics of Cambridge University Library, MS-ADD-03975-000-00021.jpg (MS Add. 3975, p. 15)

Fig. 7: Galen Rowell, *Mountain Light*/Alamy Stock Photo

Fig. 8: Cecilia Bleasdale

Fig. 9: Wikimedia Commons

Fig. 11: Wikimedia Commons

Fig. 12: Wikimedia Commons

Fig. 13: © 2017 The Barnett Newman Foundation, New York/Artists Rights Society (ARS), New York

Fig. 14: © Byron Kim, Courtesy of the National Gallery of Art, Washington

Fig. 15: Courtesy of the Rare Book and Manuscript Library, Columbia University in the City of New York

Fig. 16: Courtesy of Ed Welter

Fig. 17: Private Collection, © Glenn Ligon, Image courtesy of the artist, Luhring

Augustine, New York, Regen Projects, Los Angeles, and Thomas Dane Gallery, London

Fig. 18: Matt Mills, Austin, TX, http://stockandrender.com

Fig. 19: NASA

Fig. 20: Reuters/Amit Dave

Fig. 21: Flickr/Anna & Michal

Fig. 22: Liam Daniel

Fig. 23: © 2017 Estate of Pablo Picasso/Artists Rights Society (ARS), New York

Fig. 24: Scala/Art Resource, NY

Fig. 25: bpk Bildagentur/Charles Wilp/Art Resource, NY

Fig. 27: David Stroe/Wikimedia Commons

Fig. 28: Wikimedia Commons

Fig. 29: © National Portrait Gallery, London

Fig. 30: Wikimedia Commons

Fig. 31: The Nelson-Atkins Museum, Kansas City, Missouri, Gift of the Laura Nelson Kirkwood Residuary Trust, 44-41/2, Photo: Chris Bjuland and Joshua Ferdinand

Fig. 32: Wikimedia Commons

Fig. 33: © James Turrell, Photo: © Florian Holzherr

Fig. 34: Paramount Pictures/Photofest © Paramount Pictures

Fig. 35: Condé Nast/GettyImages

Fig. 37: Beinecke Rare Book and Manuscript Library, Yale University

Fig. 38: © 2017 Frank Stella/Artists Rights Society (ARS), New York

Fig. 39: Collection Musée de la Carte Postale, Baud, France

Fig. 40: Wikimedia Commons

Fig. 41: Photo: Bill Jacobson, courtesy The Greenwich Collection Ltd. and Dia Art Foundation, New York. All art by Robert Ryman © 2017 Robert Ryman/Artist Rights Socierty (ARS), New York

Fig. 43: Library of Congress, cph.3b41800

Fig. 46: New Line Cinema/Photofest © New Line Cinema

Index

■

Note: Page numbers in italic type indicate illustrations.

painting (continued)
the window applied to, 151; photog-
raphy compared to, 144; represen-
tational function of, 48, 112, 151–52,
172, 174; and transcendence, 57,
112–13. *See also* abstract art; impres-
sionism; modernism and modern
art; monochrome paintings
Pamuk, Orhan, 20
Panhellenic Socialist Movement, 89
Pantone, 122
Parks, Gordon, 202
Parti Québécois, 94
Pastoureau, Michel, 228n27, 229n33,
232n9
Pater, Walter, 189
Patou, Jean, 162
Patrick, Saint, 96
Peach crayon, 70, *70*
Penn, Irving, 197
people of color, 69
perception. *See* sense perception
Perry, Katy, 33
Perry, Lilla Cabot, 148
Philip II, King of Spain, 63
Philippines, 94
phosphenes, 15
photographs and photography, 197–213;
art/serious, 197, 200–201; black-
and-white (gray), 197–213; and
color, 197–201, 207–13; connotations
of black-and-white vs. color, 201–13;

as mechanical drawing, 199–200;
painting compared to, 144; and veri-
similitude, 197–99
photojournalism, 204
Picasso, Pablo, 104–7, 114, 116–17; *The
Blind Man's Meal*, 104; *La Nana*,
106; *The Tragedy*, 104, *105*, 106; *Yo,
Picasso*, 106
pigeons, 37–39
pigments, 109, 111, 121–22
pink (color), 101
pink (pigment), 122
Pires, Tomé, 63
Pissarro, Camille, 140, 142, 144, 150, 152;
Poplars, Sunset at Eragny, *143*
Plato, 26
Pleasantville (film), 209–11, *210*
Pliny, 124
Plutarch, 140
politics, color associations in, 83–97
Polo, Marco, 64, 124
Porter, Fairfield, 18
Pound, Ezra, 68
primary colors, 83
prisms, 27, 139, 179
Progressive Party (South Africa), 94
property, color as, 23–26, 30
Protestantism, orange associated with,
94–97
Proust, Marcel, 153
purple: dye for, 122; emotions asso-
ciated with, 101; political con-